THE FAST TRACK PHOTOGRAPHER BUSINESS PLAN

Build a Successful Photography
Venture from the Ground Up

DANE SANDERS

Foreword by David duChemin

AMPHOTO BOOKS

AN IMPRINT OF THE CROWN PUBLISHING GROUP
NEW YORK

Published in the United States by Amphoto Books, an imprint of the Crown
Publishing Group, a division of Random House, Inc., New York.
www.crownpublishing.com
www.amphotobooks.com

AMPHOTO BOOKS and the Amphoto Books logos are registered trademarks of
Random House, Inc.

Library of Congress Cataloging-in-Publication Data

Sanders, Dane, 1970-

The fast track photographer business plan : build a successful photography venture
from the ground up / Dane Sanders with a foreword David duChemin.

p. cm.

Includes bibliographical references and index.

ISBN 978-0-8174-0000-2 (alk. paper)

1. Photography–Business methods. 2. Photography–Vocational guidance. I. Title.

TR581.S26 2010

770.68–dc22

2010032621

Design by Debbie Glasserman

Printed in the United States

10 9 8 7 6 5 4 3

First Edition

CONTENTS

Foreword

It seems odd to me that people who want so badly to live by their creative wits, as photographers do, think so conventionally and uncreatively about the ways in which they want to make a living with that same craft. It's not only ironic, it's tragic, because so many of them end up failing financially or, worse, unhappy.

Photography is, for most of us, a creative endeavor. Taking our photography into the marketplace should be no less a unique act of expression, one that begins with our vision and talents and ends in serving a client base willing to exchange what they have for what you have. Sadly, many photographers who are inspired when they're behind the camera—photographers who would never dream of doing what everyone else is doing—step in line and do just as the photographers around them are doing when it comes to business and marketing. They become one of the crowd, a commodity duking it out for market share and underpricing each other into failure. It needn't be this way. The reasons for this disconnect, of course, are not difficult to understand. Most of us decided to pursue this vocation because we love photography, not business. We know how to create a compelling photograph, but creating a compelling brand at the heart of a vital, and solvent,

business is another thing altogether. And so we assume—or we allow ourselves to believe—that if we're talented enough, or buy the right gear, or create the best work of our lives, then we'll succeed. It would be nice if that were true. But real life doesn't work like that.

The best corporations do not succeed because the CEOs really, really want them to. Nor do they succeed because they do what everyone else does. They do not even succeed because the CEO knows how to build whatever widget the company happens to sell. They succeed because the CEO knows how to run a great company and hire the best widget makers he or she can find. Similarly, the rise or fall of your business has less to do with your photographic chops than your business chops. If that scares you and makes you put this book back on the shelf in favor of yet another book about "The Best Wedding Portrait Poses *Ever!*" then Dane has done you a favor. Better that you stay in your current job and still have a hobby you love than to lose both.

I know, forewords are meant to be encouraging. Dane should have known better. He could have found someone much more positive to write this and illustrated this page with kittens and rainbows. But Dane didn't write this book to make you feel better. He wrote it to help you—with truth, kindness, and the voice of experience—to build a business that will not only survive but thrive; a business that will not only meet your clients' expectations but exceed them because you yourself have done something exceedingly rare: You've followed your vision instead of the crowd. Dane could have written an easier book. Maybe even put a unicorn on the cover. Everything's happier with unicorns.

See, the thing is, I'm an idealist. I believe you can have your metaphorical cake and eat it, too. There is a way to sell your art without selling your soul. There is a way to do that which you are passionate about—a way to create something amazing, challenging, something you love—without starving.

Whether we all have the drive or the skill set to do so is another thing, and you'll be much closer to knowing if you've got it in you once you've read *The Fast Track Photographer Business Plan*. If I had written this book, I'd have called it *The Backtrack Photographer Business Plan*, because my journey was a little more circuitous. But it can be done. I have done it. My friends have done it. We've fallen on our faces, we've had to start over, and we've learned the hard way, but we've done it. But if it's to be done, it needs to be done the same way you'd create a great photograph. It's an act of creativity, begun with vision for what might be, and executed in your own particular way. This book won't show you what that way should look like, but, more important, it will help you discover it for yourself.

The principles Dane discusses in this book are profoundly important, and we're in desperate need of more voices to preach the kind of sermons Dane is preaching here. The old rules are gone, and their absence has created a vacuum. The pull of that sucking void will force some to create new rules to fill that space, but the real visionaries will take this sudden absence of rules as permission to forge their own paths—paths that are scarier, full of more potholes than we ever imagined, and littered with risks. But they also take us through the best scenery and return the best rewards.

Whatever your path looks like, there will be risks. It's never a question of whether you risk or do not risk. It's a question of which risks you choose. I hope you'll take the risks with the biggest payoffs, the ones that—should you succeed—allow you to craft a life doing what you love. The other risk—the one with the highest cost and no payoff, except the illusion of safety—is doing nothing, getting to the end of this life and facing regrets for never having tried. As I wrote in my book *VisionMongers*, there is no reward for tiptoeing carefully through life only to arrive safely at death. We've got one kick at this great adventure, so we might

as well make our mark and live it in the way we were uniquely created to do.

Soren Kierkegaard said, "To dare is to lose one's footing momentarily. To not dare is to lose oneself." If the voices in your head tell you this is something you must try, listen to them. I dare you. But do not listen to those voices alone; those voices are high on motivation but low on experience. They are big on the "why," but contribute nothing where the "how" is concerned. Dane Sanders is one of those alternate voices. He's as big on passion and risk taking as he is on doing so with wisdom, and we ignore voices like his at our peril.

Wherever your own path takes you, I wish you peace.

David duChemin
Vancouver, 2010

Open Me First: The Old Model's Broke—Don't Fix It

The world of photography is going through a seismic shift, make no mistake about it. You probably don't need this book to tell you that. Are we living in the Best of Times or the Worst of Times? That all depends on whom you ask. Casual shooters, newcomers, and part-time pros who love all the new photo gadgetry and the easy access to great technologies, forums, and markets might say the former. Struggling professionals trying to make a living, maybe the latter.

One thing is for sure: Today's photo world is not suffering from a lack of *passion*. More people than ever before are actively involved with photography. Look at Facebook, look at your email inbox, look at your iPhone. Everywhere I go I see photographers intoxicated with new ideas about the images they are capturing, making, and manipulating. Never before have so many shooters, amateur and pro alike, had so much access to so much cool technology and so many places to share and explore that technology. And never before have there been so many exciting venues for talking about the *artistic* side of photography. Ask a photographer about his or her creative ideas and you're probably in for a fun conversation. A long one, too.

And yet, the moment the conversation turns to business, many of these same photographers grow awkwardly silent. It's as though the money-making part of their work has eluded them and they feel bad about it. When I ask them about their ideas for going out and getting customers, many have no answer. It's not that they don't understand what I mean or aren't interested in finding a way to bring in new clients. It's that they're exhausted from trying and failing. For many of my peers, the "business stuff" can seem like one enormous headache, especially when you compare it to the more creative work of lighting a subject or composing an image. It seems too overwhelming to tackle.

Other photo friends of mine, particularly the seasoned vets, take an even dimmer view. Many of them are wearing looks on their faces these days as if they've just been hit by a Kodak truck. They've been in the business for years, have "paid their dues," and have even experienced a taste of financial success as professional photographers. But suddenly the sands are shifting under their feet. The old models for "making it" in the photo world are crumbling before their eyes. Markets are being saturated, price tags for photo work are shrinking, and business is being spread too thin. The career they *thought* they signed up for has become almost unrecognizable.

And all of this seems to have happened practically overnight.

The New Landscape

Thanks to a "perfect storm" of recent developments—the changeover of the photo world to digital photography, the drastic drop in price for high-end cameras and photo technology, and the blossoming of internet commerce—the barriers to entry for professional photography have become little more than speed bumps. More people are able to equip themselves competitively and learn the pro's toolset than ever before. What does that mean for all of us?

Well, because more would-be shooters can now afford professional-level equipment and because the learning curves for figuring out how to use the stuff are much shorter than ever before, more folks are throwing themselves into the fray. It's a numbers game. At the same time, the internet has opened up cheap and easy markets for selling photos. As a result, more people are *selling* photos for money. And because many of these new shooters are part-timers who don't need to pay their mortgage via their photo sales (or are living in parts of the world where a dollar goes a lot further), the price of photos in many markets has plummeted. People are willing to sell for whatever they can get.

This is a big problem for established pros.

But here's what *really* irks the old-timers (i.e., those who got a taste of the old model before the new model came crashing in): the new shooters entering the business don't seem properly *seasoned*. They don't have a sense of tradition and hierarchy. They don't use the sacred lingo. They haven't paid their dues by working their way up the ladder. They don't have reverence for the right things.

Worse, they have no sense of business etiquette. Many of them seem to be rogues and upstarts who have no stake in playing the game the way *we* were taught to play. It's like *World of Warcraft* out there. The Horde versus the Alliance. No rules. No sympathy. No accountability.

And, boy, does that terrify the old-timers.

Meanwhile, the newcomers—and perhaps you're one of them—are just trying to learn the rules of the game. They don't understand all of the hostility they're encountering.

So How Do We Respond?

The way many established shooters have chosen to respond to these new developments is the fear-based approach. The good old fight/flight response. They retreat to the corners of the boxing ring where they feel safe and throw punches to keep others out.

Take the online photo forums for example. As the upstart new shooters start posting their photos online and joining the discussions, members of the old guard react with predictable defensiveness. They try to employ browbeating and put-downs. Pay your dues, they tell the newbies. Apprentice for a few years. *Learn* your craft before you try to *sell* your craft. Stop watering down the market for all of us by selling underpriced goods.

And many of the newbies try to listen. They really do. But they see their friends making some money at this craft and they want in. They may not *like* the fact that selling photos at bargain prices is watering down the market for trained pros, but they still want a piece of the action and they want it now. They don't want to wait. They don't want to pay dues. And who can blame them? The fact is, in a digital world, they don't really *need* to wait anymore.

Still, the old guard clings ferociously to the traditional models. It's as if they hope that, by sheer force of resisting the new, they can *will* the old models back into existence. They fondly recall the day, not so long ago, when there was a fairly predictable path in the journey to becoming a pro shooter.

What did that old path look like? Well, of course, it varied a bit, depending on your specialty. For a photojournalist, for example, the path might look something like this: Go to photo school. Get a job shooting for a small newspaper. Develop your craft for a few years. Get a job at a better newspaper. Then a better one. Win a few prizes, get some name recognition. Get a job teaching.

For a commercial photographer, perhaps it would look more like this: Spend a couple of years building a portfolio. Apprentice with an established shooter, learn the ropes. Get your first break with an agent or an ad agency art director. Work with low-level clients for a few years. Then get some mid-level clients. Then high-level. Maybe become an art director yourself.

For other types of photographers the paths had similar trajectories. Spend some years learning the trade. Pay your dues. Impress the right people. Get some breaks. Work your way up. Get rich and fat.

It all seemed so fair, so right, so meritbased, so egalitarian. The only problem is, it's now a fantasy. The old model is broken. Kaput.

We're no longer living in a print-only world where print-only rules apply. We're living in a new Wild West of ever-evolving media. Google Ads and social media are the new marketing tools of the day. Online images, in all their various forms, have supplanted paper ones. Video clips are now being used in many places where still images once served. Newspapers are disappearing or going online. Photographers' agents and art directors are applying for unemployment. The list of changes goes on and on.

The old model is broken, my friends. And it doesn't need to be fixed. It needs to be jettisoned.

What's Needed Today

We are living in crazy times. Not just for photographers, but for everyone. It wasn't long ago that our world was flush with cash (or at least credit), and working hard was usually enough to guarantee career safety.

Yet now, everywhere I look I see friends scrambling to deal with a tilt-a-whirl economy, working desperately to stay ahead of bills and hold onto their jobs. What used to *feel* secure—working for a company that offered a steady income, benefits, and the promise of a future—now feels about as substantial as a smoke ring. "The Man" is no longer standing by the career ladder and handing out gold retirement watches to those who make it to the top. The ladder is gone; the rungs have been sawn off.

So it's no surprise that so many have decided, voluntarily or not, to forge their own trails in small business. This is especially true in creative industries that don't require degrees or years of training to enter. Industries like photography.

From the outside, it can seem as if the only requirements to create your own photo start-up business nowadays are a modest

investment in equipment and a willingness to jump into the fray. Obviously, this is a frightening turn of events to established pros.

But I would like to take this opportunity to put everyone at ease, both the established pro and the newcomer. As I see it, the problem with photography isn't that there are too many photographers vying to make a living. There are just too many photographers *failing* at business. And, frankly, they don't need to be.

I believe that business success is not only possible but well within your grasp. But you need to want it keenly and you need to reimagine the game you're playing. You must start by realizing that you are never again going to own the competitive business edge strictly by having…

» The best equipment

» The best training

» The most prestigious degree

» The most experience

» Access to markets that others can't break into

» A great apprenticeship record

» A stellar resume

» Your dues paid up

In today's Digi-flat world (a term I coined in *Fast Track Photographer,* my previous book), none of these things matter very much. Then what *does* matter?

Well, here's where it all gets interesting. And thrilling. If there's one thing I've learned through my many conversations with photo professionals in recent years, it's this: The most successful businesses are those that have grown directly out of the photographer's own identity, creativity, and vision. The

way these photographers have succeeded in the face of fierce competition is not by trying to outdo others at their game. It is by *ignoring what everyone else is doing and building a business that stands apart.*

Success today is not about having the best gadgets or posting the most blogs. It's all about knowing exactly who you are as a photographer and using the new technologies to put it out there in the ideal form for all the world to see.

When you compare yourself to your competition or tailor your services to match other businesses in the field, you're forgetting the one thing their business has that no other does: you. If, on the other hand, you build a business around your own unique talents, ideas, and vision, you're ensuring that not only will you stand apart from the pack but that you'll do the work you love and were meant to do.

The Creative and the Businessperson

Let me expand on this idea a little more and, in doing so, spell out the premise of this book.

"Back in the day," when there was still a discernable path to success in the world of photography, you didn't need to worry too much about being either (1) highly creative or (2) an amazing businessperson. There was a model to follow.

Because the path to success was externally laid out for us and marked by observable guideposts, and because these guideposts were reinforced by institutions such as newspapers, ad agencies, art galleries, and chambers of commerce, your job was only to work hard and improve at your craft. You didn't need a *particularly* unique edge. You didn't need to be a brilliant marketer. You didn't need to create a magnetic brand that reached out and pulled in your market niche. You didn't need to be highly creative.

All you really needed to do—and I'm oversimplifying here to make a point—was to follow the rules, make nice pictures,

and keep your customers or employers happy. The longer you worked at your craft, the more skilled you gradually became, and the more money you usually earned. The more you earned, the nicer equipment and studio space you could acquire, which, in turn, helped distinguish you from the raw recruits. All very safe and predictable, at least compared to today's world. Not everyone succeeded on this path, of course, but if you hit the right milestones, you *could* succeed.

It was a vastly more forgiving era, so you didn't need to be an especially focused *businessperson* either. You didn't need to be mega-efficient in your efforts. You could afford to play the role of accountant, photo editor, receptionist, and maintenance person, in addition to main shooter. You didn't need to worry about leveraging and focusing your time and effort so as to produce the highest payoff.

All that has changed. Today the path is an internal one, not an external one. The old guideposts don't lead anywhere. Today the path you walk is the one you carve for yourself. Today the mandate is to know exactly who you are and what value your unique talents hold in the marketplace. That means you need to be more creative and innovative than ever before. That means you can no longer afford to waste a lot of time doing things that are not directly related to building your brand or doing the high-level creative work of your business.

What *that* means, in turn, is that you must become better at the "business" side of running your business. You can't afford to be diluting your value by working on tasks that can be done more efficiently by others. You must learn to share the workload with a support team and to systematize all those tasks that you *do* perform. Why? So that you free up more of your time and attention to to allow yourself to make the signature contribution you were born to make.

Let me sum that up again: To thrive in today's Digi-flat world, you must become the most creative and unique photographer you

can imagine being. To do so, you must dedicate lots of time and attention to that task. And to do *that*, you must become the most efficient businessperson you can become.

Do you see how it works? The way to free up your creativity is to spend less time on the routine tasks of running your business, so that these tasks no longer consume and drain you. That means becoming smarter, more efficient, and more systematized. Good business supports great creativity. Great creativity generates more business.

Business and creativity are not enemies; they are lovers.

Finding Focus in the Complexity

The reason so many artists (and business owners in general) are overwhelmed these days is not because running a business is too complex. It's *because the world we live in* has become so complicated.

For all its wonders, the digital revolution has brought with it a host of distractions that sap our attention. From Twitter feeds to Facebook updates to iPhones that make it possible for us to be contacted 24/7, we're all living a "life interrupted." Recent studies suggest that the average professional today rarely works for *five solid minutes* without some kind of interruption. It's a catch-22: Photographers and other creative professionals need time away from our computers and ringing phones if we're to live up to our creative potential, and yet we can't afford to hide away in our studios and wait for work to come to us. In an age where many clients find photographers through Google searches, or hear about cool artists on Facebook and Twitter, an active web presence is crucial. It's also a full-time job itself!

This is one of the reasons why "personal productivity" has become such a booming industry. Thanks to productivity gurus like David Allen (the author of *Getting Things Done*) and time-management pioneers like Steven Covey (who wrote *First*

Things First), we now have very sophisticated systems to help stay focused on what matters most. But despite the fact that these organizational tools can be very helpful, there is still a gap, especially for professionals whose work involves a lot of intangible creative tasks. Time management is not enough.

What creative business owners need is a whole new model for building and running their businesses. We need to reinvent how we approach business and in doing so we must account for the peculiar demands of the internet age. And that means taking charge of our business rather than letting it take charge of us. We must learn to become leaders, not followers. And this is true even if we run a business whose only employee is ourselves.

In fact it may be *doubly* true in that case.

A Better Way to Think About Your Business

I believe that the biggest problem most creative business owners face is a failure of leadership. It's an understandable dilemma, of course: You probably think of yourself as a photographer first, businessperson second—if you think of yourself as a businessperson at all.

But you *are* a businessperson! If you're making money from what you do, or actively trying to, then you're running a business. And if you're running a business, you have the same concerns and responsibilities as companies as huge as Apple, Google, or Wal-Mart. The only difference is one of scale. You, too, need visionary leadership, strategic decision making, and devoted sales, marketing, and operations teams. No wonder you're so overwhelmed!

But because your business likely consists of very few, if any, employees, you simply don't have the luxury of setting up a traditional hierarchy. And yet, the work still needs to get done.

What I'm suggesting is that it *is* possible for you to do it all without hiring so much as one staff member. I certainly did it all when I was starting out, and I have spoken with many

photographers whose companies-of-one are thriving. But if you want to do it right, there's a tricky task at hand. And this task turns out to be the very first step you need to take if you want to achieve success as a Fast Track business owner.

You need to fire yourself as the frontline photographer. Yes, that's right. You need to fire yourself as the photographer and hire yourself as the CEO.

Don't worry, you can always rehire yourself once you've finished reading this book. But if you're serious about running your creative enterprise, you must dramatically change your perspective from that of the person doing the day-to-day, ground-level work to the person who looks at your business from a much higher perspective. You need to elevate your view. You need to be the CEO, not just the service provider.

Firing yourself means *no more taking pictures*—at least not until you understand the concepts I'll be sharing in these pages. Believe it or not, your commitment to your craft may be the very thing that is holding you back from more freedom and money—not to mention enjoyment of your work.

Don't get me wrong. I'm passionate about taking pictures. But the rules for being the frontline photographer and the rules for being the CEO of a business are different. If we play by the wrong rules at the wrong times, we get ourselves into trouble. If we keep the two roles distinct, though, this new way of thinking may actually give us *more time* to take photos.

If you want your business to be a living reflection of your creative genius (and I believe you do have genius), you'll need to give yourself the gift of standing back from that work. I know it can feel scary to get off the front line and feel the weight of the company's world on your shoulders. That's why running a small business isn't for everyone.

But if your intent is to become a thriving small-business owner in today's ultracompetitive world, it's time you step up to the role and own it.

Simply put, when you're done reading this book and putting some of its ideas in motion, you'll have built a structure that gives you much more time to do the work you love. You'll have all the power (and responsibility) to put the right people on the right jobs. That might mean hiring people or working with partners and vendors. For those of you who are one-person businesses, it might also mean learning to wear the right hat at the right time and systematizing your routine activities so that you maximize the time you spend doing creative work. Either way, the new freedom will be all yours. Yours to spend doing the creative work you long to do.

Good business supports good creativity. Welcome to the life you really envisioned when you decided a day job wasn't for you.

So What Can You Expect from This Book?

My guess is that if you're reading this, you are either in start-up or restart mode. If you're just starting out, you likely have more enthusiasm than you know what to do with but aren't sure which way to turn. You're super-enthusiastic about the idea of taking your passion for photography and translating it into a moneymaking venture. Maybe you're self-taught, or maybe you're a recent art school graduate hungry for some business tips (since no one covered that trifling little concern behind those ivy-covered walls).

Or perhaps the reverse is true. You've already started building your business but your enthusiasm has evaporated. Maybe you're scared. After maxing out your credit on gear, a website, and business cards, you're wondering where all your clients are hiding. You know there are opportunities out there, but you have no guide to help you find them. Perhaps you're stuck in the trenches of day-to-day details, with no time to be creative or get ahead.

Or maybe you're just looking for a great big, red RESET button to give your career a fresh start. You may have lost your job and

are thinking that maybe if you could make the kind of creative living you've always dreamed of, you'd be thanking your old boss for liberating you.

Whatever your particular story, know this: how you got here is less important than where the ideas in this book will take you. I think the reason so many of us never realize our dreams is not because becoming remarkable is impossible. Quite the contrary, it's because too few of us even bother to pursue greatness for fear of failing. And by giving fear that much power in our lives, we forfeit our dreams.

So before you read one more sentence of this book, would you consider making a conscious decision *not* to make that trade-off? It's a bad deal for you. Let's take back those dreams of yours right now. How? By learning the tools to create a *foundation* for those dreams. By moving your dreams out of the realm of unrealized fantasy and placing them squarely in the realm of attainable reality. By building a plan that will allow you to more easily accomplish all the day-to-day tasks of running a business so that you may keep your main focus on the "big picture" stuff that got you into this field to begin with. If that's what you're truly interested in doing, then you've come to the right place.

If you're looking for a "how to build a business plan in twenty-four hours" book, on the other hand, you've come to the *wrong* place. This book is not about creating a formal plan for others to read or fund. If you've ever bought one of those business-plan books in the past, I suspect you've been as frustrated as I've been with how little they've had to offer beyond a glorified template to fill in the blanks. The book you hold in your hands is meant to help you discover what goes *in* those blank spaces! You *will* be writing a business plan at the end of this book, but it will not be a traditional one; it will be a Fast Track business plan.

I should also point out that if you're looking for a comprehensive checklist of "things I need to do to start a small business," such as

get an employer ID number, start a business checking account, and buy the right kinds of insurance, you will want to look further than this book. All of those concerns are valid, but they are addressed in many other resources, both online and in print. I've included some info in the appendix section to help you find guidance in these areas when you need it.

Here we need to keep the focus on learning the Fast Track approach to business.

How Fast Is This Fast Track?

Now, I want you to know that just because I call this method "Fast Track" doesn't mean it's instantaneous, although I do believe it is the most efficient way to achieve success. The goal is to help you build a *real, functional* approach and plan for your photo business that will last for the life of your company. That will require an investment of time and effort on your part.

Moreover, since this book has been written for all practitioners of photography, any one-size-fits-all, "how-to" attempt would feel thin in its treatment and thick in its volume. Instead, I'm going to invite you to play a much bigger game: the game of *leading* your company, large or small, by actively playing the role of "Visionary CEO." There's no such thing as a one-size-fits-all business plan, but there are some exciting principles you can follow that will help you build a business all your own and keep it running smoothly so you're freed up to do the work you really love.

Surprisingly, the ideas I'm offering here are pretty simple. But I won't lie to you: finding the discipline to *implement* them will not always be easy. There is, after all, a huge difference between *simple* and *easy*. If you're intending to treat this book like a gym membership you never use, you may be left wanting. But if you're up to the challenge of *using* the ideas in this book, I'm committed to offering all the direction you need to get where you dream of going.

How This Book Relates to *Fast Track Photographer*

Before we get rolling, I want to make an important point. If you are still trying to discover and forge your identity in this industry, I'd strongly recommend you start with my first book, *Fast Track Photographer*. In that book, you'll learn about what matters most when you decide to go pro: not the photos you take, but your development as a *photographer*.

The Fast Track Photographer Business Plan will help you actually build a business based on your unique vision. So, *FTP* is about the *photographer* and *The FTP Business Plan* is about the *business* its owner is building. Make sense?

I want to mention, too, that in my first book I introduced two different types of shooters: Signature Brand Photographers and Freelance Photographers. Consumers, art directors, and editors hire Signature Brands directly because they know these photographers' names and styles by reputation or from previous work. A Signature Brand's images are certainly important because they showcase a photographer's vision, but they are not the only factor in hiring decisions. As a Signature Brand Photographer myself, clients have often confessed to me that their primary reason for bringing me on was that they just felt confident that I'd be able to deliver the goods. When customers hire a Signature Brand shooter, they are hiring the person as much as the images.

The Freelance Photographer, on the other hand, operates largely anonymously. These photographers must also develop their personal style; the difference is that rather than marketing their names and personas, they market their skills and images to agents, art directors, editors, and photo agencies who then broker deals on their behalf. Imagine that the art director at outdoor-clothing retailer Patagonia was in the market to find a photographer for one of their catalogs and wanted a fresh look. Instead of combing through shooters' websites, the art director might contact

a company like Greenhouse Reps whose job it is to link commercial clients with Freelance Photographers. In a case like this, having representatives who get your style and personality is perhaps more important than connecting with the clients themselves, at least initially.

The ideas in this book will work for you, regardless of whether you consider yourself a Freelance Photographer or a Signature Brand Photographer (or a hybrid of both), since both types of photographers build businesses based on their unique qualities. Further, since the focus of this book is less on the photographer and more on the company that is being built, the fundamentals remain the same for both types of photographer.

How to Use the Book

The book is broken into four sections. In Section 1, Envision Your Business, I establish a few important core concepts before we move on to the brick-and-mortar stuff. Specifically, we will explore the idea that effective leadership of any business, huge or tiny, flows from having a strong and clear *vision*. We'll also look at how your vision for your company intersects with the marketplace. We'll see that it's pointless to develop a powerful vision that no one wants to pay for. A viable vision must be one the market will support. And the rules have changed for how you determine that.

Now, if you read *Fast Track Photographer*, you've already done a lot of work toward honing your vision for *yourself as a photographer*. The pDNA (photographer DNA) tool helped you define exactly who you are and what you bring to the profession. (If you have not taken the pDNA assessment, you might want to consider taking it now or at some point during the course of reading this book. You can do so by logging onto mypdna.com.) When we talk about vision in *this* book, we are talking about a vision for your entire photography *business*, which includes your pDNA but also goes beyond it to encompass what you want to

accomplish as a businessperson. So even if you have read my first book, I strongly encourage you to do the vision work here as well.

Once we've established the vision on which your business will be built, I invite you to take the Business Stress Test (BST), an online assessment tool provided free to anyone who has purchased this book. Unlike the pDNA tool, which assesses the qualities of the individual creative person, the BST is meant to put stress on fundamental components of your business in order to give you a sense of its relative health. Said differently, the purpose of the BST is to "take the temperature" of your current business, whether you're just starting out or you've been at it for a while. Think of it as providing a snapshot of where you're currently at. Remember, though, that health is fickle; this is just a glimpse of your business at one moment in time. You want to constantly be taking its temperature. For now though, the BST should give you a good idea about the "treatment plan" you want to tailor for yourself. In that regard, it's almost as if you're going on a diet and you're about to take your "before" picture.

As you move through the book, you'll be invited to take portions of the test online, giving you LIVE feedback as to where you're at and where you need to concentrate your efforts most strongly.

To get started, go to http://ftpBST.com and enter the code found on the back cover of this book. You only need to register this code once. You'll then be able to log in to take the various sections of the assessment as well as return to the results whenever it can help. You might even choose to take the test periodically to track how your business is improving over time.

The remaining three sections of the book are designed to help you get your business up and running, keeping in mind both your vision and the unfolding results of the BST. In Section 2, Create Strong Foundations: Give Yourself Your Best Shot, we'll lay out the nuts-and-bolts *foundation* for a working business. We'll talk about getting your financial house in order, building a team, creating standard operating procedures, and making sure you are

backed up on all fronts. We'll also talk about some crucial mind-sets that will power you through the lean and mean days.

Section 3, Get to Work: The Fast Track Photographer Business Cycle, is all about understanding the three parts of the customer-generation cycle: booking jobs, shooting jobs, and leveraging past jobs so that you can book more jobs. This section is full of tips and strategies for growing your customer base.

Finally, Section 4, Start Your Business Engine, offers strategies for lifting your business above the herd and making it a viable entity for the future, without compromising your values. Finally, and most important, it provides you the opportunity to build your own Fast Track business plan that incorporates all the ideas discussed up to that point.

Let's Do This Thing

What I'm offering here is a way to build a creative business from the ground up. It starts with your unique strengths and vision, but it doesn't stop there. It takes you through the practical steps you'll need to take to *support* your vision with action, smarts, and a team concept (yes, even if you work alone).

When you're done reading this book, you'll know how to set up your business so that it generates more returns with less effort. You'll understand how to scale your business intelligently. You'll have a much better grasp of who you are and where you're going as a company. You'll learn how to share the burden of running your business—and that it's a lot easier and less expensive than you probably thought. And you'll have no idea how you worked any other way before.

As far as I can tell, the only downside to reading this book is that by the time you're done, you'll no longer have the excuse of "not knowing what to do." With your game plan in hand, the only thing left will be to live it out.

SECTION 1 | **ENVISION YOUR BUSINESS**

Chapter 1
Get Clear About Vision

Living on Zoom

A friend recently confided that, as the owner of a small business, he feels as if he *lives on zoom*. In other words, he's so focused on the so-called critical day-to-day details and worried about avoiding mistakes on the front line that he's blind to the "big picture"—the ability to see what is truly worth his time.

He's not alone. This isn't just how we run our businesses; it's how most of us live our lives. The tyranny of the urgent is omnipresent. And yet, it doesn't have to be. As a small-business owner who's fortunate enough to take pictures for a living, I understand how tempting it can be to get caught up in the craft and let the "what am I really trying to accomplish here?" questions fall by the wayside.

And yet if you don't "zoom out" every once in a while, you're putting your ability to make a living as a photographer in danger. Our work requires more than just snapping photos. There is a creative aspect to *being a photographer* and running a business that extends far beyond the photos we take. This creative work requires

focused energy. And if our businesses aren't running smoothly, they're going to suck up all the energy we need to do that.

So we must learn to do more than react to the urgencies of the moment. We must zoom out, elevate our view, and make a conscious declaration about who we are and what we're trying to accomplish with our businesses. Once we do that, we must streamline our business processes so that we have more time and energy to focus on the big picture.

In short, we must be *willing* to *lead*.

Lead or Be Led

When you think of how you actually spend your days as a small-business owner (or someone working to establish a small business), what comes to mind? As a dear friend once put it, "The gift of leaving my day job and becoming a small-business owner is that now I'm completely *free* (dramatic pause)…to work 24 hours a day, seven days a week for my business."

Ironic, isn't it? The idea of trading in a cubicle for freedom is often what motivates us to dive into life as a professional creative. And yet, many of my peers seem more overwhelmed now than when they were working for someone else.

What is the reward for this tireless devotion to your business? Ask anyone who's been at it for a while and you'll hear a common lament: burnout, discouragement, and failure. Too few hours in the day.

The good news is that you *can* avoid being run into the ground by your business—but only if you're willing to *lead* it.

How often have you heard a creative say something like, "I'm completely devoted to my business!" For years, when I would hear comments like this, I took it as an indicator that the speaker was *serious* about the entrepreneurial life. But think about it. The very idea of being *devoted* to your business is not a measure of leadership at all. It's a measure of "follow-ship." If you're *devoted*

to your company, you're not serious about *running* it. You're serious about having *it* run *you*. A devotee is not a leader.

If you've ever tried to run a business, there's a good chance you've fallen into this trap: sacrificing sleep to finish a job on time, missing out on family activities because you're always behind, fighting with your spouse because you're feeling so much pressure about mounting bills...

You need to find a way to turn the tables so that *your business is devoted to you.* If you don't commit to leading your business, your business will lead you to a proverbial prison. Let me say it more personally: If I don't take responsibility to lead my business, I will eventually forfeit my viability as a professional photographer who loves what he does. There's no way around it. I must lead.

So, what does it even mean to lead a business? Or, to ask a big-picture question, what does it mean to lead at all?

Do a quick search in any thesaurus and you'll be amazed at the number of synonyms you'll find for *leader: chief, boss, principal, chair, director, CEO, skipper, numero uno, head honcho.* What do these words mean to you? When I started thinking about them, they made me realize that, at bottom, it's my job as a leader to decide which direction my business is going. A *sense of direction*—that seems to be the key.

It's when I looked up the word *follower* that I started to get nervous. Words like *minion, servant, hanger-on*, and *devotee* don't seem that far off from the way many creatives operate within their businesses. For many of us, the momentum of the business has become the real leader and we merely jump to its demands.

When I look around our industry, sorry to say, I mostly see followers. People run by their businesses.

Leading to the Right Place

The word *leadership* implies that you are steering the ship of your business somewhere specific. It means you have someplace to go.

I frequently come across photographers who are eager to declare their disdain for day jobs and the thrill of being free as the owners of their businesses. But if I ask them just a couple of direct questions about where they are leading their companies, I'm left with blank stares and mumbled hopes about "making money."

Really? Is that kind of vague semi-goal going to fuel you with the energy, inspiration, and direction needed to really *lead* your company?

I recently had the privilege of presenting at a photographers convention in New Orleans. I noticed that when night falls in the French Quarter, especially around Mardi Gras (or when the Saints win the Super Bowl!), the endless bars and restaurants begin to blur into a confusing jumble of color and motion. Add to that a sea of intoxicated visitors and anyone, sober or not, can get lost pretty quickly.

Now, if you wanted to, say, get back to your hotel room, but had completely lost your bearings, what would you do? You could certainly ask for help. But what if you weren't confident that the advice of the tattooed guy holding the triple-sized margarita tumbler was trustworthy? You'd be left to anxiously wander about, wondering if you were going in the right direction.

To press the metaphor a little, what if the crowd was all heading in one direction, but you didn't know why? You might be tempted to join the crowd and hope for the best. Of course, this tactic might work. But only because you got lucky, not because you *led* yourself home.

Now, imagine a different approach: What if instead of wandering, you could get some perspective on your predicament by elevating your point of view? For example, what if you were able to get a satellite picture of your global position through, say, a GPS map on your phone? Don't you think the likelihood of you finding your path back to your hotel would go up significantly?

Photographers often encounter the same dilemma: Because our skill set is "on the ground"—we're concerned with front line tasks

like taking pictures, lighting a subject, and manipulating objects in Photoshop—we often crop the picture of our businesses too tightly and fail to gain the perspective we need to lead.

Be the Map

Let's take this idea further still: What if instead of borrowing a map to run your business, you actually *were* the map? Better yet, what if *everyone* you associated or teamed up with had the same map guiding them? The benefits would be immeasurable. Picture everyone connected to your company sharing the same values so that you moved to the same drumbeat in lock step.

Many photographers believe the strength of their art rests wholly on their photos. This misunderstanding is what leads so many artists to believe that they're only as good as their last piece, totally missing the fact that the engine that created that great work is with them everywhere they go. By failing to harness their true potency, they try to leverage the power of tools (like cameras, computers, and software) to produce the magic instead of understanding that the roots of their creativity were *inside of them* all along, with or without those tools.

The moment you begin to understand the skills, experiences, and values you possess that set you apart from the rest, you create an internal compass that can guide you wherever you go. When you live from that perspective, you also grow more fulfilled and secure. And you put yourself in the best possible position for starting and leading a fulfilling business.

What I'm talking about, quite simply, is creating a *vision*. A vision means having a clear idea of the following:

» Who you are, uniquely, as a photographer—the signature contribution you believe you were "born" to make (see my earlier comments re: pDNA)

» How your business will embody and leverage that uniqueness

» The target market you plan to attract

» The size and scope of the impact you intend to make in the photo world

Identifying your vision is a process that involves a combination of pinpointing your strengths and weaknesses, incorporating your life experiences, noticing the kinds of images, ideas and experiences you're drawn to, and identifying the kind of people that might be attracted to your work.

It all starts with having a clear sense of what *excites* you in the world of photography. What gives you juice? Is it fine art imagery? Nature? People? Do you have an unquenchable thirst for capturing the drama of live events or the gritty action of athletes in competition?

Knowing what excites you gives you a clue to the kind of contribution you were born to make. It tells you what market you should be in and what specialty you should be pursuing. Passion and purpose are joined at the hip.

Knowing your own *strengths and weaknesses* is also crucial. When you look at the competition within your niche of the photo world, what is it that you feel you can do better or more uniquely than anyone else? What is your signature talent? Is it your sense of composition? Your eye for an unusual subject? Your technological wizardry and ability to manipulate images? Your ability to put subjects at ease?

Last, what personal values, tastes, and personal history do you bring to the table? Who are you, and what do you care about? Can you imagine making the world a better place, even in a small way, through the way you take photos *and run your business*? If so, how?

Vision First, Technology Second

It's only after we ask and answer these types of big-picture vision questions that questions of *execution* kick in. *That's* when we can

start to worry about what tools, techniques and strategies might be most appropriate for us to adopt. Today, of course, there are more tools and technologies available than ever. A still camera doubles as a video camera. Software and hardware tools can manipulate images in every way imaginable. There are also endless possibilities for delivering a physical photograph. Paper is no longer necessarily the go-to medium. Images can be displayed on a wide range of electronic devices and printed on almost any kind of real-world object imaginable. What is your physical product (i.e. the imagery and/or photo service package that your customer will purchase) going to look like and how will you get it into people's hands?

You have to have a vision before you can answer these questions. If you let technology drive your bus, you'll be torn in a hundred different directions and you'll never feel as if you're keeping up. You'll always feel behind the eight ball. But in a vision-driven world, your tools become servants to your big idea. Some photographers, for instance, will find that they want to *add* tools to the mix, while others will see that they are better off removing tools and offering a simpler, more focused product. Some will discover that incorporating writing, music or voice-overs into their product makes sense. Others will steer their work toward next-generation platforms like the iPad. Whether it's *adding* tools or *subtracting* them, it's critical that you know what you're offering first and then get as refined as possible about what you're delivering.

Vision must drive the bus. That's the essence of leadership.

So how do you start this process of defining your vision and using it to build your creative enterprise?

How I Discovered My Inner Visionary

When I launched my photo business in 2003, I couldn't believe how overwhelmed I felt—and I didn't know why. On the surface, it seemed like I was doing everything right. I bought the latest

tools and gadgets in the hopes that they would give me an edge. I studied the styles of my photographic heroes and tried to emulate them. Like a kid with tracing paper, I would carefully follow the lines that others had drawn, in the hopes of creating a masterpiece.

I put so much emphasis on what others were doing and what tools might bring me success, I completely overlooked the one thing my business had that no other did: me.

I finally decided to take a more introspective approach. My hope was that by looking inward rather than outward I might discover what my unique contribution to the field of photography would be.

I started by examining my passions and my personal story. In the process, I began to reflect on why I fell in love with photography in the first place. I realized that I had a genuine curiosity about people and a bit of an obsession with getting an accurate picture of them in frame. I loved asking questions and finding out what made people tick. People's stories held endless fascination for me. My friends and acquaintances appreciated this quality in me; they loved telling me about their lives and experiences because I was genuinely interested in what they had to say. When I finally picked up the camera to take their picture, not only were they at ease with me and my lens, but I had a lot of great information that I could use to coax the "real them" out.

Fast-forward to today. Now, before I shoot an event, whenever time allows, I sit down with each of my clients and get to know them personally. I like to ask questions about how folks spend their time, who and what is important to them, and how they choose to enjoy life. I work hard to listen and to note what they value and what makes them special. This helps me to care about each person I work with as an individual, not just an accounts-receivable line item. Over the course of our relationship and the shoot itself, I work hard to affirm who clients are in subtle ways that make them feel at ease. Even when I'm creating products

for them weeks or months later, those conversations come to mind and can inform the qualities I emphasize.

It wasn't until I took note of how this aspect of my personality could benefit those I was serving that I began to maximize it in my business.

I still didn't have a solid vision, but I was getting closer. I needed to find a way to *talk* about my signature talents in a way that made sense to others, a way that would position my business in a unique way. I needed to refine and clarify my vision. I needed to put my vision in a few simple words so that I could *harness* it.

Discover What's Inside

Perhaps nobody understands the power of harnessing your uniqueness better than Marcus Buckingham, whose books include *Now Discover Your Strengths* and *Go Put Your Strengths to Work*. Buckingham invites his readers to see the connection between their unique talents and the work they were made to do. It was after reading his books that I came to realize that it was my job (and mine only) to find the right way to talk about how my own vision could inform my business. It was then that I started thinking like a leader—or, as I like to think of my role, a "Visionary CEO"—for the first time.

For those who might think a CEO's job is dull and bureaucratic, think again. At heart, the job of CEO is all about dreaming. It is the CEO's job to hatch and hold the vision for the company. With that in mind, I began allocating a few hours each week to doing nothing but dream. I would simply quiet my mind, find a place where I could sit uninterrupted for a while, and scribble words and ideas about what I thought my unique contribution to the world might be. The process was very helpful and productive. After a while, though, I thought an outside perspective might also help.

I didn't know of many supportive networks back then, so I began reaching out to friends, photographers, and fellow

businesspeople who seemed to have similar values. A growing number of photographers, as well as folks in other entrepreneurial businesses, slowly began to populate this circle.

In time, these people became some of my most trusted advisers. We would meet regularly for coffee and encourage each other to dream big and not be afraid to talk about those dreams out loud. It was in one of these conversations that I had an epiphany. I was telling my non-photographer friend, Michele Mollkoy, about my struggle to come up with a single phrase that truly encapsulated my work. It needed to be big enough to cover all my dreams but also specific enough to give meaning to my day-to-day work, especially my photography. I felt stumped. But Michele was able to mirror my mental musings in a succinct way. "What you do really well," she said, "is help others *discover what's inside* and put that in the best light for all to see." She was right!

As I thought about it, I realized that it's never been enough for me to get canned shots of my subjects. What motivates me is the chance to discover the *particularities* of each subject and make those stand out. For some of the couples whose weddings I've shot, it has meant understanding the dynamics of their relationship. For others it might be a unique facial expression that offers a window into their personality.

Eureka! In a flash, the mantra "Discover What's Inside" gave me a way to talk about the vision I believe I was meant to make good on. It was big enough to grow into and authentic enough to be more than just a clever phrase. It had marketing cachet, yes, but it was also a true reflection of who I was to others on my best days.

Now I had the tool I needed to make those days happen much more often.

Vision Translates into Brand

The way you frame your vision becomes, in essence, your company's brand. Your brand is important because it's the criterion clients

and decision makers will use when picking which photographer is right for them or their client. If your branding tells them a story that's compelling and authentic, you greatly increase your chances to win them over.

Everyone understands that if you don't have customers, you don't have a business. But what newer photographers often fail to recognize is that sometimes the wrong clients are worse than no clients at all. Ideally, you want to be hired by the customers who are the best fit for you. That's what brand is all about.

As I was starting out, I was tempted to make branding choices based on trends in the marketplace. If I noticed a photographer I thought was doing well had a certain look to his website, I felt obliged to make my site look similar. The logic is understandable: That guy is booking. I want to get booked. I'll market like him.

But, of course, this is the exact opposite of what you want to do. The point of branding—the point of vision—is to stand out. If that photographer is indeed doing well, his branding is probably shining pretty bright. If my branding has a similar look and I try to turn it on right next to his, mine will look dim at best.

All the more reason to get serious about naming your vision. Once you do, you'll have a powerful tool that will guide your branding decisions for you. It's amazing the influence that capturing my vision in a phrase has had over my entire business. In fact, "Discover What's Inside" has affected everything from my logo to the entire look and feel of all my marketing efforts.

Which images get featured in my studio or in editorial work that I submit for publication? That's right…the ones that show off my ability to *discover what's inside*. What do I say about myself on my website? Go take a look. You'll see a video of me inviting you to *discover what's inside* my site as well as a declaration of my vision and values. The hope is that by the time clients get introduced to my pictures, my story has introduced them to me. If I can make a connection in that transaction, it's almost a guaranteed booking.

More importantly, the work I do is fulfilling because it's an honest reflection of my values, of who I am. Of course, I don't book every lead but the target clients I'm interested in are far more engaged since I've taken the time to craft an honest, thoughtful message. If my pictures back up my story, I'm usually the one that gets hired.

What's Your Vision?

Are you starting to get a clearer idea of what I'm asking you to do? I'm saying that you must assert your role as CEO of your company, even if you are its sole employee. And your first job as CEO is to name the "big idea" of your work and to strategize how you plan to share it with the world.

In the next chapter I'm going to try to help you get clearer on what it means to own your vision, and then I'm going to ask you to do some exercises that will make all of this concrete. But before we go any further, I want you to pause for a second and remind yourself that this challenge is yours and yours alone. The answers are inside *you*, not this book. I'm going to help you as best I can, but just remember that I'm only the trainer; you're the one lifting the weights. Your job is to use the tools I'm offering to make your own forward strides.

So make sure you're wearing your "visionary hat" right now. If you find that you're tempted to put on your photographer hat, resist! At least for the moment. Your vision as a *photographer*—the kind of pictures you like to take, your style, your techniques—will, of course, inform your business's vision, but these two types of vision aren't one and the same. Right now, it's your job to think like a Visionary CEO. That means you're thinking about more than your pictures. You're thinking about your loves, your values, and your deepest aspirations as a human being, a photographer, and a businessperson. You're also thinking about the kind of

impact you want to make with your business and the unique value you want to bring into the world.

Zoom out, my friend. Trust me, you'll get back to the role of being a practicing photographer soon enough.

Okay? Just wanted to put that in your head before we move on. Now let's look at how you can craft a vision that works for you.

Let's Review

» The way to free yourself from the "tyranny of the urgent" is to zoom out and look at your business from a wider angle.

» If you want your business to thrive, you must be willing to lead it.

» Leadership starts with vision; it is the CEO's job to dream.

» A vision for your business is rooted in your unique strengths and talents, the work you feel "called" to do in the world, the values you bring to the table, and the type of audience you want to attract.

» Honing your vision down to a few powerful words will give you the power to harness it as a working theme and a marketing tool.

Chapter 2
Forge Your Own Working Vision

Own Your "Big Idea"

One of my favorite brands on the planet is Apple. I'm certainly not the only one who loves the company that made computing cool. How has Apple managed to generate such disproportionate attention compared to other technology companies?

Recently, I stumbled onto an article written back in 2008 by Peter Elkind in *Fortune* magazine. The piece, "The Trouble with Steve Jobs," made the case that the same character traits that make Apple's CEO so great are the ones that put the company and its investors most at risk. I was fascinated with Elkind's observations but came to a slightly different conclusion. Whereas Elkind believes Apple's success rises and falls with their visionary CEO himself, my take is it rises and falls depending on *how well Jobs' vision is implemented.* The distinction may seem subtle, but the implications are significant for regular business owners like you and me.

Many believe, as Elkind does, that the core of Apple's success rests squarely on the shoulders of Mr. Jobs. Easy to see why: When

Jobs is about to give a keynote address, the entire world stops and listens. When the first rumors about Steve Jobs' illness hit the papers, Apple's stock price plummeted. Pundits like Elkind are quick to critique Apple's board for putting all their eggs in Jobs's basket. But I think those critics are missing what's really going on.

Jobs is an undeniable genius who deserves a ton of credit for founding and launching, and later resurrecting and transforming, one of the great companies of our age. But I don't think it's Steve Jobs, the man, that's responsible for the Apple's success. I believe it's Steve Jobs' *vision*.

Of course, without the man there would *be* no vision; true enough. But what he seems to have done is set up the company to be a scaled reflection of his artistic vision. It's as though the Jobs ideal has been infused into Apple's DNA.

On the surface, it's tempting to believe that Apple's competitive advantage rests in the cool factor of their logo-emblazed computers, mp3 players, apps, media devices, online music store, and cell phones. No one would deny that Apple products are beautifully designed and easy to use, but that's not the reason so many of us love the company. Rather, it's because each and every one of their gadgets and services is connected to a much deeper *idea*. That idea is that technology should be elegant, fun, amazing, and beautiful. Technology should not be "techie"; it should be art.

The question is how strongly his vision has penetrated into Apple's culture. If he's done his job well, and I think he has, Apple should be able to continue to carry out his vision, with or without the man himself at the helm. I believe it's Jobs's "technology as art" vision that explains why the company is currently worth around $50 billion.

If you're concerned that wearing the Visionary CEO hat will take you too far from the creative photography work you love, consider Steve Jobs. If he had stuck to creating circuit boards at Atari, think of what the world would have lost. Think of the creativity that wouldn't have happened. Of course, we can't

all be Steve Jobs, nor would everyone want to be. But for our conversation, his story is still an important one.

Imagine if you were able to craft a vision that aimed not to fit in but to *own* your particular corner of the photo market as Jobs did with the tech-gadget market. You may not be trying to do anything near the scope of what Jobs has done with Apple, but you still need to dream at an entirely different altitude than what you're used to. You need to escape from strictly front line thinking. You need to explore, name, and claim your unique vision and in so doing apply your best creativity toward your photo *business* and not just your photography.

Who knows what fire you will light when you do?

> "Dream big. Don't allow your current market to limit your thinking of what is possible. When I first moved to my area of Wilmington, Delaware, from my hometown of Boston in 2002, I was very young—about twenty-four or so— eager, enthusiastic, and ready to learn. Some of the local photographers who had been at their craft for a long time were very interested in letting me know 'how things were.' They said, 'Laura, don't even try, because no one gets more than $3,000 for wedding photography in Delaware.' I intuitively believed they were wrong and that the higher paying market was not being serviced. In 2009, our wedding average sale was just over four times that amount."

> —LAURA NOVAK, OWNER, LAURA NOVAK PHOTOGRAPHY

Keep It Personal

As I mentioned in Chapter 1, coming up with my vision meant doing some soul searching. I had to ask myself why I was drawn to photography in the first place, and that question brought back some very old memories. I already told you how I came up with the "Discover What's Inside" vision. What I didn't mention was that there were some important reasons why this vision was so *personal.*

As the youngest of three brothers, there weren't as many photographs of me as there were of my siblings. This was certainly understandable. As any parent of a brood will tell you, the more little people you add to the mix, the tougher it gets to pull out the old Polaroid. You're too busy doing crowd control, for one thing. And, let's be honest, many of those amazing "first moments" just aren't as amazing the second, third, and fourth time around. In many families, this lack of early photos doesn't matter all that profoundly. But in my case it did.

You see, my father died when I was just shy of three years old. We lived on a farm, and in those days cameras were not as ubiquitous as they are now. Consequently, only a single picture of my father and I in the same frame exists. Growing up, that 2x2 piece of paper became increasingly valuable to me. It also served as a reminder of how unpredictable life is and how important it is to appreciate those I love while we're together.

The image itself captured a candid moment of my dad playing with my brothers and me. It isn't posed. In fact, it's come to represent, for me, my real dad at his best: loving his kids. Are you beginning to see why it's so important for me to connect with clients and really help them *discover what's inside*?

Today, as a husband and father of four, you can imagine that I'm rather obsessive about taking pictures with my wife and kids. And when it came time to name and claim my big-picture vision of what I wanted to achieve for my clients, my personal storyline became incredibly informative.

As a photographer of people and moments, I've made it my mission to capture those 2x2 images for others. With each frame I take, I believe I honor my dad and redeem my loss, just a little bit. Clients I've worked with appreciate that my vision is so authentic; it gives my business the kind of authority that no sales pitch or marketing campaign, however cleverly crafted, can achieve.

Refine It Over Time

Of course, this discovery didn't happen all at once. I wish I could say that after a few short weeks of regularly focused time, I landed on the magic formula for discovering one's vision. It's not that cut-and-dried. The truth is that some people discover what they're made to do right out of the starting gate. They know it intuitively. For others the vision process is more like software development: it might take a test-run "beta" version, and a few more versions after that, before they land on something that really works.

But that's okay. Don't be afraid to get it wrong. In my consulting work helping creatives discover their vision, the ones that have found success the quickest have been those willing to take a chance by asserting *something* right now (version 1.0) and then upgrading to a more accurate iteration (version 2.0) later.

The way I actually arrived at my "Discover What's Inside" vision, for example, was a little more complicated than I first described it. It all started with a vague collection of ideas that I more or less symbolized in my first business logo, a flying *S*. The flying *S* was meaningful to me because my dad was a pilot (thus, the wings on the *S*) and a rancher (the flying *S* was what he branded his cattle with). I made one of the wings clipped to represent the loss of my dad, but on the opposite side, I added *double* wings to show redemption of that loss through my wife and child. Then, with each new child that came along, I would add another wing. Well, not only did it start getting logistically ridiculous by the fourth kid, but I also had to confront the fact that, although the logo was meaningful to me, it meant nothing at all to the average viewer. It was just too obscure.

I started doing some branding work with the company Elevation. This led me to declare some important core values about my work, which led me to think about the 2x2 photo. *That*, in turn, drove me to create the "Two by Two" video that I still use on my website. People began resonating with the video

and *that* was what led me to my conversation with Michele Molkoy in which I struck on the simple "Discover What's Inside" statement of my vision.

In short, the process was messy and iterative and imperfect. But if I hadn't gone out with my early flying *S* stuff, flawed as it was, I wouldn't have been led to the more robust vision that now steers my business.

What Promise Are You Making?

Here's another way to think about vision. Ask yourself, "What *promise* do I want my photo business to make to the world?"

As a starting point, consider the following sentence and imagine how you might complete it: "When my clients let me into their lives, I will use my camera to help them [insert your big promise here]."

Once you've gotten a version of that promise you feel pretty good about, then you can think about how to leverage all the tools at your disposal to make good on it. Keep in mind that "tools" also include your skills and personality traits, not just your camera gear.

Of course, you don't get to make just any clever promise. You're not looking for a generic marketing slogan; you're trying to discover what you *authentically* have to offer that will set you apart from the rest. Let's take a peek at a couple of examples of how a workable promise looks in the real world.

The Best Always Make Good on Their Promises

Born out of the fitness craze of the 1970s, Nike is a company that *inspires activity in everyone*. According to their website, the Nike vision is based on the idea that anyone with a body is a potential athlete. Though inspired by a simple statement made by Bill Bowerman, one of the company's co-founders, it is a vision that has truly defined the company. Nike's big *promise*, then, is about a lot

more than sneakers. They inspire regular people like you and me to get off the couch. They sell courage! What is their promise? Let Nike in your life, and we will give you everything you need to "just do it."

Let's look at another example. Starbucks is easily the most successful coffee shop chain in history. On the surface, they sell beans and water. But, as their mission statement declares overtly, they promise a lot more than a cup of joe. They pledge "to inspire and nurture the human spirit—one person, one cup and one neighborhood at a time." The coffee (and everything else they sell) is just the vehicle to make good on their promise: "Let Starbucks in your life, and we'll give you a comfortable and nurturing 'third place'—neither work nor home—to relax, meet with friends, or just prepare for the day ahead."

Of course, if a company breaks its promise, it breaks our trust. If it breaks our trust, it's just a matter of time before the luster of the brand will tarnish and ultimately fade from view.

The same is true for you and me. Your job as CEO of *your* photo business is to find and keep the promise *you* were made to make good on. If you don't commit to championing your vision, no one will. Put simply, *leading through vision* is what Visionary CEOs do every day. The good news is, you don't need to have a huge corporate structure or branding consultant to get started. All you need is a well-defined promise and the courage to declare it out loud.

When identifying your promise, keep in mind the following:

1. You need to clearly name what you're promising. In my case, I promise to help people discover what's inside of them with the use of my camera. Embedded in that promise is a commitment to create pictures like my 2x2 print with my dad that capture candid, authentic, and meaningful moments in life.

2. You need to know *who* you're making this promise to—in marketing speak, that's your "target audience." The more you understand them, the more power you will have in targeting your message. One way to do this is to think beyond your own industry, as the owners of Little Nest, a children's portrait studio, did. When they were thinking about their target market, their founder, Laura Novak, told me that they identified Baby Gap customers as a common demographic. With your target audience identified, you'll know better how to connect with the right clients and meet their needs.

3. You need some way to know whether you've kept your promise. You must provide a means by which your audience can tell you how satisfied they are with your work. *You* may know that you've done your best to deliver, but that is only half of the equation. The other half is this: did your target audience experience the outcome you were going for? Do *they* believe you met your promise? If you're a Freelance Photographer, make sure to get feedback from your art director or boss. If you're a Signature Brand photographer, get feedback from the client directly or from the gallery owner. If you're not comfortable asking, "Did you like my work?" then try to find a way to collect unsolicited feedback. But if you do feel comfortable and you believe your clients will be honest with you, ask away!

In my case, I look for clues that affirm that I've met my goal to *discover what's inside*. When a father of the bride, for instance, tells me in tears that I "really captured" his little girl, I know I'm moving in the right direction. Of course, word-of-mouth referrals are perhaps the best indicator of success and the highest form of assurance that we've delivered on our promises.

A powerful vision weaves a legacy of meaning beyond the products and services sold. Failure to define where you want to lead your company, on the other hand, leaves you in the middle of the pack, chasing customers with hollow sales pitches and scrambling to get up to speed on new technologies.

Vision Work—Some Rewards and Challenges

Here are just some of the benefits you'll gain from dedicating time to vision work:

» By temporarily freeing yourself up from the small tasks, you open the door to dream big.

» When you come back to the day-to-day tasks, you'll have a better understanding of their importance.

» You'll discover a story that clearly explains why you do what you do. This "why" will offer meaning to your customers and will ultimately help them to choose you.

» You will feel confident that you are on top of your work, running your business, instead of letting it run you.

While thinking like a Visionary CEO has countless benefits, there can be challenges as well. Here are a few to anticipate:

» You may feel anxious about setting aside smaller tasks that feel urgent. This "tyranny of the urgent" will try to distract you from your vision work and, if you give in, will actually slow the growth of your business.

» You may have a hard time justifying time away from tasks like communicating with clients or actually taking photos. Earmarking time and making vision work a priority, though, is a non-negotiable for any leader.

» You might find the "dreaming" work so enjoyable, you don't want to "come down to earth" and return your emails. So, yes, dedicate some quality time to vision work, but also stop it when the time comes. Do let your sense of vision and purpose percolate into your daily activities, however, and see how different even mundane activities feel when they are part of a bigger picture.

Now It's Your Turn

So now comes the moment of truth. I'm not going to let you off the hook by allowing this to remain an abstract discussion. It's time to commit to *your* vision, or at least to get a good running start at it. I want you to put words on paper, in black and white, and I want you to do it sooner rather than later. Toward that end I'm going to ask you to complete a series of Vision Assignments. The end goal is to come up with a clear and inspiring one-sentence summary of what you envision doing with your business that sets you apart from the rest. (Even if you have read *Fast Track Photographer*, do these assignments; we're developing a *business* vision here that goes beyond your identity as a shooter.)

#1 STRENGTHS & WEAKNESSES (30 MIN.)

Let's get the ball rolling with a little warm-up exercise. I want you to dedicate about thirty minutes to writing down your strengths and weaknesses, both as a person and a photographer. So you'll be making four separate lists: strengths as a person, weaknesses as a person; strengths as a photographer, weaknesses as a photographer. Be honest, be fast, and don't rest too long on any one detail. Just get them down on paper and remain open to what comes.

#2 FIND THE RIGHT ADJECTIVES (20 MIN.)

Now I want you to frame your vision. With your strengths and weaknesses fresh in mind, please choose six adjectives—three that

strongly describe you and three that strongly do not. Think along the lines of *fun, elegant, contemporary, modern, traditional, relevant, healthy, sporty, exciting, eager, warm, inviting, friendly, eccentric,* and any other adjective that has resonance with you.

These words will provide practical guidance for you. For example, if you choose a word like *traditional* or *elegant,* that will tell you whom you should and should not be targeting as your clients. The same is true if you choose a word like *eccentric.* The words that *do not* describe you are equally helpful in offering practical guidance.

These descriptive words should prime you to jump right into assignment #3.

#3 BOIL DOWN THE VISION (1–2 HOURS)
This assignment has a few steps.

> **Part 1:** I'd like you to answer the question, in about 250–300 words (one double-spaced page or so), "What were you made to create?"

"Yikes!" you may be saying. "I'm not a writer. I'll need to think about this for a bit…" Not so fast! If you're tempted to put this off, it's an indication that you're already resisting the truth that's just begging to come out. Your temptation is probably to avoid the question entirely and go make a sandwich.

If this was your reaction, you're already getting a clue about what's holding your business back. Fear. Please, I can't emphasize strongly enough how helpful it will be to do this exercise right now. Don't put it off!

You're not going to write a lot, but the insights you'll take away from this little exercise can be groundbreaking. The exercise should be done in one sitting, as quickly as possible, and should not be over-thought.

As you write, consider the question from two different angles: (1) think about the experience *you* believe you are uniquely made to create; and (2) think about the experience *your target market* would like to have. In both cases, write in the first person and from your own point of view. For example, start the first part of the essay with, "The ideal experience I believe I am uniquely suited to create for my target market is..." Then when it comes to answering the second part, put yourself in the *client's* shoes by using words such as, "If I was the ideal target client, I would feel most satisfied with my photographer's work if she or he did..."

For both parts, I encourage you to not look for the *right* answers but to simply picture the answer in your mind and describe what you see. Use language that is tangibly descriptive. In my case, for example, I might start my answer with something like, "As a photographer, the ideal experience I believe I am uniquely suited to create for my target market is to help them feel known. So before each shoot I would want to have a conversation with the client in which I would put him or her at ease and allow my natural curiosity to guide my questioning. My efforts to discover what's inside would yield images that feel like real reflections of who my clients are. After the shoot, my clients would give me feedback along the lines of, 'I've never been revealed so authentically in a picture before.'"

Turning it around and playing the part of my own ideal target client, I might write something like, "I would love it if my photographer would put me at ease the moment I arrived at the shoot. He would give me cues that he's anticipated my anxieties and would show me exactly how to be most myself on my side of the lens. He wouldn't expect me to be a professional model but would make me feel natural and safe so that my true self would want to come out..."

Are you getting the picture? If you have trouble writing your version of this kind of story, try talking it out with a trusted friend first. Again, the goal isn't perfection. This is just a draft to work

from. So go ahead, "talk on paper" about the experience you feel tailor made to provide for your clients, then about the experience your target clients would like to have. The more specific you are, the better. Take about fifteen to thirty minutes to do this.

Part 2: Did you get something on paper? Good. Now, with that work behind you, I'd like you to boil those three hundred words down to one hundred. Note that the two elements I mentioned above—what you feel called to offer and what your ideal customer might want—still need to be contained in those one hundred words.

Part 3: Next I'd like you to reduce those one hundred words down to twenty-five. Remember, the two elements still need to be encapsulated in those twenty-five words.

Part 4: Now please reduce those twenty-five words down to seven or fewer. Again, the essence of the two elements still needs to show up in those seven words. For example:

Reveal nature's beauty in unexpected places.

Bring a spiritual dimension to landscape photography.

Tell funny character stories through portrait photography.

#4 HONE THE VISION STATEMENT (1–2 HOURS+)

With your descriptive words in hand, your next task will be to get *your target audience to care*. You need to phrase your message in such a way that your vision becomes a clear promise to those you seek to attract.

So, considering everything you've written so far, take a stab at writing twenty-five different phrases that capture your promise to the world. Or, to put it more accurately, take twenty-five stabs at coming up with the one perfect promise. That promise should

be simultaneously true to you, crystal clear, and magnetically appealing to your audience. List all twenty-five versions on paper.

Try to keep them to no more than eight or nine words apiece, fewer if possible (not counting *a, the, and,* etc.). For example, with the nature photography example, you might try, as a few of your choices:

Stun magazine editors and readers with my urban nature photos.
Bring an appreciation of nature to urbanites through surprising photos.
Establish a new way of seeing nature that creates a buzz.

#5 FIELD-TEST THE VISION STATEMENT (1–2 HOURS+)

Finally, it's time to go public. Identify three to five people whom you believe are especially intuitive and know you well. Write out your twenty-five phrases on index cards with a black Sharpie marker. Then, like trying on pairs of jeans with a friend, try each phrase on for size and ask for feedback. Pitch all twenty-five and ask your helpers to choose their top three favorites. Did any of your phrases make it into more than one person's top three?

Using the feedback you received, narrow your search down to *your* top three. Now sleep on it. See how they look in a day or two.

You should now be close to having a working vision statement that you can use as a launching pad for your business. Remember, even a vision that isn't perfect is better than no vision at all. You can always refine it later.

Let It Steep

Of course, you don't have to rush into this. If you're not ready *today* to nail down a vision you feel ready to live with for the years to come, that's fine. And if the vision you crafted still doesn't feel right yet, that's fine, too. I would recommend you give yourself maybe a cup of coffee or two a week to dream about it. You'll be amazed by how setting aside just a few hours a week for vision

work in the first few months of getting your company ready for business will take you where you need to go.

Even now that my business is established, I still devote time to doing this work. I journal periodically, asking myself if what I'm doing is lined up with what I want to accomplish with my business. I also plan an annual getaway to give myself a couple days of completely focused vision time.

You don't need to escape to an exotic location, though. Just make sure to prioritize this vision-crafting time until you have something to work with. Because until you do, the other steps to creating your business plan will feel like hollow rituals. Don't skip this part or rationalize some excuse for why you're a special case who doesn't need a clear vision. You do. And until you are able to articulate it clearly, your business won't gain any traction.

Remember that this is an evolutionary process. Your goals for your business and life will inevitably shift over time. Don't worry about getting things "perfect"—just be as honest as you can.

Let's Review

» Vision is about more than your strengths and talents; it's about the values you personally hold dear.

» A business vision should contain an element of promise— what promise are you making to the industry, to your customers, to the world?

» Spend time honing your vision until you have a compelling statement that resonates with you and your target market.

Chapter 3
Marry Your Vision to the Market

A New Dance

Now we're going to take what may seem like a bit of a leap forward. We're going to talk about taking your vision to market. Not necessarily for dollars just yet, but at least for a test drive. The question we need to ask before we get too far into our planning process is this: *Does anyone want what you're envisioning?*

This might strike you as a premature consideration, but it's really not. First of all, you don't want to invest a lot of time and energy developing creative ideas that have no legs. Second, the Digi-flat Era is forcing us to rethink old notions about approaching the marketplace. To use a dance metaphor: In the old days, you took dancing lessons for a year or two, then you asked someone for a date, then you bought a ticket to the club, and then you danced. Today, it's more like asking someone for a date *while* you're learning to dance, *already* out on the dance floor. In short, today we meet our market while we're still learning the dance steps. Marketability is no longer a consideration that waits till later.

Much of this book will be devoted to *learning* the steps for the dance (i.e., Section 2 of the book helps you build a foundation

once you're pretty sure this is the path you want to take; Section 3 explains how to get, do, and leverage the business once you're confident your vision is viable, etc.), but it's important to be asking, right from the start, whether you can even get a date. Does your vision—and the creative ideas that flow from your vision—have a good shot of connecting with the world?

Make Your Vision Real

In the years I've spent as an entrepreneur, I've discovered that there are times when certain ideas about my business just click. I dream up images of new products and services that are so vivid with color and texture, I'm tempted to believe my enterprise is destined for greatness. When an idea reaches that level of clarity in my mind, it's as though it already exists in the real world.

But, of course, it doesn't. It's still in my head.

Ideas, *on their own*, no matter how cool or big or inspiring they might be, are pretty useless until someone does something with them. They are like ungrounded electricity. They don't have much power until they touch down. Execution is the true test of any brainstorm. How will the idea fare when it reaches the marketplace?

Have you ever come up with a "brilliant" idea only to watch someone else act on it first? Did you dodge a bullet? Or did you miss an opportunity to do a better job than the other guys? If you failed to act, you'll never know. Ah, the safety of inaction.

The moment you *do* something with your ideas, however, you will have graduated to a whole new level of business leadership. Succeed or fail, you will be closer to your real vision. Action is the key. And today, the game is all about taking action as soon as you can, at least in small and experimental ways, rather than planning and strategizing till you "get everything right" in abstraction. Because while you're prepping in the abstract, your competition is out there creating in the real world. And that's where *you* want to be.

Of course, action alone doesn't guarantee success either. Nor does it guarantee the kind of success that is right for you. You need to keep your big-picture vision in mind. In other words, you must find common ground between your vision and what will work in the real world.

Does Anyone Want What I'm Selling?

Let's assume, at this point that you have crafted at least a rudimentary vision for your business. Let's also assume that this vision is beginning to suggest the seeds of an idea about a product you might want to sell. By "product" I mean whatever it is that you plan to offer to the market—a distinct style and genre of photograph, a photo-related invention, a type of photography service.

Before you get too far into building the foundations of your business, which we'll be talking about in the next sections of the book, you have to ask the simple question: *Will anyone want or need what I'm selling?* You may have crafted the most elegant and compelling vision ever captured in English syllables, and that vision may have inspired an idea for a product or service that has you quaking with excitement. But are real people in the real world going to be willing to pay for it? Now, not later, is the time to start giving this question some serious thought.

A more targeted way of asking the question is this: Are you offering a solution to a genuine problem or desire in the market? Because if you're not offering a tangible, perceivable solution that a client (whether it's a consumer or an agency) can get *only from you,* then your impact in the market will be minimal. Just because you feel inspired to create something does not mean that you have a "right" to earn income from it.

An audience will only *pay money* for something that fills an authentic need or fulfills an authentic desire.

Your business success, to put it bluntly, dwells at the intersection of (a) your unique vision and (b) the world's willingness to pay

money for it. Lose either element and you end up with a business plan that is unworkable. You either have a visionary business with no customers or a commercially viable business idea that holds no interest for you in particular. And if you wanted only the latter, you would not have gotten into photography in the first place; you'd have bought a Dunkin Donuts franchise.

From the moment you begin to shape your vision, you must be trying to find the "sweet spot" in which your vision fuses with a willing market.

In mathematics, there is a model known as the Venn diagram that can help us visualize the mental task at hand. Venn diagrams are designed to show the relationship between *sets*. A set is a group of items that share a particular characteristic. Each set is represented by a circle. So, just as an example, let's say we call circle A (below), the set of all things with four legs. This would include tables and chairs as well as many living creatures. And let's say we call circle B the set of all animals. This would include six-legged, two-legged and no-legged animals in addition to the four-legged variety. The *intersection* between the two sets (C) is the darkened area. In that area we would find all four-legged animals. See how it works?

In your *business* Venn diagram, circle A would contain all product and service ideas that are consistent with your vision. These include any and all business offerings that might conceivably flow from the big-picture vision you have just crafted. Circle B would contain all products and services that people are willing to pay money for—that is, products that provide a solution to a felt need or fulfill a desire.

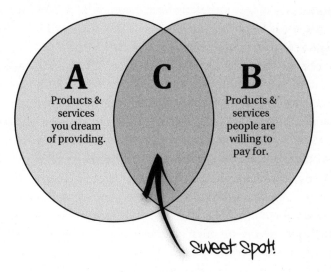

A
Products &
services
you dream
of providing.

C

B
Products &
services
people are
willing to
pay for.

sweet spot!

As you get serious about launching your business, you must look at the intersection (C) between these two sets. Let's call it the C zone. That's the only area you can afford to dwell in as a businessperson. The larger part of circle A, to the left, is fantasy land. It contains products and services that may hold a special place in your heart but that don't solve any needs or desires for real people. We creatives have to be especially careful that we do not get stuck in that area. The larger part of circle B, to the right, contains products and services that people have a commercial desire for, but that you have no interest in, or talent for, providing. You need to live in the sweet spot between the two.

Put another way, your task, before you invest a huge amount of time, money, and energy in launching your business's products and services, is to test the opportunities that are out there and balance them against what you authentically want to do. You don't want to sell out to opportunity by scrambling to capitalize on the latest trend. You also don't want to kid yourself by imagining that people are going to willingly pay for an idea that is weak or esoteric. *You* may enjoy taking formal portrait photos of car tires, but, really, is that a genuine answer to anyone's needs or desires? You must balance vision and opportunity.

This is not necessarily new information. What *is* new, though, is how we approach the task. The model for *discovering* our C zone has changed in the twenty-first century, I would argue. In the traditional business model, where reliable information was hard and slow to get, there was a tendency toward paying your dues and making educated guesses. You spent some years in training and apprenticeship, you did your market research (or paid to have it done), you calculated whether your product or service idea had a good chance of selling, and then your took a financial gamble and launched the product on the market. Then the product/service either succeeded or failed. We've all seen stunning examples of products or services that were launched on the market, at considerable expense, then just lay there like dead trout on a sidewalk. No one wanted them.

But today, thanks to the world-flattening power of the internet, we can gather market information in real time. We don't have to rely on guesswork, marketing research, paid experts, or blind product launches; we can proceed more organically and intelligently. We have the tools at our disposal to "market test" our own ideas *as we go along*, and allow them to gather momentum *before* we risk all of our time and energy on a hope that they will sell. We have the tools to start developing a customized market that is primed and ready for our services by the time we are ready

to offer them. Many of these are the very tools we accuse of destroying our profession.

Though much of this book focuses on business *planning*, I want you to know that I'm very much in synch with Jason Fried and David Heinemeier Hansson's *ReWork*, Tim Berry's *The Plan-As-You-Go Business Plan* and Guy Kawasaki's *Art of the Start*, all of which caution against the paralysis of *over*-planning. Obviously, that doesn't mean you should be impetuous about going to market or that you should *avoid* planning. That would render this book pretty pointless! But it does mean that you should not get *lost* in planning or use planning as an excuse to avoid getting real-world feedback on your ideas. It means you should start developing a good sense of your C zone sooner in the process than later. This implies that *as* you're doing the business planning we talk about for the rest of this book, you'll be *simultaneously* reaching out with your creative ideas, getting feedback on them, and building a "fan club" in any way you can.

Chase Jarvis

There's perhaps no photographer I know who both understands today's marketing opportunities *and* lives within the C zone more beautifully than commercial and lifestyle photographer Chase Jarvis. Jarvis's goal is to remain true to himself while simultaneously running a thriving photo enterprise. That goal becomes obvious when you look at what's he's been up to in recent years.

In addition to the corporate clients such as Reebok and Microsoft who commission his work, tens of thousands of photographers around the planet follow him on Twitter and Facebook. Add to that the thousands who have bought his book *The Best Camera Is the One That's with You*, a collection of photographs he captured with his iPhone, and the masses who have purchased his Best Camera iPhone application, which allows you to shoot, edit, and

share your images directly from your phone to multiple social media outlets, including Jarvis's own online community. In a world full of commercial Freelance Photographers eager to make a name for themselves, why does Chase Jarvis stand out? Did he just get lucky? I don't think so.

Although he has worked with some of the world's most prestigious companies, I came to appreciate Jarvis for the simple yet powerful vision for which he's named all of his products for photographers: *The best camera is the one that's with you.* This is more than a clever tagline. It's a full-out artistic and business strategy.

In one little phrase, Jarvis has managed to capture a new vision of photography for the digital generation. By inviting shooters to forget about the gear and focus instead on what they see, he's empowered photographers like you and me to shoot more *and* get more out of what we're shooting.

Jarvis's passion for artistic exploration has coalesced into a brand that has inspired many in the photo industry to focus their energy on the creative process over and above the tools that we use to create. Jarvis's story serves as a great example of how important it is to clarify your vision and tailor it strategically so that it solves needs for all your stakeholders, chief among them yourself. What's especially cool is that *as* he was declaring his vision, he was simultaneously unearthing a need that existed in the marketplace—namely, too many photographers were getting hung up on (and hung up *by*) technology. And Jarvis offered a solution.

The Jarvis Business Strategy: "To Thine Own Self Be True"

When I recently spoke to Jarvis, he told me that it's the creative process that drives him. Jarvis views himself as an artist first. Like Steve Jobs, that's integral to his vision. All of the products he creates, whether images for a corporate account's print campaign or one of his inventions for photographers, are real-world extensions of that artistic vision.

Of course, Jarvis is not blind or naive to the realities of business. He just believes that the best business model for a creative is to keep one's integrity and hold onto one's vision. I get the sense, for example, that Jarvis doesn't see the people who follow his blog merely as customers. In fact, I don't believe he originally intended to monetize his community at all. On the contrary, my guess is that his primary motivation was simply to build things that empower creative people, including himself.

It's certainly true that he's generated substantial revenue from the book and the iPhone application, but the financial payoff seems to flow directly from Jarvis's commitment to creatively solving problems.

"The book was really just a personal art project, and the iPhone app helped me invite others to join in. I had decided I didn't want any single medium to define me," says Jarvis. "When I started sharing them with the rest of my community, I noticed my friends were benefitting: They were inspired to take more pictures and to see the world differently. But I was just as inspired. What I discovered was it wasn't about the gear. It was about the moments and the conversation. I wanted to foster my artistic goals to innovate and create and inspire. I guess at the end of the day, I just wanted to make cool [stuff] and share it with the world. It just so happens that people like what I made."

Jarvis "got lucky," in the sense that his C zone came into focus fairly sharply and readily for him. What's important, though, is that he *used* the active feedback of his audience to inform him about where he needed to be investing his business energies. Rather than do abstract research and launch products based on theories and educated assumptions, he let *his audience* tell him, in real time, what they were interested in. If his ideas had not triggered such a strong and positive response, he would not have chosen to develop them commercially. They would not have been in his C zone.

Find the C Zone

Jarvis believes that if you stay true to yourself, opportunities create themselves. And his story serves as a great example of how important it is to first identify your vision and, second, to deliver on it in a practical way that translates into solutions for real people. Now, of course, if you were seeking to be a *non*commercial artist, you wouldn't need to create financially viable products; you would only need to honor your vision. You could play in whatever artistic sandbox you wanted to. But as a *businessperson,* you have an added criterion. You need to make money with the company you are building.

That's why you need to look for opportunities to offer unique products and services that meet clients' needs, fulfill clients' desires, and solve clients' problems. That's certainly what Jarvis has done: He's stayed true to himself while creatively identifying solutions for his growing customer base. But note which of those two dynamics came first. Jarvis is adamant that Vision is the primary "set" that must be honored in the Venn diagram. If you ignore your values by looking at the market and opportunistically creating products and services that you hope will later resonate with who you are, you probably won't enjoy the result, even if you're successful. You'll be following someone else's bliss right into a quicksand pit. So vision comes first and solving problems comes second.

But you need both.

What Jarvis Did Right

Jarvis's success suggests a model for marrying vision with problem-solving that can work for anyone.

First, his vision spurred him to tackle a project that would bring him back to why he took pictures in the first place. Like photographers before him who've used pinhole or plastic toy cameras, Jarvis wanted to share one elegant idea with the

photography world: you don't need expensive high-tech gear to be a creative photographer; the best camera is whatever one is with you. He had a deep desire to get back to the basics of photography in today's technology-driven world, and he suspected that others might share this desire.

Next, Jarvis needed a means to show off the amazing shots he was taking on his "best camera," which happened to be an iPhone. He began to spread his photo philosophy online by inviting others to join in. In the process, he inspired shooters to make the most of the camera they had with them at all times. For a lot of folks, that meant taking pictures with the low-res cameras built into their cell phones. Foregoing his fancy gear, Jarvis published his first book using photos captured with his iPhone. Jarvis's vision was a solution that addressed a lot of people's needs, and his book crystallized that solution into a product that people could buy.

Even more important, as Jarvis was putting his vision out there in the world for people to react to and participate in, he was creating a community. A market of his own that he could explore. He could now ask, "Is this new market expressing any related interests I might cater to or encountering any new problems that might solve?"

As Jarvis began to post photos to his blog, he discovered he sometimes needed to open up four or five different software applications to get them just right. Recognizing a hole in the marketplace, he seized an opportunity by creating a new iPhone application that simplified the process. His app, like his book, *solved a problem* for his followers and *honored his big-picture vision* by not only teaching his readers new techniques, but also making their lives easier. Both his book and his software app are perfect embodiments of his vision. And both of them "solve problems" in their own way.

The result? Jarvis has entered a whole new stage in his development as an artist while raising his stock with commercial

clients thanks to his increased popularity. He's emerged as an industry leader to photographers of all genres. With every one of his unique offerings, Jarvis has not only served his client stakeholders but also himself (the primary stakeholder). He took responsibility as the Visionary CEO of his business and put his vision to work strategically by leveraging his photo worldview, as well as the talents and tools at his disposal.

By *starting* with vision, rather than tools, he was able to create some profitable products that solved real-world problems for himself and his community. Not only was his strategy commercially viable, but it has now extended his art project to include photographers from all over the world. And he did all this while simultaneously raising his value with corporate clients.

You don't need any of Jarvis's talents and circumstances to experience success (although his Best Camera worldview may serve you). In fact, what you need are *your* unique talents and circumstances. As with Jarvis, the business you were meant to build might be right under your nose.

The New Approach

Now we're starting to glimpse a new model for assessing the market in today's Digi-Flat, highly competitive world. Instead of (1) pay your dues for an extended period, (2) research the market, (3) launch a product or service (at substantial expense), and (4) hope for success, it's:

1. Develop an idea that you think is in your C zone.
2. Using the appropriate tools, do *something* with your idea in the real world. Test it out, get some response. Start small, keep your risk and expense low, but put it out there. In the words of Seth Godin, "Ship!"
3. See if the world really does want it.

4. Reframe and refine your idea or the way you're presenting it.
5. As you begin to build a "fan club," look for new ways to solve problems within this community.

In this new model, you let your audience act as your collaborators by sharing your work with them, sooner rather than later. If they don't bite with the bait you're using, go back to the drawing board; you're not in your C zone. If they *do* bite, continue to develop that product idea and try to build a following, exploring any further needs that naturally emerge within your audience.

These steps, it turns out, give us a great, workable strategy for both (a) assessing whether there is indeed a market for what we plan to sell and (b) entering that market when the time is right. This is not a model for success in yesterday's get-your-formal-training, pay-your-dues, work-your-way-up-the-ladder world. It is a model for success in a world where markets are wide open, technology is cheap and universally available, communication is instantaneous, and creative *solutions* are worth more than creative pedigrees.

In case I haven't made the point strongly enough, let me restate it here: The distribution channels for creative, digital content are now free and available to all. The top-down, controlled-by-the-big-boys model has collapsed. There are no more gatekeepers that need to be bribed or impressed. In increasing ways, Disney has no more access to the channels of distribution than you and I do. It's up to us to take the very technologies that are supposedly "destroying" professional photography—such as the internet—and turn them around and make them our allies.

We do this not by following a set of rules but by being as bold and creative as we can imagine. For me, that meant producing my "Simple Photo Minute" video podcast, which turned out to be one of the very first vodcasts about photography, before I really knew what I was doing. How did I do it? I learned as I went. But because the vodcast answered a need in the iPod market

(i.e., photo-related content that you could *see*, not just hear), it became far more successful than I had anticipated and led to many opportunities, such as, indirectly, the book you hold in your hand. How *you* choose to use the new distribution channels is up to you. But one thing's for sure: If you do something creative and novel and it answers a need for real people, the public will pay attention. Momentum will grow.

What I'm trying to tell you in this chapter is that vision is vital, but it is not enough. We must field-test our vision with real people and find ways to graft that vision to products and services that people are willing to pay for. We do this not at some later point in the business planning process, once we have all our "ducks in a row"; we do it *as* we're laying the groundwork for our business in the ways we'll be discussing in the chapters ahead. From day one, we make use of the vast new distribution channels that are now available to all of us, and we do so as creatively as we can.

What exactly does that mean for you? There is no set formula. One thing's for sure, you can't emulate what others have done; those stories have already been told. You have to tell a new story. But, just for example:

» If your vision is to become a "cowboy" wedding photographer, you might do a sample shoot in your signature gritty style, featuring the wedding party in boots and cowboy hats, and share your images not only on wedding forums but in country and western music forums as well.

» If your vision is to create emotionally moving life-retrospective DVDs for elderly people nearing the end of their lives, you might make a sample of your work and post it on YouTube. Then work to provide links to your sample on sites for retired people, families of the elderly, bereavement services, and estate planning.

In short, try to generate some genuine buzz for what you're up to. You may not be ready to take a product or service to market yet, but with the right buzz working for you, you may find yourself eager to *get* ready sooner rather than later, and you may find a market eagerly awaiting you.

A New Option: Ease into the Market

The approach we're discussing here presents some interesting new options for breaking into your entrepreneurial business. Many of you are probably thinking about launching your business in a more-or-less traditional way—that is, taking a single, discrete step from non-businessperson to businessperson. That's terrific, but I want you to know that there are other alternatives. Because of the tools and resources now available, you are invited to consider a more graduated process, one in which you continue to make money from a "day job" as you field-test your ideas and develop your products and services in a more organic way. Keeping a steady income flowing until the market tells you you're ready to take a bolder leap can help lower your anxiety, too.

In this alternate route, you make your creative stuff, you share it with as many people as you can get to look at it, and then you refine it, developing your "professional" market as you go. Going this route might mean holding off on calling yourself a full-time pro for a while. (That label no longer means what it once did anyway.) It's more of a case of *do what you do because you love it*. Keep the day job for a little while, if you can. Maybe even leverage it.

My favorite example of this is Julieanne Kost, Adobe evangelist and fine artist. Her day job is promoting and supporting Adobe, the world's most dominant software company for photographers (thanks to Photoshop). The job suits her perfectly, while serving her passion for creating art for gallery shows. Her two kinds of

work not only complement one another, but *cross-promote* one another. She leverages her success in each endeavor to serve the other. In the Digi-Flat world, she gets to have her cake and eat it, too. It's this kind of approach that has contributed to *Fast Company* magazine ranking her sixty-seven on their "Most Creative People in Business" list in 2009.

Those who take this alternate approach allow the market to come to *them* in its own natural way. They're not obsessed with "making it" right away or getting rich quick. They do, of course, look for opportunities to offer creative solutions that will generate income for them while keeping their risk low. And when the opportunity presents itself, they seize it with gusto.

I'm not trying to sell you on the idea of a more graduated approach to launching your business or the idea of juggling complementary careers, I'm merely trying to point out that these are now a viable options, more than ever before. I want you to know, before we barrel ahead and talk about the nitty-gritty business stuff, that there's no shame in taking your time "going pro" and that this staggered approach, in fact, has some distinct advantages. In today's new photography game, where the rules are being written and rewritten on a daily basis, we want to consider the widest possible number of career options while minimizing risk.

If you do decide to dedicate all your work time to the profession, you can at least make it easier on yourself by minimizing risk, too. And the easiest way to do that is to be thrifty.

The benefits of living frugally while you're building momentum are many. By lessening the pressure on yourself to generate immediate revenue, you give yourself a great shot at marrying your vision to the market. This is one of the reasons why a leader like music and commercial photographer Zack Arias recommends making the most out of whatever gear you have. Despite being known worldwide for his body of work as well as his "One Light" workshops, his philosophy of frugality is embedded in everything he does. By his own admission, his humble start has contributed to

this "blue-collar workingman" approach to photography. Rather than focusing on buying expensive gear to improve one's craft, he (like Jarvis) encourages his students to maximize whatever gear they've got. Not only is this a powerful habit, but by limiting expense and debt, you reduce stress and are able to engage your creativity more deeply.

If you proceed at this unhurried and unworried pace, you can build a reputation and a following that has deep roots, too.

"But this doesn't sound very much like a Fast Track," you might be saying. Well, paradoxically, you may find this apparently "slower" approach taking you where you want to go a lot faster than if you rush into "full-time businessperson" mode before you're ready. There's a saying in the human development movement: "Infinite patience brings immediate results." What that means is that when you are no longer focused on the goal (i.e., getting rich), but instead on what you are doing right now (i.e., creating great work), the results often come to you much faster. You also put yourself in a prime position to snag those great opportunities that can lead to "overnight success."

If You're Still Not Convinced

Whichever way you decide to start your *business*, piecemeal or in one fell swoop, I do believe you should be developing your *market* in the way I've suggested: Get your idea in front of people, listen to feedback, make adjustments, and try to build a captive audience. I recognize, however, that some of you may not feel you have the "luxury" of proceeding in this way. In your zeal to get started with your business, you may be tempted to do a more traditional form of market research. Some of the ways you might try this include the following :

» Hire a marketing consultant.

» Contract with a PR/marketing firm.

» Do your own market surveys.

» Do online and offline consumer-ratings research.

» Organize informal "focus groups."

» Join a small-business support group or network.

Nothing's wrong with any of the above choices, and some of them may, in fact, be genuinely helpful. What I suspect you will find, however, as you explore these more traditional forms of market research, is that there isn't much vital information to be discovered there. The old paths are too eroded. The distribution channels today are so fluid that the best answers to any market question are to be found in real time, not by digging into yesterday's purchasing patterns or by reading theoretical tea leaves. I believe you will discover, sooner rather than later, that you need to develop a real-time–driven, "build it, share it, and revise it" mind-set if you want to get people to buy into your vision in today's marketplace.

We'll talk more in Chapter 7 about some ways to reach out to your customers, once you've committed to the product or service you plan to market. For now, though, we're ready to move on. We're almost done with Section 1. But before we plow ahead, I encourage you to invest some time on a couple of exercises that will help solidify some of the ideas we've been discussing.

Now It's Your Turn

Please complete these "assignments" at your earliest opportunity.

#1 TEST RUN (1–2 HOURS)
For this assignment I'd like you to imagine taking what you're hoping to sell through the following steps, which expand on the simple formula we looked at on pages 56–58. You can do this in your head or write it down (writing is always better). Specifically:

1. Rooted in your overall vision, develop one rough product/service idea that you think might solve a need or fulfill a desire for clients or consumers. If it's photography itself you're selling, your product idea might involve a particular *style* of photograph, such as "classical oil painting"–style pet portraits; an *idea* about photography, such as Jarvis's "best camera" notion; or an interesting *technology* applied to photos, such as 3D studio portraits or videoclips to be placed in picture frames. Describe the seeds of your idea and how it fits into your C zone (i.e., vision meets consumer need/desire).

2. Think about the most fitting tools and technologies you might use to create and distribute this product. High-tech? Low-tech? Virtual distribution? Real-world distribution? Obviously, when Jarvis chose to do his non-technology-driven "best camera" photos, an iPhone was the right tool solution for him. What's the right solution for you?

3. Now think out the product more fully, in line with the tools/technology you plan to use. Describe your product or service in complete detail.

4. Who is your target market? For whom, specifically, will your product represent a solution to a need or desire?—e.g., fashion editors tired of working with attitude-laden shooters or mothers looking for non-corny, artistic shots of their children. Write it down.

5. List at least five creative ways you can put your product idea in front of your target audience, using both online and offline resources. Consider giving it away for free, at least in sample form. Think about other products your target market buys. How can you use that information to help get your product in people's hands?

6. Imagine what your target market might say about your product, good and bad. Where might people post or share this feedback? How might you use the feedback to refine the product?

7. Imagine that you have now grown a following online, a dedicated group that follows your blog or responds to your posts or photos. What does your community talk about? Can you think of a new need, problem, or desire that might emerge as you listen to members of your community?

8. How might you fulfill that need or solve that problem with a new product?

You may not be able to apply the above approach, in its "purest" form, within your new business, but I encourage you to consider it first, before you revert to more traditional approaches.

#2 TAKE THE BST!

Finally, before we move on to Section 2, I'd like you to go to http://ftpBST.com and sign in, if you haven't done so already. Then, I would like you to take Part 1 of the Business Stress Test. When you're done that, come back here and we'll proceed.

What's Next

Now we're ready to start the concrete planning of your business.

The next sections of the book are all deal with the more practical, nutsy/boltsy aspects of running your business (whether you choose to jump in with both feet or one foot at a time). But they'll only make sense if you understand what we've talked about so far: the need to make vision the primary driving engine of your business and the need to marry that vision to real needs of real people.

Let's Review

» Vision is critical, but clients must be willing to pay for what you offer.

» Successful commercial ideas usually solve a problem or fill a need.

» Giving away samples of your creative work away for free allows you to build a following and create a market for the products and services you will later sell.

» There is more than one way to enter the ranks of photography business owner.

» Whichever way you choose to start your business, the best way to learn about the marketability of your ideas is to get them out there, sooner rather than later.

SECTION 2 | **BUILD STRONG FOUNDATIONS—GIVE YOURSELF YOUR BEST SHOT**

Chapter 4
Get Real on the Numbers: Can You Afford to Do This?

Function from Your Foundation

Building a business—whether you jump into it all at once or take a more graduated approach—is a lot like building a house: There are *foundational* elements and *functional* elements. The foundational requirements of any soundly built home include things like level floors, sturdy walls, and roofs that don't leak— that sort of thing. Examples of foundational requirements for a strong business include a commitment to mind your money well, creating systems that work, and building a strong team.

There are also *functional* aspects of every home. For example, there are designated spaces where you can cook, take a shower, sleep, or sit by the fire and read a good book. When you're building a house with functionality in mind, you fashion each area with an intended purpose. The function of each spot is defined by your intentions. Likewise, there are sound functional practices that can guide your company's actions so as to maximize revenue across your business cycle. Whether you are (1) attracting clients, (2) shooting an assignment, or (3) leveraging past work to generate

future jobs, your functional practices will define what to do at each stage.

Successful owners of photographic enterprises have both strong foundations and strong functional practices. This section of the book and the next deal with these two important elements of business. Here, in Section 2, we look primarily at foundations, those underlying structures and practices you need to have in place for any successful small business to function. We'll talk about these as they relate specifically to photography, but, in truth, they could apply to any entrepreneurial concern. In Section 3 we look at the functions themselves. We explore the three main functional aspects of running a photo business: booking jobs, shooting jobs and leveraging past and present jobs, to attract more business.

Money Matters

Any exploration of the foundations of business probably needs to start at the place that got you here: money. After all, the reason you've decided to turn your love of photography into a business is that you desire to make money at it. If money weren't a motivating force, you wouldn't have bought this book; you'd be continuing to enjoy photography strictly for the fun and magic it brings into your life. But you are not just a hobbyist. You have decided you want the magic *and* the income.

It goes without saying that you can't be in business if you aren't making money. Bringing money in the door needs to be a priority of every business owner. But there's a lot more to running a financially sound business than generating revenue. Even if you're successful at making money, figuring out how to keep it is even more important. And having the right elements and attitudes in place before the money starts flowing will give you your best shot at doing just that.

Getting your financial house in order begins with a simple understanding. That is, to be successful, a business must find ways to: (1) increase revenue, (2) decrease expenses and (3) maintain positive cash flow. Nothing could be simpler. In theory.

And yet the day-to-day numbers, as well as the presence or lack of capital in out back accounts, often cloud our vision. So let's talk about the basics of money.

How Will You Charge?

The very first question you need to answer, when considering starting a business, is the most obvious one: How do you plan to make money? By what engine will you be generating income? As we all know, there are many ways that photographers exchange goods and services for payment. Some sell their prints outright, some sell their services on an hourly or fee basis, some sell a combination of the two, along with additional products. So we can't cover the ins and outs of every potential business model. Instead let's look at some basic ideas for establishing *prices* for your work. After all, before you engage your very first paying customer you need to figure out what you are going to charge for your services. And it turns out that figuring out pricing is a good entrée into looking at other financial matters.

THE MARKET-RATE APPROACH

When it comes to setting prices, many photographers survey how their competitors are pricing *their* photography and charge a little less, so as to be competitive. This market-rate approach is dangerous because it's difficult to get accurate market data, and even if you did, it would be incomplete. Unless you can take a peek at your competitors' books, you won't know how much *they* are paying to produce their products and services. You won't know

what their costs are, so their prices, seen in isolation, won't give you enough information.

The market-rate approach also limits your financial potential based on other people's strategic choices. My guess is that you don't want to make your pricing decisions based on your competition's values.

THE SALARY-EQUIVALENT APPROACH

Another common method for determining pricing is the salary-equivalent method. If you have been a full-time employee and you are now starting out on your own, you look at what you were earning at your full-time job and figure out what you need to earn *now* to make the rough equivalent. Then you price accordingly. Most self-employed folks conclude, after taking into consideration fringe benefits, Social Security contributions, equipment overhead, and other hidden benefits of full-time employment, that they need to earn about 50 percent more than they did as full-timers. The problem with this approach is that it does not tell you *how* to price your way to the right salary, nor does it account for the money needed to grow your business or pay your overhead.

THE CUSTOMER-FEEDBACK APPROACH

Yet another approach is customer-based. You reach out to your potential clients and try to determine what they would be willing to pay for a service such as yours. But this approach can be tricky, time-consuming, and inaccurate, especially if your product or service is innovative. The truth is, customers often don't really know what they'd be willing to pay as an abstract notion, and even if they did, they have no particular reason to be straight with you.

THE COST-OF-SALE (COS) APPROACH

A more fiscally responsible and reliable approach is to start by deciding what services and products you want to offer and then figure out what your costs will be to deliver those to your clients.

With that "cost of sale" (COS) in mind, you can mark up your prices relative to those costs and decide in advance exactly what kind of profit you will generate when you sell.

The COS approach simplifies things, since now your success will be exclusively determined by your ability to generate new sales. By making the price of your photography a reflection of your costs (which you know), rather than how much someone is willing to pay (which you don't really know), *you* control all the moving pieces. You know that if you sell at your prices, you'll be successful. If you don't sell at your prices, you need to adjust your market approach and/or the product you're offering.

Consider the alternative: If you let the market (what you make up in your head about what people will pay) determine your pricing, you could end up making sales and still failing at business, unless you happen to get lucky and price profitably. By setting your prices based on cost, you remove luck from the equation. You get to focus all your resources on one single task: selling your services.

COS pricing allows you to factor in three considerations:

1. The costs associated with doing *this particular job*—materials, manpower, outsourcing costs, etc.
2. General overhead costs of running the business
3. Profit

COS pricing is appropriate for virtually all genres of photographer, including both Freelance and Signature Brand shooters. If you're going to make money (i.e., earn more than you spend), then you need to know what a job is truly going to cost you before you take it on. It's that simple. Otherwise you'll be "shooting" in the dark and basing your numbers on what works for someone else.

So how does the system work?

First, Determine the Direct Costs

The way COS (cost of sale) pricing[1] works is simple. First, you identify all the direct costs that go into delivering a particular product or service to your client. When I'm shooting for a client, for example, my direct costs begin when I show up at the job. Since I have more than one photographer on staff, anyone who is at an assignment gets paid a predetermined rate. Once the shoot is complete, I have postproduction costs that go into getting the files ready for output. Since I outsource my postproduction, I know down to the penny how much I'm spending on each file that gets processed. (The benefits of outsourcing are covered in Chapter 5.) Those outsourcing fees become part of my direct costs.

Once the images are ready, I post them on an online shopping cart so my clients can proof them. The cost of placing every item on the cart is also known. Finally, when I'm ready to transfer the image to some sort of medium, such as a book or a mounted print, I know exactly how much it will cost to do that, and to ship the product as well. Once I know all my direct costs, I create a list of every single item I offer to customers, along with the costs associated with them (what I pay). I then mark up the offered items appropriately in order to (1) cover my overhead, and (2) realize a profit. These marked-up figures then become the prices I tell my clients about. I often present them as an a la carte menu, although clients never see my costs or my math.

With that list in hand, I'm now able to give quotes on assignments that have my own predetermined mark-ups added to my costs of sale. Since I price out each individual item with a substantial profit mark-up, I have the flexibility to offer discounts when large orders are made. I may make less of a profit on each individual item, but because I'm selling quite a few items in one sale, I'm able to make more money on the whole lot. In all cases,

[1] It's also called cost of goods sold (COGS) pricing, depending on the industry you're in.

however, I know the profit I'm making before I agree to shoot the job. That way I'm able to focus all my energy on booking, shooting, and leveraging my work (see Section 3), confident that with each sale I am making money.

Remember, though, that the difference between your *direct costs* for a job (or product) and *the amount you charge* for the job—in other words, the amount you *clear*—isn't *all* profit. Your overhead also needs to be factored in. A lot of businesses get in trouble because they don't charge enough to cover both overhead and profit.

Overhead

To generate a positive cash flow, you must earn more than you spend. That's the simple rule of business. It presupposes that you have an accurate idea as to what your expenses are. Your expenses are not just the direct costs you incur on each job you do or product you create; they also include the general costs of staying in business, often referred to as overhead.

An astonishing number of new entrepreneurs find themselves charging too little for their services or painting themselves into financial corners simply because they fail to take a true accounting of their overhead.

Overhead costs, for photo businesses, include the following:

» Utility costs (heat, water, electricity)

» Internet and phone costs

» Marketing and promotion costs

» Professional services (legal, accounting, etc.)

» Licenses and permits

» Professional memberships

» Travel and transportation, including gasoline and automobile costs (some of these can be calculated per job, others cannot)

» Trade show fees

» Insurance premiums

» Trade publications

» Photo equipment and supplies

» Office and computer equipment

» Software, including periodic upgrades and renewals

» Website hosting and other web expenses

» Office expenses (postage, printing, paper, etc.)

» Furniture, fixtures and office décor

» Rent or mortgage (even if for only part of your house)

» Property taxes (if applicable)

» Maintenance of equipment and physical space

» Professional attire

» Your salary (if you are paying yourself a salary)

» Office help and other staff (if you plan to hire staff)

» Health insurance

» Tax contributions (employers must make contributions to employees' Social Security taxes, in addition to simply withholding)

Note that these expenses may not all fall under a "business textbook" definition of overhead. When I use the term *overhead*, I simply mean expenses not directly related to a specific job.

To ensure that you're charging enough for your services, you need to figure out your total overhead on a monthly basis. Then

you need to divide that amount by the average number of jobs you expect to shoot (and/or products you expect to sell) per month. Add *that* amount onto the direct costs for each job to calculate the minimum price you should be charging. For a very simplified example, let's use these figures:

» Monthly overhead costs: $920

» Average number of jobs per month: 10

» Direct costs per job: $185

So in this case you would divide $920 (monthly overhead) by 10 (number of jobs/month), to give you $92. That's the amount you need to charge per job to cover overhead. Add that $92 to the $185 per job, for a total of $277. That would be the minimum price you would charge to hit your breakeven point. Your breakeven point is the point at which your prices are covering all of your costs, both direct and overhead. (We'll do some more price calculating for your business at the end of the chapter.)

If you ignore, deny, or rationalize away what your true overhead costs are, you will never be able to gain real traction with your pricing structure. You'll be "playing businessperson" rather than growing a business.

Profit

The last leg of the COS pricing structure and the one over which you have the most control is your profit.

When you're starting out, it's natural to worry that you won't get hired if you're priced too high. But this still doesn't mean that you should let your market determine your prices. What it means is that you *can* adjust the profit mark-up to be more competitive, while making sure not to fall below your breakeven point.

The higher you raise your price above your breakeven point, the more profit you'll be making relative to your costs. So, if a job or product costs you $277 (including both direct and overhead costs) and your ideal retail price is $425 (what you'd like to sell it for), you *can* sell for less than your ideal price as long as you don't drop below the $277 mark.

Reducing profits is a sacrifice many new businesspeople are willing to make to drum up business. In fact, some new businesspeople are willing to make almost no profit at all for a while. This may be feasible if you still have a full-time job and/ or you're living rent-free and are able to keep your personal living expenses really low, as we discussed in Chapter 3. It's inadvisable, however, to make *no* profit at all. I'll talk about that a little later. For now let's look at another important factor that needs to be considered: how much you need to make to support your lifestyle.

Living Expenses

Here are a couple of major questions you're going to need to answer as you start your business:

» How are you going to pay yourself, at least for now?

» Will you be covering all, part, or none of your living expenses with the money you earn through your photography business?

Ideally, you want to be making enough through your business that you can live entirely off the money it pays you. That may not happen right away, however. You may wish to live "lean and mean" for a while, keeping a day job and not relying heavily on your photo income to cover living expenses. Still, you got into this business to make money, not to just have a hobby. So you need to think realistically about pay right from the start.

The main options for paying yourself are these:

» **Don't pay yourself at all.** You might decide that, as you try to get your business off the ground, you're going to live off savings or income from a day job for a while. All business income, at first, will get plowed back into the business. The no-pay option may be a necessary temporary measure, but make sure to keep it temporary. The danger is that you will build a business structure that can't ever support you.

» **Pay yourself as a shooter.** You can pay yourself as a shooter only. You would then make income based solely on the number of jobs you shoot. The advantage of this approach is that you won't end up costing more than your business can afford. Your pay is prorated. If you do six jobs, you get paid six fees; if you do nine jobs (or sell nine products) you get paid nine fees. The disadvantage is, you are *not* just a shooter. You are the CEO of your company, with many other responsibilities. If you decide to pay yourself only on a per-job or per-sale basis, keep this arrangement temporary and account for your fee as part of the direct costs of shooting a job.

» **Pay yourself a salary.** Finally, you can pay yourself a set amount per month. Your salary then gets lumped in with your overhead costs. This is the ideal option. You can reduce the costs of this option by paying yourself a part-time salary at first and/or by keeping your salary as low as possible in the early days.

How you choose to pay yourself, obviously, will have a huge effect on the way you figure costs. The *amount* you end up paying yourself, no matter which option you use, hinges on whether you have savings and/or additional sources of income on which you can live, in full or in part, as you get your business rolling. It also, obviously, depends on how high your living expenses are.

No doubt you are more than familiar with what your living expenses are, so I don't need to go into that. But the amount you decide you must earn *from photography* to cover your living expenses determines how much profit you tack onto the breakeven amount we discussed above. Remember, though: As you are starting out in business, it behooves you to keep your expenses and your salary requirements as low as possible. It also helps to have savings and/or other sources of income.

Keeping that in mind, divide your monthly cost of living (the amount you decide you need to earn from your photography to cover your living expenses) by the number of jobs you expect to do per month. You then add that amount to your fee as profit. Let's say, for example, that the amount you decide you need to earn per month from photography is $2,000 (factoring in other sources of income, etc.). You would divide that $2,000 by 10 (estimated number of jobs per month) to arrive at a profit figure of $200 per job. Adding this to the $277 figure you arrived at above, you would want to charge $477 per job.

Finally, and ideally, you would want to factor in an additional amount as "business profit"—money set aside strictly for the future growth of your business. This figure might be, say, 10 percent per job. In our example case, that comes to about $48. Added to the $477, this would give you a final fee of $525 per job.

Of course this is a simplified version of a process that is usually quite a bit more complex in practice, but the principles are valid.

Start-up Expenses

So far, we've talked about pricing and expenses relative to the *running* of a business. These are important matters to look at right from the start. Obviously, though, there is another set of costs we need to look at: the costs of *starting* a business. Whether you choose to launch your business in one fell swoop or ease into it

gradually, there are certain costs that must be accounted for. And even though the barriers to entry have been lowered for photo pros, these costs can still be considerable.

Start-up costs include (some of these are running expenses as well) the following:

» Deposits to utility companies

» Internet and phone equipment and setup costs

» Licenses and permits

» Development of basic marketing materials (business cards, stationery, brochures, etc.)

» Website development

» Insurance premiums

» Photo equipment, including redundancies (backup equipment in case of failure)

» Office and computer equipment

» Photography, productivity, and office software

» Furniture, fixtures, and office décor

» Rent and preparation of a physical space (if you plan to have one) for meeting clients

» Professional attire

Start-up costs will vary quite a bit, depending on whether you plan to have a physical space (and how expensive that space will be), hire staff, or mount an aggressive marketing plan, and whether you plan to *jump* into the business or *ease* in. But many of the start-up costs, such as software, camera and computer equipment (including backups), insurance premiums, and licenses/permits, are non-negotiable.

You might want to do a tally of the *minimum* costs required to get started as well as the costs for launching in a more polished and "professional" way. Then decide which route seems best for you. You will also need to answer questions such as these:

» Do you have enough savings to cover start-up costs?

» If not, what is your plan? Borrow money? From whom? Delay start-up till you have enough? If so, what is your plan to save enough?

» How long can you live on savings and other income, assuming little or no income from your business? By what date do you absolutely need to be making your primary income from the business?

» Are you willing to consider "easing into" the business, deferring a salary, keeping a day job, and maintaining low living expenses? For how long?

Obviously there is no one-size-fits-all formula for determining when and if you are ready to start your business and at what scale you can operate it at the start. There are simply too many variables at play to give you highly specific advice. But it's not rocket science; it's just a matter of being realistic about (1) your start-up costs, (2) your operating costs, (3) your current resources, (4) your pricing structure, (5) your living expenses, and (6) your ability to survive economically as your business lurches out of the starting gate.

Let's look at a few other financial principles that will serve you well.

Set Financial Goals and Take Them Seriously

It is not enough to hope and pray that the right amount of money will come in the door. You need to set some financial goals and

hold yourself to them. I recommend both monthly and annual goals. These goals should take into consideration how much you *need* to earn, as we discussed above, but also how much you *want* to earn. Financial goals should include growth and should reflect your ambitions. They should increase over time.

Once you have set your goal, you must do everything within your power to meet it. Take it seriously. If you can see that you're going to fall short for the month, don't change the goal; redouble your efforts to bring in more income.

Of course, if you discover that your goal is truly too easy or too difficult to attain, make adjustments. A good financial goal should be challenging enough to provide motivation and stimulate your best efforts but also realistic enough to be doable. You have to be honest with yourself. If you give it your very best effort for three months in a row and you still can't reach your goal, then that goal should be temporarily lowered (you can build back up to it as you gain momentum). A goal that can't actually be met is worse than useless. It also makes you feel like a failure. Conversely, a goal that you meet too easily every month does not offer a motivating drive. If you're coasting along month to month without a challenge, you need to push yourself by raising your goal. It can help to involve others in the process. Start an informal support network in which you encourage one another to meet business goals but also serve as a reality check for one another.

The important thing is to treat your business *as* a business. And businesses have goals. Why? Because goals motivate action and provide structure.

Live Within Your Means

One of the simplest approaches for staying healthy financially is to commit to living within your means. By that I mean don't spend more than you have. Wow, who knew?

So, for instance, if you don't have enough money to buy that new piece of photo gear you really, really, *really* want, and you don't have a concrete plan for how it will generate more revenue, you don't get to buy it. It's that simple. This is even truer if you are planning to pay with credit. Without a plan as to how any charged purchase will generate revenue, its price will inflate with every minimum payment you make on your credit card. Purchases without a plan are not investments; they are emotional itch-scratchers.

Here's a real-life example: When a photographer friend of mine (we'll call him Chris) was starting out, he was convinced he "needed" to buy a $1,500 lens. Thankfully, he ran into a more seasoned pro (we'll call her Paula) who encouraged him to think about how the purchase would affect his bottom line.

Now, Chris honestly believed he had a good argument for why he "needed" this lens: If he was going to call himself a pro, he needed pro gear. He believed clients and colleagues would respect him more; he thought his pictures would improve, and he thought he could afford the lens because he had some hot cash in his pocket thanks to the last assignment he shot.

Paula could smell the rationalization a mile away. So she began asking him what else he could do with that $1,500 if he didn't buy the lens.

Chris was immediately reminded of an idea he had considered a few months back but thought was too expensive. Ironically, it had the same $1,500 price tag. It involved printing and distributing a mass mailer to his target market. Paula asked how many jobs he thought he could line up if he did the targeted mailing instead of making the purchase. Given the quality of his list and the volume of mailers he hoped to send (several thousand), he estimated he could conservatively land at least five assignments. At that time, the revenue he was generating from an average job was around $4,000.

Paula smiled. When she asked Chris whether he'd rather spend $1,500 and get a cool lens or invest that same amount and possibly bring in $20,000 in revenue, the decision became pretty obvious.

Now, I'm not endorsing the idea of using a mailer to generate work. What I'm trying to illustrate is that a plan to *make* money is always better than a plan to *spend* money, regardless of how it ultimately turns out. Spending money may feel better in the short term, but making money feels better in the long term. Everyone knows that our consumer culture is driven by the desire for immediate gratification. But when a company behaves like a consumer, it is in trouble.

> "When I was beginning my business, I did it on a shoestring. I didn't want to sustain my business with family money, so when I bought my first camera, I had a solid plan of how I was going to see that it was paid off. Ever since then, I've been mindful of what I can afford and how I was going to manage debt as well as excess. I knew debt could limit my future. Working smartly, right from the beginning, was essential. I have now been able to contribute to the family, as well as pay for better equipment, further business-building endeavors, and invest in more education. We all have to start from somewhere, and not everyone has the ample means at their disposal right out of the gate. And that is okay—make what you have work for you. Make simple chic."
>
> —JENNY ALSTON, OWNER, SILVER APPLES PHOTOGRAPHY

Separate Your Business and Personal Finances

Many fledgling entrepreneurs fall into the habit of mixing their business finances with their personal finances. They use money from the business to pay personal expenses; they use personal credit cards to pay business expenses, etc. They muck it all in together. The underlying thinking seems to be this: I am my business, and my business is me.

It is far better, right from the start, to handle your business and your personal life as two very distinct entities. Start a checking account for your business. Get a business charge card. Establish a business line of credit.

Even though you may *think* of your business as an extension of yourself, don't treat it that way. Don't use your business as your personal "emergency fund." Don't buy photo paper with your family grocery money. By keeping your business separate from you, you will be able to treat it with less emotional baggage and more objectivity.

Don't Work for Nothing

I understand that sometimes shooting for free is the fastest way to get your foot in the door. Fashion photographers who are just starting out and working to build their editorial portfolios, for example, frequently shoot gratis in the hopes of someday finding an agent and landing commercial gigs. This is okay if you call it what it is: paying your dues and learning about your C zone. Just don't fool yourself into thinking you're running a business yet. Businesspeople get paid, plain and simple.

When I spoke with Gary Chapman, a humanitarian freelancer (a photographer who shoots for nonprofit companies and NGOs) who has shot in over sixty countries over the last fifteen years, he told me that his photojournalism training gave him skills to shoot creatively in the field but failed to give him a business foundation at home. As a result, whenever he got wind of an important story, he would hop on a plane, often without concern for money. This kind of action certainly appears altruistic. But, by his own admission, it was short-term thinking.

"After a while, I figured out how this thing worked," he said. "Because photographers like me are often willing to shoot without a plan for getting paid later, nonprofits sometimes take advantage

of us. But we're to blame, too. Because we care so much about the stories being told, many of us give our images away for free. Financially, this just isn't very smart."

Unless it's an occasional personal or pro bono project, my recommendation is to always cover your expenses and make a profit, even if that profit is small. Otherwise, you'll fail to recoup your costs and will soon be out of business. Just because photographers like Chapman regularly *work* for nonprofits doesn't mean they have to act like nonprofits themselves.

This can make for some tough decisions. Chapman didn't go to Haiti when the big earthquake hit in 2010. When he realized no one was willing to commission his work ahead of time, and he took into account that Haiti's story would likely be well documented by many other photographers, he had to let that one go. He knew that if he didn't he might jeopardize his ability to do more trips down the line.

By the way, a great resource to help you understand more about charging enough to *stay* profitable, especially as a Signature Brand shooter, is the Professional Photographers of America's (PPA) Benchmark Survey. It suggests some very helpful baseline standards for revenue, expenses, and profits, depending on the kind of photography business you are running. It's available free to all PPA members, and more information can be found at http://ppa.com.

Now It's Your Turn

Let's crunch a few numbers of your own by doing the following assignment.

WHAT'S YOUR PRICE? (1–2 HOURS)

This assignment will give you a rough idea of the prices you will want to charge.

1. Estimate your general overhead per month. This can (and should) include all the items on the list on pages 91–92. It should also include any additional expenses special to your case. These are not job-specific expenses but the general overhead costs of doing business in your genre and market. *(Let's say, as a simple example, your costs are $1,000.)*

2. Assuming you will be paying yourself a salary, estimate how much you need to earn, personally, per month to cover your cost of living. Aim for a "sustain" level for now, not a comfort and luxury level; that will come later. *(Let's say it's $4,000.)*

3. Add items 1 and 2 together. That is your monthly breakeven target. *(In this case, $5,000.)* This amount must be covered, every month, out of the amount you "clear" from all of your jobs/sales combined (clear = price–direct expenses). If the monthly breakeven target is $5,000, that means you need to complete five jobs or sales that clear $1,000 apiece, ten jobs or sales that clear $500 apiece, twenty jobs or sales that clear $250 each, fifty jobs/sales that clear $100, etc.

4. Now, assuming for the moment that you only do one kind of job/sale (you probably offer *more* than one, but for now just think about your main product or service),* ask yourself the following questions:

 » How many jobs or sales is it realistically *possible* for me to do per month (allowing time for the other aspects of running a business, such as attracting and booking jobs)? *(Let's say it's 12.)*

 » How many jobs/sales do I realistically and reliably think I can pull off per month? *(Let's say it's 10.)*

5. Now estimate the cost of sale (COS) of doing a typical job. Factor in materials, paid helpers, outsourcing costs, etc. *(Let's say it's $275.)*

6. Estimating the number of jobs/sales per month that you think is feasible, from step 4 *(in our sample case it's 10)*, divide that into your breakeven dollar amount from step 3 *(in our sample case it's $5,000)*. That *gives you the amount (roughly)* that you *need* to clear per job/sale. *(In our sample case, it's $500.)*

7. Now add your COS expenses to that amount. *(In our sample case, $275 + $500 = $775.)*

8. Now figure the "business profit" you want to add to each job. Again, this can grow over time and you can adjust it from job to job. At the beginning, perhaps an additional 10 percent over the total you figured in step 7 might be about right. *(In our sample the 10 percent amount would be about $78.)*

9. Add this amount to the figure in step 7. That, very roughly, is your price. *(In our sample case, $853; perhaps you'd round it down to $850.)*

*If you sell a variety of products and services to make up your sales total, here's one general way to figure your markup on all sales:

1. Start with the figure you generated in step 9. *(In our sample, $850.)*

2. Now subtract the COS amount you wrote down in step 5. *(In our sample, it was $275.)* The remaining figure is your total markup. *(In our sample, it was $575.)*

3. Using a calculator, determine the percentage of $850 that $575 represents. *(In our sample, about 68 percent.)* This is your mark-up percentage.

4. Determine the COS (direct costs) for each of your other products/services, then add the same *mark-up percentage (in this case, 68 percent)* to determine your price.

The above is only an exercise. Many things will change over time: your needs, the market, your general expenses, your number and mix of products/services, your COS expenses. But the basic formula should remain helpful.

An important point to remember is this: You don't know yet *whether your market will pay* the price you set. That is something that only testing the market will determine. You can do *some* market research to get a general idea, but you can't be too boxed in by what others tell you the market will bear. Remember Laura Novak from Chapter 3? Everyone told her the market in her area wouldn't pay more than $3,000 per event. She believed the upscale market was being underserved and was eventually able to command over $12,000 per event. You have to keep your vision in mind and filter it through common sense. Surveying the competition's prices and potential customers' opinions will help, but, alas, there is no true way to determine what the market will bear until you try it.

If, after your best marketing efforts, you discover that your market won't bear the prices you've set, then you need to go back the drawing board and ask questions such as the following:

» Can I alter the product or service I'm offering?

» Can I lower my overhead?

» Can I lower my COS?

» Can I augment my income in some other way for now?

» Can I live on less money for now?

» Should I aim for a different target market?

You'll find that there is no set formula to determine whether a person can afford to launch a photography business. But the principles we've looked at here should help you determine whether launching a business makes financial sense in *your* life right now.

Let's Review

» A positive cash flow means you're taking in more money than you're spending.

» To know if your cash flow is positive, you need to know your true expenses.

» The cost of sale method to establish pricing is the most reliable and useful.

» Pricing must cover these four items: COS, overhead, cost of living, and business profit.

» Set financial goals and strive to attain them.

» Limit your spending/investing to things that will earn revenue, rather than getting into debt.

Chapter 5
Create the Right Team: Who Will Help You Make It Happen?

The Dream of Team

Because you're not simply *running* a business, but also inventing it in real time *and* learning how to play countless new roles, the job of a small business owner can feel a little like flying a plane...while simultaneously learning to fly...and *building* your plane in midair. No wonder you feel scared every once in a while!

When I began experiencing firsthand how difficult it was to keep my business from crashing into the ground, I realized that what I was craving was help. I finally came to the conclusion that I couldn't both lead my business and do all the work it required (getting new clients, taking photos, postproduction, etc.). There was simply too much to do. And it was often the most time-consuming tasks that led me farthest away from the visionary leadership role I knew I should be playing as the CEO of my company.

My frustration had just about reached boiling point when I became friends with Jeff Jochum. Jeff has spent the past two and half decades working in technology and photography. What's unique about Jeff is his approach. He thinks about small, service-oriented industries from the very pragmatic angle of the client's perspective: How do those who use our services *experience* us?

When you think about it, what else really matters? The entire purpose of our company, after all, is to *create a positive experience for our clients/customers.* If we're letting any other concerns—such as efficiency, convenience, or profit—take precedence, we're missing the boat. And if we're letting other themes guide our decision-making, we're sailing our boat in the wrong direction. It's all about the customer experience. That's why we exist as a business.

When I've put Jeff's wisdom to work, I've witnessed excellent results and when I failed to, I've suffered for it.

Here's what Jeff told me when I was still pretty wet behind the ears: "If I had to point at a single cause of most of the startup business failures I've seen over the last twenty-five years, it is letting short-term cash-flow-oriented circumstances undermine long-term, strategic decisions to make clients happy."

Trying to save money by doing all the jobs ourselves is the most common way we undermine our "long-term strategic decisions to make clients happy."

Jeff wasn't suggesting that business owners are too good for manual labor. His strategy wasn't elitist but, rather, pragmatic: If I wanted to win clients over, I needed to be *attending to them* instead of spending time on tasks that other technicians could easily handle. Every hour I spent with my face jammed in a computer screen or hunched over a ledger was an hour I wasn't spending leading my business. I needed to spread the work around. I needed to consider outsourcing.

A Rookie Mistake

What I realize now is that back when I had no customers and no money, I was making a rookie mistake every time I did a chore that I deemed too expensive to delegate: photo editing, print fulfillment, bookkeeping, that sort of thing. Of course, my logic for doing these tasks seemed eminently logical. Since I had more time than money, I thought I'd be giving myself a financial edge if I took on those roles myself. The problem was, there was no end to these responsibilities. The tyranny of the urgent kept me glued to low-level tasks day after day, steadily wearing me down. I remember, for example, the day I thought it made sense to do my own accounting to save money. Ha! Bookkeeping not only took an inordinate amount of time, it left me feeling down and exhausted. Not a great place to be if you want to create an exhilarating customer experience.

More to the point, I came to discover how *expensive* it was to spend my time that way. Even if doing it all myself did save me money in the short term, it was costing me money over the long haul. Every minute I spent on mundane tasks that I could easily have outsourced (for a fraction of what any good CEO should be making), I was avoiding my main job as the boss of my photo business, which is to hit the bricks, meet people, get my business out there in the world, and generate more business.

As Jim Collins, the CEO of Pictage, put it, "The secret of success is being willing to do what it takes to make sure customers are happy. There is no internal business task that can take the place of that. Effort to win and please the customer is the principle driver of success."

For me, taking on internal business tasks did little more than distract me from my clients and slow my company's growth.

Jeff's brilliant advice about outsourcing opened my mind to the possibility that I could have a team without having to hire employees. Since my bank account wasn't big enough to justify

hiring full-time staff, this was like a gift from above. I still didn't know how I was going to pull it off, but I knew I needed help. I was sold on the idea of building a team.

What About You?

I wonder if you've found yourself in a similar spot. You're genuinely excited about the business that you're building but you don't know how you're going to do it all. You don't have enough time in the day to get everything done, and you probably don't have the money or energy to hire and manage people to help you, either. It's no wonder that so many photo businesses run out of gas midflight.

Think about your own business for a moment. What is the customer/client experience you are committed to offering? How much time do you spend working on tasks directly related to tailoring that customer experience? I'm talking about tasks such as meeting clients, doing marketing and promotion events, talking to strategic partners, upgrading your website design, following up with past customers, and taking great photos. How much time do you spend doing routine or "generic" tasks that could be done by someone else?

Consider the revenue you could be generating if you reallocated the time spent on internal tasks and focused it instead on bringing in new business. How fast might your company grow? And, in the end, won't bringing in more business serve your company better than nickel-and-diming your way to short-term savings? I think the argument is pretty compelling. By distinguishing which responsibilities belong to you as boss (bringing in clients and meeting their needs), and those which do not (smaller, more routine tasks that can be outsourced cheaply), you're freeing up your time to focus on what really matters. The customer. The client. The vision.

And you're *growing* your business, rather than just merely treading water.

> "I believe very strongly that the foundation of small service-based businesses must be rooted in direct owner-to-customer selling. That means it's the business owner's responsibility to go where the customers are, personally engage with them and bring in the business. ...I would put anything that has you meeting people and discussing your service at the top of the list and anything that doesn't include personal engagement at the bottom."

—STEVE BENDER, CO-CEO, INHOUSE IT

My Experiment with Team

For my first seven years in business, I had no formal employees. But early on, thanks to Jeff Jochum's advice, I started to put people on my team who allowed me to multiply my efforts dramatically. They were team members in every sense of the word; they just weren't on my payroll.

I'm talking, of course, about my *outsourced* team. The areas they help me with include: studio management, postproduction editing, photo book design, photo book making, online proofing, print fulfillment, bookkeeping, taxes, legal, branding, customer service, IT support, book editing, and formal representation.

My team consists of more than two-dozen important and trusted members, yet I've never had the need to hire more than two employees. Currently, my two "official" staffers each direct a division of my company (the photo side and the education side), and their main responsibilities consist of making sure there aren't any hiccups with our outsourced operations.

I'm not suggesting that you and I need the same kind of team. What I am suggesting is that your team could be more supportive than you think if put your focus on what strategic alliances you could be forging rather than on the bills you have to pay. If you do it methodically, you'll give yourself a chance to *scale* your efforts so that your business can yield more than the value you could create on your own.

Scalability; that's where it's at—if you want to grow a business in which you are no longer the bottleneck to your own success.

Scaling

Scaling one's business is a concept that has been made needlessly complicated. All it really means is finding ways to increase your returns while decreasing your efforts. In other words, you're successfully scaling your business when you find yourself spending less time and resources while making more money.

I suspect some of you read that last paragraph with a hint of skepticism. How can you make more money as a photographer if you're not there to take pictures, press buttons on your computer, or create the experience necessary for the client to be wowed? That's certainly a reasonable question.

My first experience at scaling my work as a photographer came in my first year of business. I had a very specific need: If I was going to sell prints as a means to generate revenue, I needed a vehicle to (1) proof images, (2) take orders, (3) receive payments, (4) create prints, (5) deliver the product, and (6) generate interest in my pictures in the first place. Since photography was a side business at that point in my career, the idea of personally leveraging my time to do all those functions seemed overwhelming. Instead, I solicited the help of the online photo lab, Pictage.

At first, I was nervous and reluctant. Pictage's service felt expensive relative to the money I was taking in. As a start-up, I didn't believe I could justify hiring them as a vendor. In retrospect, I realize the problem wasn't expense; it was that I wasn't confident enough that I would ultimately succeed at business. That's the real reason many of us are afraid to invest in outsourcing. We let fear keep us small by trying to *save* a nickel instead of *earn* a dollar.

Somehow I mustered up the courage to stick it out. It wasn't too long before I realized that Pictage was more than just a vendor. They had become a strategic business partner. In a relatively short

amount of time, Pictage started paying me more than I was paying them thanks to an increase in client orders that I never would have gotten without them. Furthermore, all the time I would have spent on the tasks I listed above—proofing, taking orders, creating prints, delivering the product, etc.—was now freed up for the more important job of going out and getting more work.

In case I've been too subtle about this point, let me state it again: *Going out there and leading your business to new opportunities is a far better way to leverage your time than trying to save money by doing every job yourself.*

My relationship with Pictage is an example of a solution that worked for me and simultaneously introduced the power of scaling. When I viewed Pictage solely as an expense, I worried about giving up some of my profit margin on prints. But when I viewed Pictage as a strategic partner that allowed me to spend time bringing in new business I would have otherwise missed, I caught a glimpse of what could happen if I expanded my team.

By the way, I'm not telling you all this to pitch Pictage. I'm using this as an example of a larger principle. If, hypothetically, you came to the conclusion that a particular company could cover internal tasks for you profitably, why would you not hire them?

Do What You Do Best and Outsource the Rest

Management consultant Tom Peters sums it up with this little rhyme, "Do what you do best and outsource the rest." As I look around the photography industry, I see that this message has not yet filtered down into the collective consciousness of photo business owners. It is truly tragic to observe the sheer volume of individual talents that are being underutilized because photographers are so busy trying to do it all.

On the other hand, I know very few photographers running flourishing businesses who do not outsource large chunks of their operations. Putting this idea into practice, however, is sometimes

harder than it first appears. It's not always easy to identify which tasks are made for you and which should be outsourced. So I went back to Jeff Jochum and asked for his advice. He gave me three answers that were so good I decided to name them *Jochum's Laws for Outsourcing*. Here they are:

Jochum's First Law of Outsourcing: Never outsource roles that are central and critical to your growth and survival. In a small business like photography, this normally includes networking for referrals, doing what's required to build your unique reputation, shooting the high-profile jobs, overseeing your marketing strategy, and other "high level" tasks that require your personal touch. Identify those areas of your business that only you truly understand and that leverage your signature value. Don't ever trust this work to someone else.

Jochum's Second Law of Outsourcing: Outsource as many "profit centers" as you can find. Profit centers are places within your business that take in money and where the cost of the outsourcing is absorbed in revenue you'll pull in from the service or product. Unless the cost of outsourcing is greater than the cost of the service or product, this is a no-brainer. In the photo industry, an obvious example of a profit center might be product fulfillment. Hire someone to do the steps of physically getting your product into customers' hands—taking orders, processing payments, shipping the product, etc. Don't spend valuable time doing this yourself.

Jochum's Third Law of Outsourcing: Outsource "cost centers" based on your expertise and how long it takes for you to complete these tasks. While profit centers are areas that *generate* revenue, cost centers *burn* revenue. They are expenses to your business. Unless you're unusually skilled at one or more of the cost-center responsibilities that your business requires, and unless your contribution adds value to the customer experience, you should hire these out. By outsourcing these tasks, you're liberating yourself to focus on your core tasks as the CEO. A good example

of a cost center is accounting. Unless you happen to be an accountant and can add value to your business by performing this role, hire someone else to do this job.

Even after reading these rules, you may still be skeptical about outsourcing any of your tasks because you are so desperate to not go broke. I understand. I was, too! It may seem counterintuitive to spend money on anything you can do yourself, but consider this: Every hour you gain from outsourcing profit centers and cost centers gives you new time to invest in the mission-critical stuff listed in Jochum's First Law. If you agree with me that the tasks connected to your brand identity and client satisfaction are most important to your growth, this model should make sense.

> "Outsourcing isn't about creating free time. It's about creating freedom. The freedom to create, innovate, educate, sell, market, and cover all the other things that matter most. Every minute you spend self-fulfilling orders or handling a support call or writing and sending out promotional emails or working with product vendors to expand your product catalog is a lost minute that only you could've spent on succeeding."
>
> —JEFF JOCHUM

But How Can I Afford It?

Okay, so you're still saying, "This all sounds good, but how do I make it work financially when I'm just starting out?"

Outsourcing, like anything else, takes practice and experimentation. The more you try it, the more confidence you will gain. Tasks that may be outsourced can be broken down into two categories:

» Tasks that generate *direct costs* associated with your products and services.

» Tasks that generate *overhead costs.*

Tasks associated with your direct costs are the easiest ones to outsource first. Why? Because they are easily itemize-able and can be built immediately into your pricing structure. When you use an outsourcer, you always know, for example, exactly how much it will cost you, per photo, to have your images color-corrected, hosted on an online proofing site, payment-processed, printed, and shipped. You then simply build these costs into the prices *you charge your clients.* You don't have to wait until a nebulous "someday" when you're making more money. You can and should do it right from the start. "But I'm trying to stay competitive!" you say. And I answer, "Outsourcing is *how* you stay competitive."

Think of it this way. There are two possibilities when it comes to your competition: (1) They are outsourcing, too, in which case it makes sense, competitively speaking, for you to do it. (2) They are not outsourcing. In this case, they are doing all the routine work themselves and therefore are not out there in the market doing the high-level tasks it takes to remain competitive. Your use of outsourcing allows you to attend more aggressively to those high-level tasks, which means you will soon be bringing in much more business than them (not that you need to worry about this).

Some examples of per-job tasks that can be outsourced include:

» Photo editing/color correction

» Online proofing

» Photo book design

» Printing

» Payment processing

» Product fulfillment

There are plenty of online companies that handle these jobs. I've listed some in an appendix at the end of the book.

Tasks associated with the overhead side (indirect costs) of the business produce similar benefits when outsourced. These costs are built into the overhead cushion that you charge customers. You may not be willing or able to outsource *all* of these tasks just yet, but here's an important point: Don't become too comfortable doing them yourself. Even if you feel you need to personally perform certain routine tasks for now, have an eye toward outsourcing them as soon as is practically possible.

Here are some examples of business/office tasks that can and perhaps should be outsourced (again, depending on whether you add genuine value to the task):

» Bookkeeping

» Accounting

» Website design

» Website management

» Blog and forum updates

» Marketing/branding

» General invoicing

» Travel management

» Virtual assistant

Resources for these services are easy to find online and in local phone directories.

The main point is that outsourcing, particularly of job-specific tasks, is an expense *you account for in your pricing*. You build it into your price structure from day one, which means you can start outsourcing from day one, rather than waiting for some time in the future when you imagine it will be more affordable. As a general practice, outsourcing typically *saves* companies money rather than costs them money.

Focus

The chief benefit of sharing the load and choosing to spend all your time living out your core talents is that it enables you to exercise the single most important muscle that any photographer and business owner can have: focus.

Your bandwidth of attention is only so wide. Granted, some of us have more of it than others, but even if you do have the capacity to juggle a lot of balls in the air at once, doing so dilutes your focus (like texting while driving). If, instead, you outsource your profit and cost centers, you'll no longer be the only one responsible for making everything work. Imagine the potential results if you used all that new time and energy on tasks critical to *growing* your business, not just keeping it afloat.

By focusing on what you do best and letting other team members handle the rest of the tasks, you now have a way to go all-in, without distraction, on the high-level tasks where you add your greatest value. And doing *these* tasks with care and energy will be the engine that drives new business to your door.

The Mark of a Great Strategic Partner

All of my outsourcing partners understand that if they do their jobs well, they're freeing me up to bring in more business, which is good for all of us. If they don't do their jobs well, they leave me trapped at the studio dealing with tasks less deserving of my time as the owner. So whenever I'm in a discussion about what I want my team members to do, I don't get lost in the technical aspects of their job. Instead, I spend most of my time talking about the *values* I want them to hold to, and trust them in their expertise to do just that. Of course, this all starts by choosing the right partners in the first place.

For example, I rarely concern myself with talking with ShootDotEdit (which I'll say more about in a minute), one of

my partners, about *how* they edit and deliver my images. That discussion happened back when I was screening to see if I should take them on as partners. Now I get to talk to them about bigger-picture values—such as my belief that the client experience is the most important aspect of sales—and hold them accountable to those standards.

If I ever were to get a complaint about an image that didn't get edited properly or a print that arrived to my client damaged, I wouldn't get lost in the "What happened?" conversation. Since I trust my team to take care of issues like that, I'd instead spend my time talking about the values I hold as fundamental to my brand. Then I'd ask my team how their solution to the problem would reinforce a positive client experience. I don't want them to just "fix the problem." I want them to fix it in a way that will promote the values of my brand.

Here are some things to look for in a strategic partner:

» They have a culture that resonates with yours (see "Creating a Culture," below).

» They assign a real person to work with you on an ongoing and steady basis.

» They listen to your concerns and are able to mirror them back to you.

» They show a motivation to do the job *your* way, rather than by a strictly rote process, offering customizable options and built-in flexibilities.

» They make an effort to understand your brand, style, and customer experience, striving to understand your high-level thinking.

» They remedy problems quickly, and refine their processes to avoid future errors.

» They know when the human touch is needed.

» They complete jobs on time, on budget, and with consistent quality.

» They have great testimonials, and you are able to verify these by talking to some of their existing clients/partners.

» They pass the "gut check."

When you first start working with an outsourced team member, you will learn pretty quickly whether that person is listening to you and committed to delivering the customer experience you want to provide. If you get a sense that they are *telling* more than asking/listening, you might want to end the relationship before it even gets rolling. Outsourcers need to be service oriented. You are *their* client, and they need to be bending over backward to offer a great customer experience to *you*, just as you do for your customers. Responsiveness, attentiveness, professionalism, and flexibility are critical. You need to be able to trust the assigned person as if he or she were an in-house employee.

How do you ensure that that happens? One way is through "WWYD" thinking.

WWYD?

If you want to make sure that your team, whether it includes outsourced vendors or even staff employees, will do the kind of work that's in line with your vision, try to encourage "WWYD" thinking. When faced with a decision, it should be second nature for your team to ask themselves, "What would *you* do?"

This means, of course, that you need to spend some time with new team members, looking at work together and communicating your tastes, values, and standards.

One of my favorite examples of WWYD thinking comes from an experience with my postproduction partners, ShootDotEdit (SDE). When first approached by the owners of SDE to consider

using their services, I was hesitant. I had already developed my own post-shoot workflow to edit my images and was under the belief that creating the right look for my images in post was a central task only I could do.

Since the owners of SDE were photographers themselves, they anticipated such concerns and had a policy of assigning specific editors to each client for the life of the relationship. So I was told that if I decided to outsource with them, I could work with one editor until he or she was editing my images to look exactly how I wanted them and then stay with that editor. We wouldn't have to keep training new people. I gave them a try.

After a few jobs, this editor was acting more like an employee than an outsourced vendor—an employee that didn't need training, a workstation, insurance, payroll, or benefits, that is. Since editing was his only job, it didn't take long before he could edit my work better than I could. Once we got clear on exactly the style I wanted, my SDE editor began to make editing decisions as if he were me working the computer. It was clearly true WWYD in action.

As your confidence in your team grows, you'll be free to focus on the one thing that no teammate, however skilled, possesses—namely, a sense of urgency around bringing in new business. As the owner, bringing in business and satisfying clients should be your chief day-to-day concern.

Creating a Culture

WWYD thinking is really only the jumping-off point for building a great team of strategic partners. Eventually, you want to move the authority of your company away from *you personally* and onto the *culture* you work within. By creating a company culture that is infused with the values you hold dear, there is always a "boss" around to guide decision-making, whether or not you're present and even if you decide to sell the company. The culture of your

brand is what will rule the day. Culture is what Steve Jobs has managed to create at Apple, for instance.

What is a company culture? Think of it as the living vehicle by which your brand values are embodied and communicated. Here are a few companies that have outstanding cultures, cultures that you can "taste" just by thinking about the brand: Starbucks, Apple, Southwest Airlines, Google, Blizzard Entertainment, and Geek Squad.

Within our industry, companies like SmugMug (an online image-proofing solution company) have been investing in community culture development for years. Others like White House Custom Color (one of the largest labs in the United States) build around their investment in education. Virtually any company can build a company culture and include their clients directly.

A company's culture instantly communicates its values, style, and the customer experience it is committed to delivering. And it does so in a way that goes beyond words. Company culture is communicated in a thousand ways, both subtle and obvious: language, products, atmosphere, visual choices, sense of humor, sense of style, promises, and commitments. A company culture is an extension of your vision and immediately communicates who you are and what you care about as a company.

Your company culture eventually becomes the most important tool you use to attract and select strategic partners. You want to find partners whose cultures resonate with yours. These types of partners will immediately understand what you are seeking to accomplish through your brand. They won't need to be hit over the head, trained, and retrained. They'll just "get it." You want your clients to have a consistent, "branded" experience, whether they are interacting with you or someone representing you. You will get that by developing a culture that others can taste.

We'll talk more about culture in Chapter 10. For now, just think of it this way: Culture is the tune to which your company

dances. Play that tune loudly and clearly enough, and prospective team members will know whether they're in harmony with you or not.

Now It's Your Turn

To wrap up this chapter, here are a couple assignments to start you on your way toward planning a support team for your company.

#1 CREATE A DREAM ORGANIZATIONAL CHART (1–2 HOURS)

Your first assignment is to draw out a "dream" organizational chart for your company. You'll see what I mean as you do the steps.

Step 1. List all of the jobs, large and small, that you currently do for your company. I know it can be a little overwhelming to write down *all* your responsibilities, including ones you might be doing without even thinking. But remember, you're trying to figure out how to keep track of all that work so you can build a team and create some systems (see the next chapter) to streamline your efforts.

If you're having a hard time doing this through abstract thinking, no problem. Commit over the coming week to writing down every task you do throughout each day. Just watch and record; take notes. After one week, it's likely that you'll have listed most of your responsibilities and have some insights into all the work you actually do.

Step 2. Armed with this list, start drafting an imaginary organizational chart, populated by people you'd consider ideal for the following roles:

> » **CEO:** You (Always put yourself at the top of food chain. You're the visionary.)

> » **Board of directors:** Who would you appoint to it to keep you in line and serve as your advisors? Include people you know personally or even well-known public figures.

» **Strategic VPs:** These are the people who come up with strategies for carrying out your vision in departments such as marketing and sales, systems management, and finance. Who would run each of these departments? And are there any other departments not listed above?

» **Managers:** These are the people who come up with processes and procedures for executing the VPs' strategies. Managers make sure the frontline workers are doing their jobs. Who would you want to see in management?

» **Frontline workers:** Who would you want to carry out specific tasks as well as interface with clients?

Step 3. Reflect. This is just a thinking step. Why did you choose the individuals you did? How does the mind-set of each person differ depending on the level of the role? In what ways does each of the individuals you chose add strengths and talents you don't possess?

As a company of one, obviously there's no way you can be all these people at one time. So I'm not expecting you to try to be more than you are or to use this actual chart in your business. The point of the exercise is to help you open your mind to creating a vibrant *team* to help you realize your vision.

#2 CREATE AN OUTSOURCE LIST (60 MIN.)

Step 1. Look again at the list of jobs/responsibilities you created in Step 1 of the previous assignment. Considering the strengths and talents that go in to filling each role, please divide your list into two lists:

1. Jobs that would be better done by others. This includes jobs for which you just don't have a true talent as well as jobs that don't *leverage* your true talents. Many of these might be routine or "low level" tasks that consume your time and could be done more efficiently by others.

2. Jobs that are yours alone. These are the core roles that make great use of your strengths and talents and would be inappropriate to delegate or share; "high level" roles that are central to creating the customer experience or to generating new business.

Step 2. Start building an outsource list. Using the first list, write down five tasks that you will commit to exploring as outsourced solutions this week. For each of these five tasks, you will:

» **Research outsourcing options.** Using a search engine, with phrases such as "photo editing services" or "online photo proofing," or your local phone directory, forums, or trade periodicals, find at least three providers for each of the five tasks you are seeking to outsource. In some cases, a single provider can handle more than one of these tasks. (Also see the appendix for some places to start.)

» **Have an initial conversation.** Contact each of the three providers, by phone, email, or online form, and begin a conversation about how the provider might help you.

Excellent! You've just done some critical work toward developing your company into one that will bring you both inner and outer rewards. You will continue to work on this team list as you develop your business plan at the end of the book.

Let's Review

» To give yourself the space to be a visionary leader, build a team to help you do the non-vision-critical tasks.

» Outsourcing allows you to build a trusted team without hiring salaried staff.

» DO outsource all profit centers and cost centers that do not fully leverage your value.

» DON'T outsource "high level" roles that only you fully understand and that are critical to building your business.

» Freeing time for you to generate new business is much more lucrative than saving a few dollars on low-level tasks.

» The way to build a team of trusted strategic partners is to create a company culture that clearly communicates what you're all about.

Chapter 6
Build Systems That Work

A Vision Without a System Has No Traction

In the last chapter we discussed the idea of building a team to free you up for the vastly more important task of getting out there and leading your business. Well, team is only half the picture. It's also crucially important that you *systematize* your operations.

What does it mean to systematize? For our purposes, it simply means to create a well-defined and repeatable process—a *standard operating procedure* (SOP)—for getting a job done. Without systematizing, you will find yourself constantly floundering about, questioning your actions, and reinventing the wheel. But when you systematize your operations by creating handy SOPs, you'll accomplish a goal similar to that which you accomplish by outsourcing. You'll free yourself up to spend more time focusing on the tasks that require your creative vision and leadership. By making routine tasks more "automatic," they no longer require your conscious attention. This allows you to allocate that attention to more important matters. In short, the more tasks you systematize, the more time and energy you have for being creative and bringing in new business.

Of course, as you know by now, I recommend outsourcing as many routine tasks as possible. However, you will never be able to outsource *every* piece of business that goes into producing your product or service. Nor would you necessarily want to. Systematizing gives you a way to handle your in-house tasks in the most efficient manner possible.

The "rule" for systematizing is similar to that of outsourcing: Systematize all tasks/operations except those that require your high-level leadership or creativity. Make everything as automatic and thought-free as possible except those few identified areas that will flourish from your personal touch.

Systematizing tasks by creating SOPs does more than make you more efficient; it gives you the tools to take an abstract vision and convert it into real-world results. And here's a beautiful side benefit. Systematizing gives you a way to take the very technologies that you may feel are crushing your photo business—software solutions, automation, internet resources—and use them to your own advantage. Instead of being defeated by the commoditization of your industry, use the *tools* of commoditization to help with the routine tasks of running your photo business.

And the reason you do this—I think you're starting to catch my drift by now—is so that you can put all of your personal attention into those special creative tasks that leverage your signature talents.

Build a Machine, Not a Sculpture

One of the challenges of being an artist *and* an entrepreneur is that I sometimes get so excited by clever business ideas that I forget the reason my business exists. When I boil it down, the business part of my photo enterprise is just a machine that exists to make money. Does that sound cold and mercenary? Well, I state it bluntly to make a point. As artists we tend to fall in love with the beauty of our own creations. We are tempted to stand back and admire their symmetry and composition, as if they were

sculptures. We like to make things that endure. But that's not how business works.

That's why I suggest you adopt a "machine" metaphor. Since forward movement is critical to success, a mechanical and kinetic mind-set should drive the way you design your operations. Machines are meant to be active, not admired. The more momentum a machine builds, the better it should run.

A sculpture, by contrast, is easy to admire and appreciate because it's sitting still. It elicits lovely oohs and ahhs, but it doesn't take you anywhere. You want a well-oiled machine that's flying down the tracks. You want efficiency. You want achievement. You want mileage.

The reason you need to think machine, not sculpture, is because you want to maintain a sense of urgency around your commercial efforts with photography. At the risk of sounding crass, you want to turn tricks. If you're shooting for pleasure, you can take all the time you like. But when you're running a business, your machine needs to move fast.

You want to turn jobs around quickly because with every new job comes new profit. But you also want to do this without your clients feeling rushed. That's why efficient and well-designed operations are so important. When they work right, you will move your clients through their transactions in a way that honors the client while paving the way for the next customer around the corner.

I'm not suggesting you should sacrifice your creativity in pursuit of the almighty dollar. Quite the opposite; I'm saying that if you don't find efficient ways to make your machine move, you won't have any time to get creative because you'll be too busy turning the gears by hand. Since you probably got into the photo business to take pictures, the best way to give yourself more opportunities to take those pictures is to be more efficient with how you do the other jobs. Remember, your business is the machine that gives you permission to practice photography professionally. Honor its

purpose. Actively seek ways to make it work for you. The easiest way to do that is to create SOPs that simplify your every task.

Systemize Repeated Tasks

By creating SOPs I don't mean devising an elaborate master plan for everything that *might* come your way. You don't have time for that. Contingency plans are nice, but they're not the same as SOPs. What you *do* have time for is anticipating the jobs you will be doing over and over and thinking about how you might accomplish those tasks with maximum effect and minimum effort.

How you answer the phone, how you pack your camera bag, what you do when you're back from a shoot, how you recharge your batteries, when you update your website, how you display your logo, what you wear when you meet a potential client, and how you share portfolio images are all examples of tasks that can be systematized and standardized to more efficiently and successfully serve your business efforts.

SOPs make your job simpler and also clarify for employees and vendors the tasks they'll do on your behalf. Standard practices yield consistency.

Many new small-business owners fail to create SOPs. Each time a task needs accomplishing, they stop and take time to consider how they're going to do it. Although that kind of care and attention may seem admirable from the outside looking in, it is actually extremely wasteful. It would be much more beneficial to think the task out thoroughly *one time* and then create a template or checklist so you don't need to think so hard about it next time around.

When the task is very small and insignificant, it may not seem worthwhile to systematize and standardize it. But if you do that task enough times, your time gets eaten up faster than you think.

Here's an example. A while back I stumbled onto a software program called Text Expander. As the name implies, the

program takes customized keystroke shortcuts that I've set up on my computer and expands them in any program. So, for example, if I need to fill in my website or physical address in an online form or if I have a picture or piece of text I routinely want to embed in a document and I don't want to go searching for the data or typing it out manually, I can quickly input these saved "snippets" anywhere I want with a couple predefined keystrokes.

When I first heard of the program, I didn't think much of it but decided to experiment and see what all the positive reviews were about. As I used it for a while, I found that I really did enjoy the timesaving of quickly inputting data. What I didn't realize was just how much time that was! I eventually discovered that the program kept track of this. Each time I expanded a snippet, Text Expander would keep a tally, measuring exactly how many characters I *didn't* type as a result of using their program. It even went so far as to compute the total number of minutes and hours saved, depending on how fast one could type.

What blew my mind was that in the few months since I bought the program, I have expanded over 3,300 snippets and saved myself 235,814 keystrokes. So what? Well, if I had typed (without error) all those keystrokes at an average pace of forty words per minute, it would have taken me no less than 19.65 hours! That's almost a full day, in just a few months' time.

If you think little choices in your business don't make a difference, I encourage you to reconsider. Can you imagine getting to your last day on earth and realizing you could have had one more day except you typed it away? How much would you pay to get those wasted keystrokes back?

Whenever you can find ways to systematize tasks for your company, you're buying yourself valuable time. SOPs give you a great way to create efficiencies in your work. Devising them is easy to do, but it's also an easy task to neglect because it lacks the urgency and sexappeal of more compelling tasks.

"When I started my photography business, having systems in place was mistakenly put as a lower priority on my list until I realized how much time I was losing doing the same thing over and over again. Even clicking one extra button in Photoshop [*over and over*] can add up to hours lost."

—MELISSA OHOLENDT, OWNER, MELISSA OHOLENDT PHOTOGRAPHY

EXAMPLE #1: MAIL

At first glance, mail can seem like one of those simple chores you don't need to systematize because it doesn't take long to deal with. But if you're like most small business owners, you also know how mail can pile up. Before you know it, you're behind on bills or you're stuck with weeks' worth of invoices to file. How did this happen *again?* By putting some simple SOPs in place, you can save yourself a lot of time and effort.

Do you open the mail every day or let it stack up and open it twice a week? Do you have a plan to separate checks from bills? Do you have a routine procedure for depositing checks into your business bank account?

Whenever you encounter *any* task that has yet to be systematized, such as mail, ask yourself the following questions:

1. Is this task predictable and recurring?
2. Can it be made more "thought free" and easy?
3. Can it be made more efficient?
4. Have other people systematized similar tasks? Are there "best practices" in place for doing this task?
5. Can this task be *automated*, in whole or in part? (By "automate," I mean turned over to machines or software. For example, Quickbooks can fully automate certain payroll tasks, such as writing checks, creating pay stubs, and organizing taxes, once the initial data are entered.)
6. Can I coordinate this operation with other operations to make my whole machine run better?

When I asked myself these questions regarding my mail operations, I came to the following conclusions:

1. Yes, dealing with mail was a predictable and recurring task.
2. Yes, I was spending too much time making decisions about my mail and, yes, the operation could surely be made more thought free. This wasn't rocket science, after all—there were only five essential types of mail: junk mail, bills, checks, "reply needed," and "save for reference."
3. Yes, I was creating inefficiency by not dealing fully and in a timely manner with all mail that came in.
4. Yes, better ways for doing this job existed. By talking to a friend who ran a small business, I got the idea for using the "scan and shred" system I'll describe in moment.
5. Yes, I could partially automate the task by using the scanner technology already sitting on my desk.
6. And a final, yes, I *could* coordinate this operation with other operations, such as bookkeeping and product packing, to create a smoother-running machine overall.

In short, mail was clearly an operation that could and should be systematized. Here's the SOP I created to deal with my mail:

1. All business mail is collected in a dedicated inbox.
2. Every day, before I finish work, I place the entire stack of mail from the inbox in my hand.
3. Observing my rule that I may not put any piece of mail down until I deal with it fully, I categorize the mail as either junk mail, bill, check, reply needed, or reference material. Here's what I do with each kind.

» **Junk mail** goes in the shredder.

» **Bills,** which include anything that requires my payment or donation:

1. I scan the bill on my scanner.
2. I save the image file to a folder for bills on my server (which means I can access it from anywhere, on any computer). The scanner automatically creates dated subfolders within the main folder. All bills are thus collected handily for when it's time to do my bill-paying operation (another SOP).
3. I shred the paper bill and envelope (always a delightful step).

» **Payments**, which include checks and money orders:

1. I scan the check on my scanner.
2. I save the image file to an Accounts Receivable folder on my server. All payments are thus collected in a single place for my bookkeeper to record them.
3. I shred the envelope and put the physical check in a designated manila envelope.
4. I deposit all checks received in the drive-up ATM on my way home.

» **Reply-needed** material, which includes any correspondence that legitimately requires an answer from me:

1. I scan the document on my scanner.
2. I save the image file to the Reply Needed folder on my server (which I review once a week).
3. I shred the paper document

» **Reference** material, which includes bank statements, receipts, contracts, etc.:

1. I scan the document on my scanner.
2. I save the image file to the appropriate folder on my server (Bank Statements, Contracts, Receipts, etc.).

3. I shred the paper document.
4. When the shredder bin is full, the shredded paper goes into a "packing material" bin and is used for packing items that I ship!

Creating an SOP

To create a SOP is simply to create a "recipe" for doing a given task in the future. It involves a few simple steps.

1. **Define the task.** Identify an operation you wish to systematize by asking simple questions such as those on page 133.
2. **Observe.** Note the way you currently perform the task. How much time does the task consume (and waste)? How do you vary its execution from time to time? Note the number of steps required to complete it and the way it relates to, and is affected by, other tasks. For example, handling bill mail clearly relates to paying bills.
3. **Analyze and Optimize.** Put on your analytical hat and think about ways to make the job more efficient. Pay particular attention to the way the task is codependent on other tasks. Can you make your whole machine more efficient by linking this operation to others? For example, scanning my bills makes both handling mail and paying bills more efficient.
4. **Brand it.** As you are thinking about how to make the task more efficient, also consider how you can make it *consistent with your brand*. Most of all, think about how your handling of this task will affect the customer experience. Efficiency at the expense of customer satisfaction is not a viable trade-off. For example, an automated telephone ordering system may work for *you* but may be perceived by customers as annoying, impersonal, and opposed to your brand's values. You may wish, instead, to allow customers to record a message, then call them back personally.

5. **Write the steps of the SOP.** Now write down all the steps, in plain detail, so that you and others can understand and follow them.

6. **Implement.** Put the SOP into play.

7. **Test and Measure.** Pay attention to ways in which the SOP is working and also ways in which it needs improvement. You can do this formally or informally, but you should have some kind of metric in mind to measure whether your SOP is working. With handling bills for example, if all of your bills are paid on time and without error for three months running, then your SOP is working. With more complex or people-oriented operations, such as running a client meeting (which we'll look at below), the metrics may need to be more sophisticated or subjective. But always have measures.

8. **Tweak.** Revise the SOP so that it's working smoothly and is making the right contribution to the customer experience. But here's an important point: Don't do more than minor tweaks, at least for a while. You have to live with a SOP for a while to see if it's really working. Don't abandon it too soon, like a basketball coach who abandons a game plan halfway through the first quarter; stay with it and adjust it until you get it running better or are convinced it's a poor SOP.

Check your operations periodically and update your SOPs every time you've figured out a way to simplify them (e.g., when you've switched over to direct deposit or moved to an electronic filing system). You want to be increasingly efficient and standardized. That's what it means to build a machine.

> "If you begin putting excellent business systems into place, they'll serve you for the rest of your career. If you don't, you'll be serving your business for the rest of your career."
>
> —MARC WEISBERG, OWNER, MARC WEISBERG PHOTOGRAPHY

Major and Minor Operations

In a business, of course, not all tasks are of equal weight and importance. There are major operations and minor operations. Ideally, they should all link together. Your major SOPs (for major operations) are built from minor SOPs (for minor operations). Kind of like Lego bricks.

For my money, Lego is one of the greatest children's products ever invented. I find Lego bricks to be a perfect metaphor for thinking about the way minor operations link up with major ones. When my kids and I are attempting world dominion by building the latest and greatest Lego masterpiece, such as a fireboat, we divvy up the task. Each of us works separately at first, building a smaller unit that has a specific purpose, shape, or function relative to the whole. One of us might build the helicopter, another might work on a water cannon, and another might work on the ship's bridge. (Lego makes it easy by packaging the "minor operations" separately from one another.) Then we join our efforts together to create the larger "masterpiece." Not only is this a great way of utilizing a team—my young son, for example, has the smallest hands, so he builds the units that have small pieces—but it's a wonderful way to look at how minor operations come together to create major operations.

As CEO of your business, it's important to keep in mind the relative importance of whatever operation you're currently dealing with. How you talk to clients is more important, relatively speaking, than what kind of socks you pack for a business trip. But messing up on your sock packing can affect your confidence in dealing with a major client, such as an art director for a top ad agency. Having SOPs in place for both the major and minor operations allows you to elevate your view to high-level concerns when appropriate or drill down temporarily, as needed, to very small but also important concerns. The SOPs prevent you from being overwhelmed by minutiae but also give you confidence in conducting more important operations.

EXAMPLE #2: RUNNING A CLIENT MEETING

SOPs help me with both concrete tasks, like handling mail, and "softer," more people-oriented operations. Here is an example of how I created an SOP for a relatively major operation: running a client meeting.

1. I determined that running client meetings was a routine task that would benefit from being more systematized. Though it was not a mechanical process, it was certainly a recurring one that I wanted to optimize and get right.
2. By observing myself during several client meetings, I realized that I was often inefficient or off focus. I sometimes did too much talking and not enough listening. I sometimes failed to capture the client's story adequately. I sometimes had to rush details because I ran out of time.
3. I decided to better optimize my time with the client by breaking down the components of a client meeting and assigning time limits to them.
4. In thinking about my brand ("Discover What's Inside"), I knew that I wanted to embody consistent brand values during client meetings. That meant spending the majority of my meeting time *listening* to the client.
5. I wrote down the needed steps of the client meeting, including my estimated time breakdowns. This was my "draft" SOP.
6. I started working my SOP during my next group of client meetings.
7. I consciously evaluated the SOP, particularly the time breakdowns. I noticed that I still was not allotting sufficient time for the client to tell his or her story and express his or her needs and vision. How did I know this? I was still getting to the end of the meeting without adequate knowledge of my clients' story.
8. I tweaked the time allotments.

My SOP for client meetings, as it stands now, is as follows:

» Meet in person with client for ninety-minute session.

» Listen to client's story (70 percent of time, or roughly one hour).

» Discuss client's expectations (10 percent, or about 10 minutes).

» Share albums and talk through pricing and album predesign process (10 percent, or about 10 minutes).

» Brainstorm engagement session location possibilities (5 percent, or roughly 5 minutes).

» Confirm next steps (book today? engagement session date and place?) (5 percent, or about 5 minutes).

Note, by the way, that the percentage of time you spend on any operation—or any part of an operation—is an indication of how important that task is to you and your brand. If you are spending 70 percent of your work time doing tasks such as file management, post-production, and accounting, you are declaring these operations to be more important than shooting, generating new business, and meeting with prospective clients.

Make a Manual or "Wiki"

Now, how do you manage all these SOPs?

First of all, I don't advise that you cloister yourself away and try to build an exhaustive set of lists for your whole business in advance. Create SOPs as they are needed *in practice,* and systematize the most important operations first. The goal isn't to have a great set of lists. The goal is to standardize the regular tasks your business is responsible for as you continually discover what those tasks are. Of course, do write down the SOPs down as you create them.

As you begin collecting SOPs, you'll want to house them in some sort of company manual. The low-tech version of this is to keep a big binder and add to it as you create your SOPs. A more advanced approach that allows you to update your processes regularly and easily is to use a free online tool such as Google Sites or some other free wiki software. (You'll be experimenting with Google Sites in the assignments at the end of the chapter.) I personally love having a "wiki" of knowledge[2] for my company.

Not only can I contribute to it, so can my team members. As a living document and a working tool, it's pretty powerful. (For those unfamiliar with the term, a wiki is a website that lets you create and edit an unlimited number of interlinked web pages to manage your company's operations.)

Now, if you don't fancy yourself a list person or if you don't think you need lists to create a consistent experience for your clients, consider what InHouse IT co-CEO Steve Bender observed about SOPs: "Even talented pilots and highly skilled surgeons use processes and checklists. Why would a small business owner be any different?" Creating efficiencies and safeguards through SOPs is the kind of thing you must do if you're planning on growing. And if you're not planning on growing, I suggest you retire today.

Automation = Free Employees

Don't forget to explore the possibility of *automating* some of your operations, in full or in part, as you're creating SOPs.

A couple years ago my business started to grow substantially. I wasn't ready for the spike in work, and, as jobs started coming in, I actually started to feel resentful. The more business that came through the door, the more details I had to keep track of. I know, I know… poor me. But hear me out.

[2] For a richer understanding of the benefits of this kind technology, and to learn more on how to create your own wiki, go to this CIO.com article on the subject: http://bit.ly/wikiyourphotobiz.

The reason I was down was because I felt behind all the time. Even though new business was a sure sign of success, I was *feeling* like a failure. I began to long for a helper, someone who could keep all the details of my clients and my workflow up-to-date, as well as give me a bird's-eye view on what was going on financially. What I craved was a tireless studio manager to track my input and output, advise me on the business, and help me feel in control again.

I dreamed about hiring an employee but knew that even with the upswing in business, that step was still out of the question financially. And even if I could hire someone, I'm not sure I would have trusted him or her. I thought I was the only one who cared enough to do that kind of work well.

Finally, my dissatisfaction got the best of me and I tested out an automated solution, an online studio management software package called ShootQ. Once I started using the program, my eyes were opened to just how out of control I actually was. I felt like an incompetent bank teller who had just hired an ATM.

The web-based software was written by a group of practicing photographers in Atlanta, who also happened to be my friends. It turns out they were experiencing a similar drag on their time when it came to day-to-day business tasks and needed a better system to get organized. Once they built it, they decided to share it with the photo world.

ShootQ now largely automates the management of my entire global photography workflow—from the moment prospects fill out a contact form online to my tracking of email correspondence to all my tasks before, during, and after shooting to following up on referrals to managing production. The truly outstanding part is that this software goes for something like $40 a month.

I realize that for some, $40 per month may sound like a lot. But think about it: I was dreaming about hiring a *full-time employee* to cover all the tasks that this piece of software does on my behalf. That would have meant at least a mid-five-figure salary. For a mid-three-figure annual software fee, anyone can have an automated

"employee" that may even be more competent and detail oriented than that expensive human.

What got me even more excited was that if I could generate just one additional booking a year as a result of the time that ShootQ was freeing up for me, the service would be more than paid for. And because ShootQ is automated, it works even when employees have gone to bed. It is constantly collecting, measuring, and giving feedback.

Batch Processing

As you're developing SOPs for running your business, I also encourage you to adopt the principle of batch processing. Let me explain.

When I was in high school, I bussed tables at an upscale café called the Silver Spoon. Throughout my shifts I would get impatient waiting for the next rush of customers and would wash individual plates and glasses in their high-capacity dishwasher.

Eventually an experienced waiter pulled me aside and pointed out how my restless busywork was getting in the way of my efficiency. He said, "Why not just let the dirty dishes pile up in the dishwasher and then wash everything at once later? It's not like the dishes are going anywhere." Brilliant! The dishwasher collected the dishes, and when it was good and full I'd wash the whole load in one batch. Actually, the machine washed them for me…even better.

This approach makes sense in any business, not to mention life in general. Let's say, for example, you're both a parent and a businessperson and you have conflicting goals. One goal might be to play with your kids every day after school. Another goal, as the boss of your company, might be to return all your phone messages before the end of each day. If you have a lot of messages, you'll have a problem meeting your goal as a father. To deal with this predicament, some might recommend weighting your priorities

according to how important each goal is to you. But it's not always so simple; you'll be left feeling like a bad dad if you don't play with your kids, but if you don't follow up on those job leads, your kids might not eat. A dilemma.

Rather than being ruled by a time-driven schedule of priorities, set up your life so that everything you need or want to do is collected in batches. That way, when you're ready to attend to your tasks, they will be sitting there, queued up, organized by type, and waiting for you.

Systematically separating the *collecting* of things that need to be done from the actual *completion* of those tasks offers tremendous power. Not only does it honor the "business as machine" model, but it lets you choose when to do what needs to be done.

The trick is to set up "nets" to "catch" the tasks—such as a computer folder in which all emails that require a response go, a physical envelope for all paper checks, a computer folder for all images that need to be edited or sent out for editing, a computer folder for voicemails that need to be returned (if you have a phone system that emails your voicemails as sound files, which I recommend), etc. Make sure to separate the "catching" from the "doing." Let your stuff get snagged in your nets and, when it's time, knock off the tasks one by one.

Be sure to empty your nets regularly. The relief that comes with knowing your tasks are being collected will turn into anxiety if you don't discipline yourself to process them regularly. I make it my habit, for example, to go to bed with an empty email inbox almost every day. Batch processing makes that possible. If I let those same emails interrupt my day rather than collect and process all at once, I'm rarely able to get it all done.

The bonus is the relief I feel by knowing I will process everything I've collected in one sitting. I actually look forward to sitting down and knocking it out. In this way, you shouldn't think of batch processing as putting things off. It's just a means to do what you're responsible for more efficiently.

One note of caution: Don't *use* batch processing as a handy way of putting aside and avoiding tasks you don't like to do. Make sure *all* of your nets get emptied, not just the ones you enjoy emptying.

Back Up Your Operations and Data

As you're designing ways to capture and collect work for later processing, it's important to have secure nets in place for doing the capturing. That means your nets should not have holes in them. If certain tasks routinely escape your notice and get missed—such as returning phone calls, sending out billing notices, or filing receipts—that means you need to tighten up your nets. Or correct your SOPs!

It also calls to mind the importance of *backing up* your operations and the data being captured and stored. This means you need some redundancies and contingencies. We'll talk briefly about some of the backups specific to photography itself in Chapter 8. Some other areas where you want backup include the following:

Computer hardware and software: Ideally, you want more than one computer, with copies of your main programs (such as Photoshop, Lightroom, MS Office) installed on at least two of them. You cannot afford to shut your business down if your computer fails and needs to be in the shop for a week.

Computer data: Any important data that you collect and store—Word files, digital images, forms, email correspondence, etc.—should be backed up in as many ways as is practical for you. You can now buy easy-to-use portable hard drives that can store data from multiple computers. Also, using a remote, off-site data backup service such as Mozy or Carbonite will let you sleep better at night. A good remote backup service is inexpensive, backs up your data constantly, and allows you to retrieve backed-up data quickly and easily. Printing paper copies of very important documents is also highly recommended.

> "This past December my hard drive crashed after only ten months of use, and of course it happened during the busiest time of year. Because of my IT redundancies, I didn't actually lose anything significant, which enabled me to (a) chill out while my laptop was being fixed and (b) not enrage my clients and meet my deadlines even with losing a week of work time."

—MELISSA OHOLENDT, OWNER, MELISSA OHOLENDT PHOTOGRAPHY

Communications: Make sure you have more than one way to communicate by phone. Use both a cell number and a landline, and make sure everyone you do business with is familiar with both. As noted above, some phone systems will automatically back up your voicemails as sound files and email them to you. In this way you have an independent copy of all calls.

Now It's Your Turn

As we end this discussion of systematizing your operations, I'm going to ask you to do two assignments.

#1 WIKI SETUP (30 MIN.; ONGOING)

Go online to http://sites.google.com and register your own Google Sites account. Once established, I want you to begin building a personal wiki for your business. View your new wiki as an infinitely customizable company manual. The great thing is that Google's resource is free to use.

With your account set up, you can now create categories and sub-pages, each with its own content. Your assignment, for now, is to give yourself thirty minutes of uninterrupted time to begin creating categories for all of the various major and minor operations that are part of running your business. Your major operations are your main categories, and you minor operations are your sub-pages. Don't feel the burden of having to fill everything

in. Just *start* building out the categories and subcategories for now. You'll finish this project over time, but I want you to get a taste for it right away.

Here are some simple examples of categories and subcategories you might use:

» Accounts payable (major)

- How and when you pay your bills (minor)

- How you organize unpaid and paid bills (minor)

- How you record payments (minor)

» Website maintenance (major)

- How you update your website and/or blog (minor)

- How and when (and if) you post to Facebook, Twitter, forums, etc. (minor)

- How you make an online slideshow (minor)

» Postproduction (major)

- How you manage postproduction workflow (minor)

- How you proof shots or albums to clients (minor)

You will come up with different categories and subcategories than mine. It really doesn't matter how you break it down as long as all the tasks are covered and it is organized in a way that makes sense to you.

Even if you don't know how to do some of the things listed, create the category anyway so you'll be cued to go find out when you're ready. Remember, once you create an SOP for a particular operation, record it in your wiki!

This is not a one-time assignment. You'll be building on this wiki in the weeks, months, and years to come.

#2 TEN SOPS (1–2 HOURS)

With your working wiki in place, go through at least ten of your minor operations and, using the eight-step system described on page 139, write down an SOP for completing each task in a way that is efficient and consistent with your brand message. Define at least one tangible metric that will help you know if the task is being managed successfully, and add this metric to the wiki page as well. Systematize! Again, you'll be fleshing out this whole business wiki over time, but I want you to get a practical sense of what it feels like to *work* it right now.

#3 TAKE THE BST!

Now, before we move on to Section 3, I'd like you to go back to the Business Stress Test [http://ftpBST.com] and take part 2.

Let's Review

» Like building a team, systematizing operations frees up your time and attention to focus on the important tasks of leading your business, being creative, and generating new business.

» The way to systematize an operation is to create SOPs.

» Automate tasks whenever possible.

» Separate the *collecting* of tasks from the *performing* of tasks.

» Perform batches of the same task together, rather than as each individual task arises.

SECTION 3 | **GET TO WORK — THE FAST TRACK PHOTOGRAPHER BUSINESS CYCLE**

Chapter 7
Book Jobs: Make Clients Your Focus

Foundation Empowers Function

By laying the foundations discussed in Section 2, you've given your business a huge leg up. You now have a platform on which to stand when you tackle your day-to-day work as a photographer and business owner. As we turn the corner to the more functional aspects of your photo business, you should begin to see how the preparation you've done so far has made the work in front of you much more streamlined.

Of course, you'll always be working to make your foundation stronger, but even with the limited work you've done so far, you are better prepared to address the three main functions of a thriving photography business:

» **Booking jobs:** Attracting new clients

» **Shooting jobs:** Carrying out the photography in a way that delights the client

» **Leveraging jobs:** Using your past work to generate new business

All three of these functions are directed toward the same end: bringing paying clients in the door. For the next three chapters, we're going to keep the generation of revenue our primary goal. Again, pulling in revenue may not be your personal motivation for taking pictures, but it's the main reason you're running a photography *business*, as opposed to simply pursuing a hobby.

That said, when you follow the practices we'll discuss, you should not *feel* as if you're only in it for the money. This business cycle is much more relationship driven than that. As you meet legitimate needs for your clients while staying true to the work you're made to do as a photographer, the transactions should feel as if they're creating value for everyone involved. Especially you.

The chapters in Section 3 unfold as follows: First, we talk about how to put yourself in the best possible position to *book* assignments (here in Chapter 7). This sets up the process for actually *doing* the work (Chapter 8). And finally, we talk about *leveraging* booked gigs and delivered products to get even more assignments (Chapter 9). Which cycles us back to booking again. These three business functions make up the perpetual Fast Track Business Life Cycle.

In many cases, the approaches we discuss here represent a major departure from the way you may have been taught to do business, either in school or by experience. Many of the ideas are specifically designed for doing business in the challenging and crowded Digi-Flat world in which we are all now attempting to coexist. I believe that if you follow the advice in these pages, you will cement your reputation as a values-driven and value-adding pro, while generating substantial value for your clients and your business.

Now it's time to set your business in motion. So, without further ado, let's dive into Job 1: Booking.

Neediness Repels

In the old-school business model, the way to attract customers and generate sales was to hammer away at your market through

relentless in-your-face marketing and aggressive sales techniques. You were the hunter, and the customer was the quarry. It was your job to "bag" as many customers as possible. You hustled, you cold-called, you accosted.

And how did that work out for the customers? Well, we all play the customer role, too, so we know the answer. We've all experienced the dread of stepping onto the used car lot, answering the telemarketing call, or wandering into the electronics store with the pounce-on-the-customer-the-instant-she-walks-in-the-door culture. And we hate it. We prefer to shop at our own leisure, asking questions when the need arises. We like to survey the wares and freely choose the one that suits us best. No pressure, no gimmicks. It's what Seth Godin calls "permission marketing." The name says it all—the seller gains the buyer's permission to present his goods.

So why do so many companies practice aggressive and off-putting techniques? Because they work, in their own crude way. Or, I should say, they *have* worked in the past. But the world is changing. We have entered a new era in which the customer is king. Thanks largely to the explosion of internet commerce, which allows shoppers to browse with total anonymity and arm themselves with the knowledge they need to make an informed decision, the old ways no longer work. Customers now shop not only for a better *product* but for a better *customer experience*.

The old, aggressive, pursue-the-customer-relentlessly approach now feels more unattractive to us than ever. I think it's because that approach flows out of *neediness*. And neediness is a fundamentally repellent energy.

Think about a young man cruising the floor of a singles dance in hopes of meeting a young lady. (This works the other way around, too, gender-wise, but the male is the more common offender, so I'll use him in the example.) This young Lothario zeroes in on every woman he sees, blurting out his

carefully crafted opening line and generally projecting a sense of desperation. Because he brings an attitude of *need* to the table, what happens? Every woman he approaches wants to run the other way.

Contrast this with the gentleman who walks into the room feeling a sense of confidence and calm. He has no particular agenda, no particular need to meet someone *tonight*. He's not desperate or driven. His attitude is that *he* has a lot to offer in a relationship and he is confident that when the stars are right, he'll meet the right person. Lacking a sense of need and armed with a sense of self-confidence, what happens to this man? He finds himself the inescapable object of attraction.

Neediness in any form (except perhaps in a baby) tends to put us off. A panhandler, a needy friend, a pollster, an eager charity solicitor—all of these people make us squirm because they come from a position of wanting something *from* us, rather than offering something *to* us. And while this posture may be necessary from time to time, it's not something to which we voluntarily subject ourselves. When we're shopping for goods or services, for instance, we don't want to be stalked and hunted; we want to consider offers.

Neediness is a demanding posture, and generosity is an *inviting* one.

> "My goal is to treat my clients like they are a part of a friendship that I genuinely want to keep. I don't sell them on anything. I let them choose what they want. Our studio has been in business for just over ten years. Currently, our average daily orders are between $3,000 and $15,000. That said, each year we have a handful of $30,000 to $40,000 orders. We have not seen a downturn in our business despite working through this economy. I would attribute all of our success to being authentic and kind with each client."
>
> —CORINNE ALAVEKIOS, OWNER, ALAVEKIOS PHOTOGRAPHIC ESSAYS

The Inviting Way

The attitude we need to foster if we want to attract customers in the twenty-first century is that of *listening and offering solutions* as opposed to pressing for business. This relationship-based approach is inherently attractive. It gives rather than takes. It promises rather than demands. It is positive rather than negative. It is voluntary rather than coercive.

Using the old "aggressive" model:

» We *pursue* customers.

» We manipulate emotions.

» We spin facts.

» We pester and browbeat.

» We say and do whatever it takes to close the deal.

» We use phony ploys and gimmicks to get attention.

» We beg and plead for business.

» We try to be louder, shinier, and more aggressive than the competition.

» We make "crazy deals" to close a sale.

Using the invitational model:

» We offer solutions.

» We believe our products offer value.

» We are confident that customers will want our products.

» We engage customers with an attitude of service.

» We allow business to come to us.

» We don't apologize for our prices.

» We are interested in the *customer's* needs, not our own need to sell.

» We don't pressure, we *invite*.

Invitation, not coercion. That's the key to attracting new business in the flat new world. And the three steps I encourage you to keep in mind as you go about attracting new business all revolve around this key concept. (1) Be an invitation, (2) Forge a connection with clients, and (3) Validate that connection.

Be an Invitation

As a small-business owner who is spending a great deal of time and resources getting your photo business ready for market, you need to know that you can't expect your prospective clients to know or care about all the hard work you've done so far. They *don't* know and they *don't* care. It's not personal. But the fact is, we don't get any credit for the groundwork we've done—at least not yet. No one *owes* us their attention or interest just because we're so talented and hard working. We have to reach out and attract it.

Your "invitation" occurs the very first moment your future clients notice you. Perhaps it's the moment they click on a photo you took on a friend's Facebook page or the moment an art director sees your work in a magazine unrelated to his or her field. Maybe it's the sign you've hung outside your studio, your business card, or the comment you've posted in an online forum. Your "moment of first contact," whatever it might be, is an opportunity to invite clients to the experience you are promising.

You may have been taught to believe that the best way to drum up new business is with a summons—for example, with an

advertisement or commercial. While ads can work, they're pretty limited. To the person being invited, these sorts of messages feel more like annoying noise, or worse, spam. The Fast Track way is not to beg, coerce, or trick people into paying attention to us. We want to woo them, on their terms. That's what an attractive invitation is all about.

What if instead of merely *sending out* invitations about our business in the form of traditional marketing tools, we committed ourselves to *being* the invitation? By that I mean we take responsibility for every potential "touch point" by which we connect with prospective clients. Touch points include everything from your website to your logo to your business card to the cleanliness of your restroom. The way to *be* an invitation is to take ownership of the message you are sending with every one of your touch points. You certainly can still advertise, but this new way of thinking expands your responsibility considerably.

What would it look like to make every touch point compelling and inviting in the eyes of potential clients? This question turns the tables on the traditional sales model. You should no longer be thinking, "I have stuff to sell, so please buy it," but rather, "I've been getting ready in anticipation of you showing up for some time. I'll be ready when you are."

The best way to generate immediate and long-term business is to commit to the *invitation,* not the sale. In more "spiritual" terms, we might say, "Focus on what you are offering, and detach from the results." The results will take care of themselves. We can't control them anyway. All we can control is what we offer and how we invite.

This new way of thinking asks owners like you and me to put ourselves in the shoes of our clients and ask what they might want and need. By anticipating the needs of our potential clients, we put our company in the best possible position to meet those needs. But, as with all real invitations, the client must always feel the freedom

to choose. Instead of anxiously trying to pry a commitment out of the customer (as in the traditional "ABC: Always Be Closing" model), we tender an invitation and graciously make space for the client to decide.

Want to give yourself your best shot at business? Be the most attractive invitation you can be.

Invitation Never Stops

In case you didn't notice, this new model raises the stakes considerably. It means we're never off the hook. From the way I conduct myself in online forums to the way I interact with a fellow businessperson to the way I look when I bump into a potential client at the supermarket, I am always creating an invitation to relationship. Invitation is as much about what you *are* as what you *do*.

All of a sudden my invitation is no longer just an occasional event that occurs when I remember to bring my business cards with me or throw a discount sale. It's more like gravity—it's always happening, whether I'm thinking about it or not. In that sense, we need to think of the *world* as our potential clientele and always be exuding values and energies consistent with our vision. If I'm rude and demanding to the waiter at a local restaurant, what kind of invitation am I sending out? On the other hand, if I respond generously and respectfully to an online forum participant, what kind of invitation does *that* send?

There's an old proverb: "Everywhere I go, there I am." That's how I want you to think about bringing in clients: Everything you or your company does is an invitation to a relationship. It's your job to decide what kind of invitation you want to be sending. When your invitation focuses on the client's needs and is rooted in a clear idea about who you are as a company, magic can happen. Below is a story that illustrates this point.

The Magic

Most of the stories I share in this book are from the photo world, but sometimes it's enlightening to hear from creative pros in other industries.

A friend of mine who has a writing business was perusing writing opportunities on a popular online job site when he happened upon a notice recruiting a screenwriter for an independent romantic comedy film. The post was poorly written, unfocused, and unintentionally insulting to potential candidates. It smacked of amateurism and general cluelessness. Rather than ignore the ad or post a "newbie flame" on the site, my friend chose to write a personal note to the originator of the post.

In his email, my writer friend politely and thoughtfully pointed out the ways in which the person might rethink his ad to be more effective. He mentioned that he himself did not write romantic comedies and thus was not looking for the job, but that he had quite a bit of experience with other film genres. He shared his thoughts about the business in general and invited the ad's author to contact him if he or she wished to continue the discussion. The email was compassionate, funny, well-written and demonstrated a good knowledge of the craft of screenwriting. More than that, it answered a need and in turn made a *connection* (which we're going to talk about in a minute).

As it turned out, the original post had not been written by a filmmaking newcomer but by a well-positioned, well-seasoned studio executive. He contacted my friend and explained that he had fired the post off hastily in a moment of frustration. He agreed with my friend's remarks. In fact, he was so impressed by my friend's considerate, knowledgeable, and helpful reply that he wanted to know more about *him*. It turned out that my friend had a script that sounded perfect for another project the film company had lined up. The executive invited my friend to submit his script and the

studio optioned it. Now they have an ongoing, mutually positive working relationship. All because of an invitation.

How did this invitation make magic happen?

1. It focused on helping someone else solve his or her problem and was unselfish in its purpose.
2. It was well-written, funny, and well thought out, thus *demonstrating the writer's own skills* at the very craft in question: writing. In effect, it served as the writer's perfect "audition piece."
3. It showed that the writer understood the business.
4. It offered an invitation rooted in the writer's vision for his business: working cooperatively to improve the art of film.

Can you see now why all that work you did near the beginning of the book is so important? If you're unclear about your company's vision and your promise to the world, it's like sending out party invitations with incomplete or incorrect information. It's confusing to those receiving them. But if you *are* clear, then your vision serves as the "theme of the party."

> "At the end of our meeting, the clients told me that they were interviewing four other photographers for the job. Days later, I got the assignment. Given the competition I was up against, I was curious to know what had been their decisive factor. So I asked them why they chose me.
>
> "They said that of the four other photographers, one did not show up for the meeting, another canceled at the last minute (these clients are from out of town), and of all the remaining photographers that they did speak with, I was the only one who asked (and listened to) them about what they were looking for in a photographer. The only one! The simple question of, 'What is most important to you?' was all it took to make a connection. Everybody else made it about what they were selling and totally missed the client."
>
> —STEPHANIE LEBLOND, OWNER, STEPHANIE LEBLOND PHOTOGRAPHY

Every Touch Point Matters

Have you ever gone to a restaurant someone raved about only to have the endorsement tainted by a cranky waiter? How many times have you hung up the phone, enraged with a company because their customer service rep seemed unable or unwilling to help you? Have you ever closed a website out of sheer frustration because it was taking too long for the page to load? Can you see how a client's attitude toward a whole brand can shift because of her experience with *one touch point?*

A corporation could spend millions of dollars on public relations and marketing only to have its whole image sullied by one negative experience around a single touch point of its business. It turns out your invitation isn't just about you personally and how you relate to people. Your invitation filters down to every touch point a client can experience: websites, vendors, business partners, staff, mailings, email, Facebook pages, Twitter messages, and so on. Everywhere your business goes, there it is. All the expensive branding efforts go out the window when the invitation a *particular client experiences on a particular day* is sloppy.

I recently had an experience that brought this idea home. I was suggesting to a client that her event be held at a particular hotel that had an excellent reputation for hosting similar events. My client was adamant about not using this venue, despite its stellar reputation. She told me that in her experience the staff was rude and uncooperative. I pressed the issue because I really felt the venue was ideal. She relented, reluctantly, and eventually had an excellent experience. She later revealed to me that her previous judgment of the hotel was based on a single exchange with a rude doorman some years earlier.

One doorman, one moment in time, one touch point. And it had soured her on the entire establishment. That's how customers think (and how *we* think when *we're* customers).

Congruity Counts

The touch points of the invitation you are offering—all of them—must work in concert with one another and with your vision.

Let's say, for example, that a photography company's branding message is that they provide luxury portrait photography for discerning, affluent families. But their website is cluttered with cheesy images that don't match the marketing message. Even if the product being sold is magnificently artistic, this company will still be a failure. Why? Because its offerings (i.e., the displayed images) don't match up with the invitation.

Along these lines, I actually once saw a sign for a *sign maker's* business that was spray-painted on a bare piece of plywood and read, "Quality Hand-Painted Signs," with an arrow pointing to a rear building entrance. To this day, I wonder if it was meant to be a joke. Who in the world would believe such an invitation when the sign maker can't even make a quality sign for himself?

When potential clients pick up on such incongruity, either consciously or unconsciously, they'll move onto someone with a more consistent message that resonates with them. But imagine the opposite! What if the images on the above-mentioned website had a distinctive, elegant feel? What if the sign maker created a beautiful, hand-painted sign for his business?

> "This may sound picky, but if you are representing your brand always, then the way you dress, Tweet, drive, and live is a reflection of you (which is turn is a reflection of your brand). Don't be all about vintage chic but then dress very modernly. Consistency is important to conveying a brand people want to be a 'super fan' of. You are the determining factor in what your brand is."
>
> —MELISSA OHOLENDT, OWNER, MELISSA OHOLENDT PHOTOGRAPHY

If your invitation is visible in everything you do, show, and say, can you see how that kind of focused and integrated messaging will help you break through the noise of the competition? Can

you see how consistency and attention to detail creates its own gravitational field? It's critical to present *every* potential touch point as an invitation to partake in your business's vision. This mind-set will give you your best chance at making an amazing first impression and generating new business from both existing customers and the friends they refer.

Connection Is What Breaks Through the Noise

Now let's go a step further. What if the owners of the luxury portraiture company mentioned above realized that affluent families expect convenience, so they designed the website's navigation to be simple and elegant? Further, what if the photographer/owner included information about him- or herself on the site, suggesting to the user that they might be friends, perhaps even neighbors, and certainly could run in the same circles? Now a *connection* is starting to form. The client is being drawn in.

A connection forms when a client starts to feel personally about your business in some way.

When your potential client's interest is sufficiently piqued to generate some kind of response, that's when your first real opportunity to form a connection arises. That's when you have the chance to make it personal and make it real. The customer's response can come in a variety of forms, depending on which touch point grabs his or her initial interest. The customer might decide to:

» Step into your shop

» Call your toll-free number

» Click on your web link

» Explore your website

» Send you an email

» Click a "send me more information" button

» Actually read your brochure

» Speak to you at a trade show or event

Once this response happens, what do you do? Rejoice that you've got a "live one" and go straight for the jugular? No. You take the opportunity to make a connection.

By *making a connection*, I don't mean anything complicated or "sales-y." I just mean making a human connection in whatever way feels natural to you and consistent with your brand. Obviously the *form* of the connection you make will vary, depending on whether there is phone contact, in-person contact, virtual contact, or the client is just examining your written or visual materials. But whatever form the connection takes, it should reflect:

» A genuine interest in the client

» A desire to understand the client's needs

» Confidence that you can help fulfill the client's needs (if indeed you can)

» A willingness to help the client, whether or not he or she decides to do business with you

» A warm, informational, and invitational stance

» An assurance (spoken or unspoken) that you are standing by, eager to serve, should the client decide to work with you

If you manage to make a meaningful connection, odds are, you'll eventually be moving on to the booking process itself—if not now, then at some point in the future; and if not with this particular customer, then with someone he or she refers to you.

Please remember, you're not trying to *close a deal* when you make a connection. You're inviting clients to get to know who you are and letting them know that you're ready to help should they be interested in knowing more. Your goal at this stage of the game is to pique interest, that's it.

By taking the "close the deal" pressure off, you can focus your attention exclusively on making a human connection. If you are more interested in people than you are in potential sales, you'll develop a reputation with your clients that will serve you for life. ABC is still the rule, but it's not "Always Be Closing:" it's "Always Be Connecting."

If you can train yourself to enter into relationships with clients without the expectation of a sale, your stock will go up immediately in your prospects' eyes. But here's the deal: You can't fake it. You can't *pretend* to care about prospects' needs while manipulating them toward a sale. You have to be genuine. The idea is to be helpful and interested and to provide an opportunity for clients to choose you when they're ready.

Connections Persist

The old-school approach operates under the unspoken belief that if you are persistent and obnoxious enough, you can control the client's decision to choose you. Not so. You often have little control over getting hired—perhaps you're too expensive or a scheduling conflict makes a particular job impossible. Or perhaps the client changes her plans. What you *always* have control over, however, is facilitating an environment that increases your chances of making a *connection*.

Even if you're *not* the right person for that particular assignment, if a true connection has occurred you can be confident that another opportunity will be coming down the road. That's what happened for my screenwriting friend. The original gig he responded to was not a good fit for him and he knew it. But the *connection* he

made with the studio exec has generated ongoing projects and a mutually beneficial relationship.

What matters—at the risk of being repetitive—isn't that you close a particular sale. It's that you create a bond that will be remembered when the prospect, or someone he or she knows, has a need for a photographer later. Every time you make a connection, that person becomes your free advocate, your free salesperson, your free public relations staffer. Do that enough times with enough people and you've grown your sales force dramatically. By making it your goal to *connect*, not sell, you not only give yourself a shot at the job in front of you but any job this new advocate hears about.

The moment of connection is the most critical part of bringing in new clients, and yet it's a step most small-business owners don't think too much about. They may feel like they've done the work just by getting a chance to give their pitch. They haven't.

Validate the Connection

It's tempting to think that once you've (1) gotten your potential client's attention and (2) made a connection, act three must be the close of the deal. It's not. Since you and I ultimately have little influence on whether a lead chooses us (even if we think we're the perfect fit), "the close" doesn't really have much to do with us anyway.

So, closing the deal isn't your focus. Your focus is on what happens *after* you make a connection. If they hire you (or don't, in fact), *what you do next* is what they'll remember about the whole transaction.

If you've agreed to work together, you want to take an important next step: *validate their decision.* Confirm for them that they made the right choice. Once the handshake has occurred, it becomes easier than ever to connect on a deeper level; after all, they've

already chosen you. So lean in! Take the next step to cement a more bonded relationship.

What are some ways to validate the connection? Again, don't over-think this or make it needlessly complicated. A handwritten note is often all it takes to make an after-the-decision impression. Given how few businesspeople take the time to do this, a little personalized message can go a long way. Another idea is to send the client a thoughtful little "what to expect" list that explains exactly how the shooting assignment will unfold. Or perhaps you might choose to send a small gift of appreciation, such as a coupon from a strategic partner or a calendar with your photos embedded.

Even better, ask yourself if there is a common trait, interest, or relationship that you share with the client. If so, key in on that. Send a link to an online article of mutual interest, with a "just thought you might be interested in this" note. You don't need to overdo it; you just want to stand out enough to make an impression that others don't.

What would impress *you* if you were in the client's shoes? Do *that*. A thoughtful follow-up after you make the deal reinforces the client's belief that you were the perfect choice. And a reinforced belief *sticks*.

And what if the client *doesn't* choose you? Still find a way to reinforce the positive impression you made when you connected with them. Remember, you want to validate the *connection*, not the sale. Since there can be a thousand reasons why a job doesn't come your way, don't just assume the client didn't like you. Again, you can't control the hiring decision, but you *can* control the way you choose to keep the connection alive and vibrant.

Seasoned business owners know how much easier it is to build on an existing client relationship than to start a new one from scratch. Make it your goal to reinforce your client connections so if they had the chance to reconsider, they would go with you the next time.

> "Your reputation is the most important thing you have. You can't buy it. You have to build it, one interaction at a time. It's also very fragile and can be permanently damaged by one careless action."
>
> —ALLISON RODGERS, OWNER, ALLISON RODGERS PHOTOGRAPHY

Ultimately, people want to work with other people they *like*. Research confirms that a feeling of personal connection is the single greatest factor in hiring decisions. If that's the case, then the most important thing you can do is keep reinforcing that you're someone people want to do business with. When the timing is right, the job will come. The real litmus test for success is how many of your clients become evangelists on your behalf.

Now It's Your Turn

As in previous chapters, I'll ask that you do the following exercises.

#1 TOUCH POINT SURVEY (90 MIN.)

In the next twenty-four hours, go to your local mall or shopping area and visit three stores.

Step 1. Make a list of at least ten different "touch points" each company presents to prospective clients. Examples include signage, smells, colors, salespeople, window displays, crowd control, how/if they answer their phone, and how/if you feel welcome.

Step 2. Look at your list and take a stab at articulating what you think each company's big promise to the world is. If you're brave enough, you can even ask the store manager for help on this one.

Step 3. Give each store a grade between A+ and F on how well its touch points delivered on their big promise.

Step 4. Give the store a grade of "yes" or "no" as to whether they've connected with you.

#2 FIND YOUR TOUCH POINTS (15–20 MIN.)

List all of the possible "touch points" you can think of, by which potential customers might first learn of *you and your business*. Remember that you can't control which touch point a customer stumbles onto first, so they're all equally important, whether large or small.

Here are some examples of possible touch points (though likely yours will vary):

» Sign and/or storefront

» Stationery/business card

» Appearance of you or a team member at a public event

» Website home page

» Blog or online forum post

» Ad

» Building exterior

» Recorded phone message

» Live phone greeting

» Email message

» Online portfolio

» Photo in a magazine, shop, or home

You get the idea. Write down every touch point you can think of for your business.

#3 TURN TOUCH POINTS INTO AN INVITATION (30 MIN.)

For each touch point you listed above, come up with at least two ideas for making that touch point part of the *invitation* you are intent on becoming. Think about how that touch point can:

» Communicate your vision

» Embody your company culture

» Be part of the promise you are making

» Carry the look and style of your brand

» Work in seamless concert with all of your other touch points

Finally, and most important, think about how it can:

» Invite a connection with you and your business

Be as creative as you can!

Let's Review

» By knowing your vision and creating a consistent message across all of your touch points, you *become an invitation* and give yourself your best shot of being noticed.

» By *making a connection*, in which the client is free to choose you or not, you give yourself your best shot of moving the relationship forward.

» By *validating that connection*, you turn your customers into fans who will endorse you with their friends, family, and colleagues.

Chapter 8
Shoot Jobs: Clear the Way for Creativity

Finally!

Remember at the beginning of this book when you fired yourself as the photographer and I said you'd need to wait until the book was done to pick up your camera? Well, Christmas came early! I am officially giving you permission to get back into the shooting game right now.

But there's a catch: I want you to keep in mind the main conversation we're having. We're not talking about *how* to shoot, although how you shoot will be influenced by the systems you have in place. There are tons of fantastic resources available to learn *how* to click your shutter, so we're not going to get into that subject here. Rather, we're going to keep our *business* discussion moving forward. Remember, our purpose here is to learn how to adopt the right practices during the assignment phase of your work so your business cycle continues to churn. If you adopt the practices I'll outline here, you'll be giving yourself your best chance to please your clients and move on toward the final stage of our work—leveraging jobs to generate future assignments.

The assumption of this chapter is that you've successfully booked a job and are now in shooting mode. When it comes to shooting, the *business* rule of thumb I encourage you to adopt is this: Get in, get out, and get moving onto the next stage of your work as quickly as you can, without compromising quality. You don't get points for taking longer on a shoot than is needed but you do get points for great work.

Clear the Way for Creativity

If you lack confidence in your systems, you can't even *let* yourself be fully creative. Anxiety over getting everything else done creeps into your mind space and robs you of your imagination. That's why it's so important to build SOPs that you trust. You need to keep your artistic point of view fresh, and that simply won't happen unless you trust your routine operations to do the work you've designed them to do. If you're constantly worried about technical issues, your focus during the shoot will be diffuse and cloudy. Similarly, if you're worrying about the bills sitting on your desk, or whether you sent out an invoice for your last assignment, you'll have missed the moment.

If, on the other hand, you're confident that your operations are working like well-tuned gears, you will have a deeper sense of freedom to explore and do your best work. This is the gift that systematized operations give. You put yourself in a mental position so when the perfect image presents itself, you'll be ready.

This is why so many professionals warn newbies not to forget the importance of familiarity with gear and common settings. If you commit the technical stuff to memory, you won't have to think about it when the perfect composition enters your frame.

By having SOPs in place for both the technical and business aspects of photography, you are freed up to be the photographer you dream of being. Not only will this creative freedom nourish your artistic soul, but it will give you your best chance of capturing

the images that will set you apart in your client's eyes. Which will lead, in turn, to new business. Taking care of business is good for your art *and* your bottom line.

Be Prepared for Anything

I remember when I started shooting I was surprised by how quickly I learned the basics of composition and exposure. Even as I began to understand the relationships between aperture, shutter speed, ISO, and multiple light sources, I was amazed at how powerful modern photo equipment had become. Under controlled conditions, it seemed there wasn't much that couldn't be done with camera gear and a computer.

After a few major mishaps in the field, however, I quickly understood that taking pictures professionally rarely happens in perfectly controlled conditions, especially outside the commercial studio. And even in hyper-controlled environments, there are a lot of practical humps to overcome. Here are some of the challenges you'll likely encounter, no matter which genre you shoot, and suggestions to systematically prepare for them.

CHALLENGE #1: THE CLOCK

Whether it's your light disappearing, a difficult subject who has decided he or she is out of time, a model who's booked for a finite number of minutes, or the availability of the space you're shooting in, the timecrunch is always present. How will you anticipate the pressure of the clock and get the results you're committed to?

How to prepare:
» Plan your shoots carefully. Make sure you know ahead of time what equipment you'll need for every shot, and have it all lined up and ready.

» Pretend you have less time than you do. If you only have an hour, plan as if you had fourty-five minutes. This will give you a time cushion when and if (okay, when) something unanticipated occurs.

» Prepare your subject ahead of time (if you're shooting humans), so you won't waste shooting time covering basic practical questions.

» Snap your priority shots—the shots you absolutely *need*—first, then use any time "left over" for retakes and experimentation.

» Once the shoot starts, relax and stay in the moment. Worrying about the clock *as you shoot* will actually cost you time and will make everyone around you nervous. Staying present to the task at hand and the people you're working with "stretches" time and allows you to get more done.

CHALLENGE #2: YOUR EQUIPMENT

Murphy's Law doesn't play favorites: Gear fails for the newbie and Pulitzer Prize winner alike. What are your plans for when your equipment breaks down?

How to prepare:
» Have backups for every piece of photo equipment that can possibly fail: cameras, lenses, lighting equipment, and even your laptop if you use it during the shoot. The added expense of equipment redundancies can seem like a headache to the new photo business owner, but the peace of mind is priceless. Blowing an assignment because your equipment fails will not only set you back financially but will deal a major blow to your reputation and brand.

» This may seem obvious, but have fresh, fully charged batteries on hand for every piece of equipment that uses them. Make this an SOP of getting ready for a shoot.

» Keep your equipment maintained. If you want to cut trees, as author Stephen Covey points out, you've got to take time out now and then to sharpen the saw. Though he meant it metaphorically, I mean it literally. Well-maintained equipment works better and is less prone to breakdown.

> "Early in my career, I was shooting an event and thankfully was onsite very early. About twenty minutes before the event began, my camera failed. Something went wrong with the shutter. I had no backup gear on site and quickly got very dizzy with cold sweats. I picked up my cell phone and called a friend. I was very lucky. She was fifteen minutes away. I met her on the street, ran back to the event, and was ready to roll moments before things began. I decided at that moment that I could take no piece of equipment for granted and have had redundant systems since then. I maintain my equipment, carry backup gear, backup files, and perform backups on backups. A pro can't rely on luck."
>
> —STEPHANIE LEBLOND, OWNER, STEPHANIE LEBLOND PHOTOGRAPHY

CHALLENGE #3: THE ELEMENTS

From shooting landscapes to sports to weddings to nesting birds, every photographer who works outdoors comes up against the elements. Will foul weather throw you off and destroy your shoot?

How to prepare:

» Routinely do a weather check, ahead of time, for your shooting location. There are several great online weather resources, such as Weather Underground, that provide forecasts for specific locations.

» Plan ways to make the weather work *for* you rather than against you. Let's say, for example, you're shooting a sports event. Can you think of ways to make the drama of the clouds accentuate the drama on the field? Can you find ways to make your subjects "glow" against a rainy backdrop?

» Have foul-weather gear on hand at all times.

CHALLENGE #4: THE PHYSICAL SETTING

Beyond the weather, sometimes the physical location can present unanticipated hurdles—challenging lighting conditions, limited access to needed areas, visual and sound distractions, competing activities, etc. If you are a photojournalist or nature photographer, the environment might even present physical dangers.

How to prepare:

» Whenever possible, scout your location ahead of time. If you can't make a separate trip to do this, show up early for the assignment and take time to "case the joint" and anticipate any environmental challenges.

» To the extent possible, make sure the space is "yours" for the duration of the shoot and that there won't be any other competing events and activities going on.

» Do a "dress rehearsal." Physically walk through the assignment in the actual space. Possible problems will become very clear to you this way.

» Think about any equipment or supplies that may help you function better in the given environment. This can range from mosquito repellent to sunscreen to wading boots to a stepladder.

CHALLENGE #5: YOUR CLIENTS/SUBJECTS

Even the kindest clients and subjects can have bad days. This is especially true if you are doing event photography. You are probably

shooting one of the client's most important life moments. He or she may be under a great deal of stress and may be emotionally fragile or volatile. But, even beyond that genre, every client can feel stress and dump it on you.

How to prepare:

» If you're shooting people, make a connection with them before and during the shoot.

» Spend a few minutes before the shoot getting into a "loving, serving, and forgiving" frame of mind. This might involve meditation, affirmations, or simple self-talk, depending upon your belief system.

» *Anticipate the worst* from the people you'll be dealing with, and be prepared not to react defensively. Your job is to be a calm and competent presence, not just a person behind a camera. *Never* get in an argument or a defensive posture with a client.

» If you know you lack people skills, by all means, get some coaching or training in this area. It may be one of the best business investments you'll ever make.

CHALLENGE #6: THE COMPETITION

If you're shooting a major sports, celebrity, or news event, you'll likely run into competition when you show up for the shoot. Other shooters will be trying to get the best angle and the best shot.

How to prepare:

» Be prepared to stay calm and avoid the "me against you" mindset. If your inner state is one of cooperation and "there's room for all of us here," you will bring that same attitude out in others.

» Plan the shoot with the competition in mind; don't let it surprise you. What are some ways you can position yourself away from the crowd? How might you get the unusual or

unique shot when everyone else is focused on the "obligatory" shots and standard angles?

» To the extent possible, make connections and form relationships with the other shooters. When everyone helps one another, everyone gets what they need.

» Show up *very* early!

> "When I was shooting the men's hundred meter final at the Athens Olympics, they provided something like seven-hundred photo credentials to some of the best sports photographers in the world. Everyone wanted the right angle, and the only way to get it was to claim your territory. The race started at 10 p.m. It would last no more than ten seconds.
>
> By 5:00 AM, I was first in the stadium setting up my gear. I'll never forget how pissed off Bill Frakes from *Sports Illustrated* was when he walked in fifteen minutes later and saw that someone beat him to the spot, especially since I was the young guy and he'd been around a while.
>
> The thing is, photographers aren't great just because they have a good eye or are driven by an internal artistic drive. What makes the greats great, over and over again, is they work their ass off and they never stop. I knew what I was up against and I was ready. That is the difference."
>
> —VINCENT LAFORET, PULITZER PRIZE WINNER AND CANON EXPLORER OF LIGHT

CHALLENGE #7: IMAGE LOSS AND/OR CORRUPTION

One of the great worries of the pre-digital era was whether your images were actually being captured on film. Film could be faulty, and you would never know it until you had the shots developed. That's less of a concern in the digital era, but still you need to make sure the images you capture survive intact until they are ready for post and delivery. Typically your images will be sitting on CF cards in your camera, but CF cards are not totally trustworthy

at securely collecting things. They can be lost, accidentally reformatted, or corrupted.

How to prepare:

» Have a secure means of collecting your files post-capture. Bring along a laptop or notebook computer, and back up your files immediately after the shoot. If you can back them up to a remote server, all the better.

CHALLENGE #8: YOURSELF

The "war" isn't just out there; sometimes it's *in here*! Fear, insecurity, and worry can throw anyone's day off. Will the subject show up on time? Will you be able to get the "money shot" when the perfect moment arrives? Will your equipment work? Anxiety can be crippling if you aren't prepared for it.

How to prepare:

» Recognize anxiety as a serious challenge, (if indeed it is such for you), and learn some stress-management techniques. Traditional psychology and energy psychology offer a wide range of stress-diffusing methods, from meditation to mantras and prayer. Find one that works for you and make it part of your preparation ritual.

» Review ways you have gotten in your own way on past shoots and take steps to avoid repeating these self-defeating behaviors.

» Practice a ritual of "surrendering to the process" as you begin your shoot. Now is the time to trust your SOPs and your advance preparation and step into the flow.

No one can have a contingency plan for every possible obstacle, but you can do yourself a huge favor by considering ways to deal with worst-case scenarios as well as how you plan to do your best work.

This kind of best-case/worst-case thinking often results in the capture of epic images. For example, the combination of learning a key bit of personal information about your subject and having backup camera equipment on hand might just save the day for you. The smart choice is to *visualize* what you want to do and show up ready. That way, when problems do happen, you'll have the best chance of getting the shot despite the challenges.

SOPs Are A-OK (LOL)

When it comes to preparation, it's important to have SOPs—those basic, step-by-step plans for getting things done that were introduced in Chapter 6. SOPs give you a solid fallback position so you can quickly get your head back in the game if you're thrown off course. Even when anxiety has you all wound up, SOPs for shooting help you remember what you need to do next in a reflexive sort of way.

One great way to keep SOPs locked in your mind is to use acronyms. For example, most everyone knows that KISS stands for "Keep It Simple, Stupid." KISS works because it sticks in the mind. By the same token, shooting acronyms can be great focusing tools.

Here's an example: CERFS is an acronym that stands for "Compose, Expose, Recompose, Focus, and Shoot." For new photographers, this little mnemonic can help bring the right questions to mind, in the right order, to simplify the capture process. Let's say you're shooting a backlit subject outdoors near sunset. The light is failing. Your subject is impatient. You're having a hard time getting your camera to do what you want it to. All of a sudden your flash setup falls over and breaks. The unprepared photographer might panic. With CERFS in mind, however, you can mentally slow things down and walk through your five-step portable SOP.

First, you decide what kind of composition (C) you prefer. What do you want inside the space you're about to capture? Like a movie director framing a scene with his thumbs and forefingers, visualize the scene in your mind. Then just make sure you have the right lens on your camera to get that result.

Next, with your composition selected, set your camera to expose (E) your image properly. Remember, the lighting is tricky in this situation. If you were thinking you could switch to Aperture Priority or some other preprogrammed mode, you might find yourself in trouble. The light in the backlit scene would probably trick your camera into underexposing your subject. But no need to panic.

You already know how you want to compose the shot, right? Why not leave that spot, walk up to your subject, and, with your hand-held or in-camera meter, measure for the best exposure given your subject's skin tones (if your subject is a person)? Then simply set your camera to Manual, dial in your settings as the meter tells you to, and you're good to go. Even if the backlight blows out your highlights, since your flash setup is broken, you will be exposing for the right light relative to the focal point on your subject.

Third, you recompose (R) your shot. Just step back to where you were before checking your exposure settings.

Following that, select your focus point (F) and shoot (S). The heavy lifting all happened in the first two steps of composition and exposure. The genius of this plan is that it's simple. The SOP, cued by the acronym, breaks down the process so you never forget. That's the job of SOPs—to break complex processes down into concrete steps so you don't have to think things out from scratch.

Nature photographer Scott Bourne has suggested some other simple acronyms to help you.

» SAS: Subject/Attention/Simplify (to maximize the effect of a single shot)

1. Define a clear **Subject**.
2. Draw **Attention** to that subject.
3. **Simplify** the photo so the subject stands out.

» EDFAT: Entire/Details/Focal length/Angle/Time (to tell a story with a series of photographs)

1. Establish a wide shot that shows the **Entire** setting.
2. Get close and capture both horizontal and vertical **Detail** shots.
3. Move in and out. Change the **Focal length** for different looks.
4. Experiment with various **Angles**.
5. Utilizing the element of **Time**, try a different shutter speed or shoot the subject at different times of day.

» LUDA: Look Up/Down/All around (to find more angles)

1. **Look Up**.
2. Look **Down**.
3. Look **All around**.

Whether you like any of the suggestions above or decide to create acronyms of your own, be sure to *practice* your SOPs before the pressure shows up so that you will be ready for whatever comes your way. When you build this functional "ready for anything" practice on top of the foundation of getting your business house in order, you should have the infrastructure in place so when things go wrong on the job you'll be well prepared.

But keep in mind that these are the just the most basic standards to which you should be holding yourself. Go one step further by preparing *more than anyone else*, so you can consistently go for the image that seems just out of reach.

Make the Client Experience the Core of the Shoot

Thoughtful preparation and a great set of working SOPs are essential elements for taking the anxiety out of a shoot and putting your attention where it belongs: on maximizing your creative attention. Good photos certainly lead to more work opportunities, but it's *the way you treat your clients* during a shoot that will probably determine, more than anything else, how much new business each assignment generates.

Some say the client is always right. Unfortunately, that's not true. Sometimes they're dead wrong, unreasonable, insensitive, and a giant pain in the butt. But regardless of how they behave toward you (in my experience, they're usually fantastic), they are the main stakeholders you've been contracted to serve.

Customers are also the linchpins to commerce. Learning to treat them well will give you your best chance at repeat business. It's not fruitful to get caught up in whether the client is right. Instead, simply commit to honoring them as royalty.

A number of factors during a shoot can contribute to a great client experience. If your subject and client are the same person, as they often are in portrait work or event photography, be sensitive to how they're feeling on the other side of the lens. Work to make them comfortable. When you're shooting an event, you should be like a great waiter at a nice restaurant—invisible and unobtrusive but constantly attentive to feelings of the client and ready to move in and make adjustments at any moment.

How do you ensure that clients are both comfortable with the experience and thrilled with you? Put yourself in their shoes and look for opportunities to serve. I'd like to share a couple of stories from fellow shooters that illustrate the value of treating customers with respect, attention, and generosity of spirit. As you'll see, by making the *client experience* the core of the shoot, not only does the client benefit, but the photographer reaps rewards as well.

"I was taking senior pictures of a high school boy. His mother was there, too. They happened to be a pretty overweight family, and the mom in particular seemed a bit self-conscious. As we were finishing up, something inside me said I needed to involve the mom somehow. I invited her to step into the frame so I could get a shot of her with her son.

She complained that she hadn't put on makeup or done her hair. I told her she looked pretty (which she did) and that if she didn't like what we came up with, we'd just delete the files. She obliged.

When they came back to the studio a week or so later, I played a slideshow of the shoot for them. The mom immediately started crying. In fact, they told me later that her son plays the DVD of the slideshow for everyone that comes to their house. Not only did she order photos, a panoramic, and an album for him, but since that time, I have also shot her younger son's senior pictures, their extended family's portrait as well as designed their holiday cards.

She said they had never had a family portrait done before. She was waiting for the day when they all might be skinny. For whatever reason on that particular afternoon, they decided being alive and together was worthy of a picture."

—VICKIE FREY GONZALES, PHOTOGRAPHER

Every time I read this story, I'm struck by Gonzales's intuitive awareness of what needed to happen for this client. Those who adopt this tradition of caring for the client enough to listen for their unspoken needs will be well rewarded for their efforts.

"Last fall, my assistant and I had just finished photographing an all-day event. I got a message via Twitter asking if I was available to come shoot a different event that evening. It turned out that the photographer that was booked for the person's wedding had not shown up and no one could reach her. Fortunately, one of the groomsmen and I had a mutual friend (the one that contacted me via Twitter).

Since we were already dressed, [had] our gear packed, and since a photographer not showing up at my wedding would have been my own worst nightmare, we

made arrangements for fresh memory cards and batteries to be brought to us and we were off. The wedding was supposed to start in fifteen minutes, and we were fourty minutes away—so they held the ceremony until we got there.

We walked in, ready to go. No questions asked other than introducing ourselves to the bride and her parents. The groom was already all set to walk in to the ceremony so we didn't meet him until afterwards. The first thing the parents asked me was how they needed to pay me, and the father of the bride was ready to pull out his checkbook. I told them to not worry about it and that the important thing was that his daughter was about to get married!

We met up three weeks after the wedding when the photos had been edited and I showed them a slideshow in person. They were so grateful that we had been able to come out and help them! I gave them a custom proposal for their wedding to cover the photography time plus a wedding album.

In the two years since that wedding, I have booked five direct referrals from that wedding. Some people might call our policy, 'Do whatever you can for your customers'—I just think of it as treating my clients the way I'd want to be treated."

—CHRISTINE TREMOULET, OWNER, BOUDOIR MON CHERI

What Tremoulet did in this case can't be done in every circumstance, but when opportunities like this arise and we seize them, we spin relationship gold. All Tremoulet needed to do was show up and be willing to defer discussions about payment and she was the hero. The noteworthy part of this story is not that she had the opportunity; it was that she took advantage of it.

The power of treating your clients as you would like to be treated cannot be overemphasized. Of course, there are a great many cases in which your client is not the subject of the shoot and, in fact, may not be present at all. That does not diminish the importance of creating a great client experience. It simply means that the experience you'll want to create will be different.

If you are doing editorial or commercial work, for example, your client may be an ad agency art director or a magazine editor.

Forging a personal connection with this particular client may *not* be the key to creating a great client experience. Why? Because that may not be his or her *felt need*. The felt need of the art director may be simply to get great images with a minimum of direction and fuss. In this case, your job, no matter whether you're a Freelance Photographer or Signature Brand, is to deliver great images with a minimum of fuss. The felt need of the busy newspaper editor may be to get dynamic and timely images that capture a unique angle on a story no one else has snagged. In this case, delivering a dynamic, unique story shot, with a quick turnaround, may be the key to creating a great client experience.

Also, in many cases, for the hirer, time is money. So think about your efficiency as well as your quality. Develop a reputation for getting the right shot quickly and painlessly. Although you may perceive your role as critical (and it may, in fact, *be* critical), remember that the client has hired you to get in, get the work done, and get out. Your compensation and reputation are connected more to output than time served. Sometimes getting the job done fast might be just the ticket to creating a great client experience.

Just remember, it's all about the felt need of the client, not about what *you* consider important. Your ability to capture an emotional moment may be more important *to the client* than your producing a gallery-quality image. Your ability to snap a front-page image at the scene of a natural disaster may be more important *to the client* than your willingness to work cheap. Develop a reputation as someone who always does what it takes to fulfill the *client's* needs, and clients will come back to you again and again.

Now It's Your Turn

Now let's return to the preparation phase with an eye toward getting *you* prepared. These two assignments will help.

#1 CREATE YOUR OWN SOP ACRONYMS (1–2 HOURS)

Keeping in mind the CERFS example on page 180, take a stab at coming up with some shooting SOPs and acronyms that will serve you. This will help you and those who work for (or with) you to develop foolproof plans for success when you're taking pictures on behalf of your business.

Step 1. Lay out the basic steps in a chronological line. For example:

1. Pack your camera gear.

2. Get the address and logistics for the shoot.

3. Arrive and set up your gear.

4. Visualize the shoot.

5. Take the pictures.

6. Repack your gear, back up your images, etc.

Step 2. For each phase in *your* capture process, create an SOP that can be summed up as an acronym (bonus points if the acronym spells a relevant word, such as BLINK or SNAP).

As you do this exercise, remember not only to make your processes efficient but to ensure they reflect your business vision and the customer experience you are committed to creating. Also, picture your worst possible day and everything that could go wrong. That way, you can be prepared to overcome any challenges that may arise.

#2 TRIAL RUN (APPROX. 1–2 HOURS)

With your SOPs from assignment #1 and your camera in hand, go through different areas of your home, indoors and outdoors, and

look for a wide variety of lighting situations and environments. For example:

» A fluorescent-lit garage

» A candlelit bedroom at night

» A natural-lit sunroom or greenhouse

» A dark attic

» A kitchen with overhead incandescent bulbs

» A cellar with dim, indirect natural light

» A living room with shaded lamplight or track lighting

» A room with patterned wallpaper

» A room with bright colors

» A garden under cloudy skies

» A sunny street scene

» A rainy woodland area

» A nighttime street, etc.

Include your neighborhood, too, and spread the assignment out over a few days. Use your SOPs to capture the best possible shots in each environment on your list.

When and if you discover that you don't have appropriate SOPs, or your SOPs fail to deliver the best results, come up with new SOPs that will help you shoot with more predictable results in each of these situations.

If you take it seriously, this assignment can be an important step in helping you prepare for any situation you might encounter on a real shoot.

Let's Review

» The way to shoot your best is to prepare for the worst before your shoot.

» Your client's experience is the most important aspect of a shoot. Treat clients like royalty.

» The client's felt needs, not yours, are what will determine your success on a shoot and as a businessperson.

» Once you've done the work to put effective SOPs in place, you've freed yourself up to create.

Chapter 9
Leverage Your Work: Make the Cycle Complete

Delivering the Goods

Now the question arises: How are you planning to "deliver the goods"? With the assignment shot and processed successfully, you're free to decide. It turns out that what you do after the shoot can be even more critical to the growth of your business than what you did to attract clients in the first place and what you did during the shoot itself.

What are the most important things to keep in mind after the shoot? At the very least, you want to deliver to the client exactly what they've contracted for in a timely manner. If you don't do that, then not only have you blown the opportunity to build great business traction, but you've created a negative impression and are now in backsliding mode. Beyond simply fulfilling your obligations, though, there are ways to enhance the delivery of the product that add value for your client and can help to (1) promote your brand for future work and (2) increase sales from the job you just shot.

In some cases, as when you're a hired freelancer, the delivery of your images has been predetermined contractually and there's

not much "extra" you can do. In that case, deliver what you've done to the exact specifications requested. If you can get the images to your client ahead of deadline, even better. Embed a message of service and professionalism in all of your post-shoot communications. The point is to make a positive impression so that in the future the client will think of you again. I'm constantly amazed at how many businesspeople seem more focused on what they are *getting from* the client than what they are giving. In the long run this approach doesn't work for either party.

Giving the client more than he or she bargained for, on the other hand, creates positive results for both parties.

Under-Promise and Over-Deliver

One simple way to give more than expected is to "under-promise and over-deliver." That is, promise a little less and a little later than you really think you can deliver. Restaurants often do this when they tell you it's going to be a thirty-minute wait for a table and then seat you in fifteen minutes. By seating you earlier than expected, they set you up to have a positive orientation toward the meal. In your case, if you think you can probably have the print ready by Thursday, promise it on Friday and then deliver it a day early.

Often businesspeople, in their zeal to snag business, do exactly the opposite. They promise the moon, hoping to win the client's business, then make excuses as to why they can't deliver on time and as promised. This is a short-term and self-defeating approach. Yes, you may succeed in winning a single assignment this way, but you are dealing a crushing blow to your future business. Not only will the present client be reluctant to use you again, but he or she will also fail to spread positive reviews, which are the best way of generating new business.

The "under-promise and over-deliver" method is one that any kind of photographer can use. It must be practiced with caution,

however. You do need to present an appealing and timely solution, up front, for the client. Otherwise the client won't choose you. Also, you want to avoid being manipulative—deliberately telling the client one thing when you intend another. What I really mean by under-promise and over-deliver is to err on the slightly conservative side with your delivery promises, then work hard to beat your own estimates. Surprise yourself *and* the client.

Throw in something extra, too. A dash of unexpected quality. Surprise them by presenting the product in a "premium" way by adding special packaging or framing. We have so little control over what people will say about our work as artists, but what we do have power over is in what *we* do and say.

> "In my photography business, I focus on commercial and editorial work. Through word of mouth I was contacted to photograph a couple's young daughter. I normally don't consider portraiture my genre, but I had come highly recommended by a previous client and was grateful for the potential business.
>
> When the work was done and I presented them with a slideshow of their daughter's shoot, they ordered several prints. The mother kept referencing one particular picture. Her face would light up whenever she talked about it. I made a mental note and finished the transaction.
>
> After what I thought was going to be the only order of the prints, I thought it would be nice if I did something special. I secretly ordered a large mounted print of the image the mom liked so much and had it delivered with the order. Not surprisingly, the phone rang immediately after everything arrived. I had a feeling she'd be grateful, but I really had no idea how big a deal this one little choice would be. In addition to the thanks, the couple decided to order even more prints and other products. The word of mouth spread. Later, they called again and ordered a fairly large order of books of the entire session as surprise gifts for their entire family (apparently I had started a trend), which in turn led to more referrals for other print orders and more photo sessions.

> I kept thinking: if I had not paid attention to the mother during the initial print consultation and decided to go a bit above and beyond with the free surprise print, I would not have reaped the benefits of more sales and bookings. But the more I thought about it, the more I realized that the benefits weren't the reason I surprised them. I genuinely cared about this family and their felt needs. I think the more I do that the more the rewards will come my way, even if it's just a heartfelt thanks. I just like making the client feel special."
>
> —CHASE GUSTAFSON, COMMERCIAL/EDITORIAL PHOTOGRAPHER

Make Your Products the Solution

When you're under a very specific contract with an employer, you may not have much direct opportunity to leverage the delivery process to generate more business. In other cases, though, you have plenty of leeway to be creative. Perhaps the client bought a package of products, as often happens with senior portraits or wedding photographs. In those cases, seize the opportunity to create value-adding products that can generate more sales right on the spot.

Being solution-minded is crucial, especially if you want to generate more work in the future. If you're not careful, you can spoil a great impression by doing too much self-promotion. The secret, as always, is to make a connection with the client and keep the focus on his or her authentic needs.

The tricky part is the way you pitch these products to the client beyond the original agreement. You want to maximize sales without coming off as a salesperson. The best way to do this is to take your focus off sales and put it on the relationship. Spend some time with the client and explore, with genuine curiosity and a problem-solving eye, additional needs the client might have. How can you solve these needs with the images you've shot?

Let's say that in talking to your client, you learn that he or she is looking for a special gift for Mother's Day or an anniversary. A framed print of the client's child, spouse, or garden might be the perfect solution. When you answer actual needs with your products, your clients perceive you as their *advocate* rather than a sales hustler trying to squeeze another nickel out of them. If your clients believe you are truly providing opportunities for them that solve genuine problems, they'll *thank* you for the up-sell, rather than feel resentful and used. The secret is to do it honestly.

> "Before I was a nature photographer, I shot portraits and weddings. My first bookings came as a result of offering solutions, not products. I provided services for my clients like spec sheets that would visually show how big prints would look in their home. This made it easier for them to see what I was selling and say yes. By proactively solving real problems for your clients, you will almost always sell more."
>
> —SCOTT BOURNE, WILDLIFE PHOTOGRAPHER

When I got married fourteen years ago, my wife and I did not have very much money. Our gifted and sensitive photographer knew our predicament and chose not to try to sell us a wedding book. As a result, we never were invited to purchase one and lived with a proof book as our album for over a decade. While I appreciate our photographer's sensitivity, in retrospect I would have preferred to be offered at least the *option* of trying to stretch my dollars and have that book made. It would have served my family to have it.

I did, in fact, finally buy a wedding book ten years later, but my family missed out on many years of enjoying it. I don't blame the photographer for this; I'm simply pointing out a missed opportunity for both of us. By assuming his up-sell would have been a burden to us rather than a long-term solution, we both lost out on something useful.

Offering clients ways to have their needs met is not selfish. By inviting clients to get the most out of the images they hired us to shoot, we actually serve *them*. By keeping "solve, don't sell" firmly in mind, we can simultaneously explore expanded sales *and* promote trust with our clients. The trick is to make sure they know that we have their best interest at heart when we offer them products to purchase and to never, never *pressure* them to buy. Our attitude should be one of great appreciation, whether they opt for the smallest possible selection of products or something much larger.

The Sales Psyche

As I suggested in an earlier chapter, there's something in the human psyche that resists being sold to. I don't know anyone who genuinely enjoys being tricked, bullied or cajoled into buying something…especially something they don't believe they want or need. As business owners we can read all the books in the world about perfecting our sales technique, but if our intention is to *persuade* people to buy from us, we'll do nothing to encourage repeat business. In the long run, we will succeed only in leaving customers feeling, well…sold to.

Everything changes, though, when the client makes the shift from being sold *to*, to wanting something they don't have. That happens when the company's representative *listens* to the client, filters the conversation for needs and problems, and offers solutions—even when those solutions don't immediately benefit the company. Then the client doesn't feel *handled*, but cared for.

The classic example for me is when I'm about to make a purchase and the sales agent advises me to hold off because a sale is coming the next week or suggests I purchase an alternative that might be a better fit but cheaper. Sometimes the agent might even recommend a competitor's product if it will better serve my needs. The store may lose a little money in the short term, but it has locked me in as a loyal customer for life! Why? It has earned my

trust. This is why I believe you and I should spend most of our pre- and post-shoot encounters with customers doing nothing but creating solutions for them.

Let me be absolutely clear on this point: You should spend *zero* time trying to sell anyone on anything. Isn't that a relief? Even if you're successful at manipulating a client to buy, you'll lose in the long haul. Not only will clients fail to come back, but as they awaken to feeling manipulated, they will spend their energy discouraging others from purchasing your services.

Now that the shoot is over, you are in a prime position to validate the client's choice by offering additional products that solve problems for them. If you focus all your energy on that, rather than trying to generate a one-time sale, you'll be serving your business best.

The custom of solving and not selling will always leave you feeling that you've served your customers well. And that makes for better sleeping at night. It also sets up the best conditions for customers to become raving fans.

Offer Products That Promote

Your "solving" relationship with the client is a powerful tool for generating long-term business. But you also have another ally that can't be overlooked: your products. If your products deliver on the promise your company has made and solve problems for the client, the client will feel well taken care of and will trust your company with future business.

If your products also promote your company in some way, you will empower your current clients to become ambassadors of your brand—that is, if you package your message gracefully. You must strike a fine balance between fulfilling your promise to your customers and reminding them it was you who created it. Do this effectively and gracefully and your embedded promotional efforts will be an added value to your product. Do it poorly and you'll cheapen your hard work.

By the way, when I use the term *product*, again, it can refer to the images you sell, in combination with the unique way you deliver, print, frame, and package them. It can mean your unique photography services. It can also mean ancillary products related to photography that you might choose to invent and/or market. Whatever it is that you sell.

> "Offering products that are promotional vehicles is just killing two birds with one stone. If your client is happy, they will show all of their pictures to everyone they know. Make it easy for them to do so."
>
> —HANSSIE TRAINOR, OWNER, HANSSIE TRAINOR PHOTOGRAPHY

The fact is, today's products are no longer exclusively about function; they are also about the designers and companies that create them. For better or worse, products are statements about the way consumers wanted to be perceived by others. Want to be known as wealthy, discriminating, athletic, eco-conscious, intelligent, thrifty, or style-forward? Choose the right label and advertise yourself! Wearing logos on our sleeves is just an easy, shorthand way to declare our values or send a message about what we want others to think about us.

From a branding perspective, the implication is that the products we sell aren't just deliverables that objectively serve a want or a need. Products are messages as well as the agents of our marketing efforts. As CEOs of our photo businesses, this dynamic has a lot to teach us about the products we sell and what we hope they will do for our companies. It's the *meaning customers associate with our products* that deserves our careful attention. Think about an iMac. Think about a Saab. Think about a pair of Timberland boots. A Fender guitar. A Calphalon pan. A Frisbee. A pint of Häagen-Dazs.

As you begin to think about the products your photo business should be creating and selling, go back to the well of your vision,

one more time. Once you've committed to staying true to your vision it's relatively simple to offer products that promote your company. But if you don't let your vision guide you, you will be tempted to offer all sorts of products that might be interesting to you but won't promote your brand (and ultimately won't serve the client either). Product and vision, if paired correctly, should create a perpetual feedback loop: Vision gives birth to product, which leads the customer back to your vision. And so on.

The Catch: Don't Let Your Marketing Show

When it comes to selling products to promote, two mandates can pull us in very different directions. The first is to sell more stuff. The second is to never lower your value by promoting so overtly that your marketing begins to reek.

I fell prey to the latter mistake in my early days. In the slideshows I would display at events, I would prominently feature my logo and watermark, as well as a splash screen showing my company info. I soon learned, though, that some customers resented this intrusion of self-promotion at their event. I decided to remove all the branding visuals and let the product be its own advocate.

The best way to satisfy both mandates above is to launch a product that appeals to your market *and* is on message with your brand. Let the product express your vision elegantly, without your needing to explain it. Does a North Face sleeping bag need to explain itself or the vision behind it? How about a Lindt truffle? How about a Tempur-Pedic mattress?

The product should flow cleanly out of who you are and the promise you are making. If you stay true to that, then you won't need to bury it in layers of marketing hype. Yes, you can tell the market the problem you are committed to solving, but if your product carries the right style, quality and function, you won't need to gild the lily.

When I stopped displaying my company info in my slideshows, for example, I generated more, not less, interest in myself and my products. Potential customers began actively seeking me out, motivated by the quality of the work, not the overt marketing messages.

Vehicles of Emotion

Products that tap into the human senses—like music (sound), perfume (scent), or, in our case, pictures (sight)—have a unique power that not all products enjoy. They can transport us to a different place and time. They trigger deep feelings we can't always explain.

There are times, for example, when a woman will walk by me in the mall and I'll catch the scent of her perfume. As soon as it registers, I am transported to seventh grade when Marla Brown gave me my first kiss. Now and forever, that smell will take me to that exact moment and the feelings that came with it. The same can be said of songs on the radio or images like that picture of me and my dad—they tap into something deep within.

It's helpful when we view the products upon which our images travel as *emotion vehicles*. Even if our pictures are of nature or inanimate objects, the power of the frame offers escape, like a portal to a different land.

Thus, the *way* in which you deliver your images can make a major impact on your clients' experience. If your aim is to *take* your clients somewhere in your particular time machine, it makes sense to think carefully about the delivery mechanisms.

» Does an electronic delivery method resonate best with the type of images you create?

» How about printing the image on a 3-D object, such as a piece of wood?

» How about a nontraditional surface, such as textured paper, glass or fabric?

» For framing, how about something unexpectedly spherical? Or perhaps sea-weathered pieces of old window frames? Pieces of rusted machinery?

Try not to limit your imagination to what has been done before. In our era of cheap technology (you know, the cheap technology that's killing photography?), mixing media is easier than ever. Greeting cards can now talk and play music. Electronic picture frames can show shots in sequence. Video clips can be embedded in virtually any online graphic as well as in many real-world objects. So think outside the frame.

Steve and Jen Bebb of Vancouver, British Columbia, for example, had been running a successful wedding photography business for years, but they began to feel they were missing something. One day in 2009, in a brainstorm, they realized how powerful it might be if they could capture what was said throughout the wedding day as sound files, then play them as "accent pieces" to accompany the images. They started experimenting with these collected sound bites without telling their clients what they were up to.

When couples came back to the studio for their "premiere," they were expecting to see their images set to music. But when they actually heard their own voices saying their vows, as well as loved ones blessing them through toasts and spontaneous remarks, clients were often left in tears.

The Bebbs's clients appreciated the innovative gift of hearing recorded speech from their weddings. But what really blew them away was that this extraordinary gift had no strings attached. The Bebbs's policy did not involve a bait-and-switch tactic of sharing the show and then taking it away unless the client purchased it. Rather, their policy was to give this "above and beyond the call" experience to their clients for free.

Thanks to their first attempt at employing their "audio+" policy, they have received six solid leads, four of which have already booked. The original client also ordered three parent albums, two wall pieces, and copies of their "premiere" program on Blu-ray, for a total after-wedding sale of over $10,000. In addition, the Bebbs then designed the clients' double-volume wedding book, adding another $8,000 upgrade. Not bad for an experiment in outside-the-frame creativity combined with customer-centric thinking.

I wonder what a similar idea could yield for you.

Deliver in Ways That Forge Connections

Although you can't control how clients perceive your images, there are a few helpful practices you can keep in mind as you deliver products. If done well, they can enhance your clients' experience and open the door to deeper connections.

ENHANCE THEIR EMOTIONAL EXPERIENCE

If possible, control the environment in which your client first experiences your images. This is tough to do with online proofing—though you *can* play music and control the background graphics—but easier in live environments. Many portrait photographers, for example, recommend that proofing happen in person to limit potential distractions for the client. In the studio, you can control the lighting, the sounds, even the scents. Don't be afraid to "set the mood," according to your brand and the effect you want to produce.

Even if the client is viewing the proofs at home, do what you can to slow the experience down. A common practice is to create a slideshow on DVD and set it to music. Clients who receive their images in this way are likely to remove distractions on their own, treating it like a movie they might watch on TV.

DON'T INTERRUPT

When the client is first viewing the images, avoid interrupting. Even if they don't seem to be experiencing them in the way you'd wish, let them do it their way. It's best to avoid controlling the presentation.

I had an experience that drove this point home. I had created an "instant slideshow" of a wedding and was showing it at the reception. I was sad to notice that the bride didn't even pause for a moment to see what I had created and was tempted to urge her to experience the slideshow before she left for the night. Thankfully, I resisted.

Later, I decided to put the slideshow on my blog. She sent me an email about an hour after that, on her wedding night, saying that she was crying joyfully at the foot of her bed with her new husband. She had just finished watching the slideshow multiple times and credited my presentation for helping her realize what had just happened.

It turned out she wasn't ready to "go there" at the reception, with everything else that was going on. But when the pace slowed down and she checked it out on her terms, it was perfect.

MAKE IT EASY FOR THE CLIENT

There is a lot of debate about making image files accessible to clients. I understand the argument. But the fact is, clients in general seem to be developing the expectation to have quick, free access to some version of the images you create. I'm all for copyright protection, but you could be missing an opportunity if you fight the wrong battles.

My advice is to leverage the dynamic in your favor. Why not give a set of tastefully watermarked, low-resolution images to your client as a gift? If they or anyone they know wants the better-quality versions, they can purchase the hi-res images without the watermarks.

If selected images are received as gifts, your client will likely work hard on your behalf out of gratitude. As you further leverage social media sites like Facebook, you'll be amazed at the kind of buzz that's possible when clients get behind your images. You don't have to give away the farm, but making it easy for your client to brag about your work is the best promotion you can buy.

Leverage the New Media

This brings us to the final topic I want to discuss in this chapter: leveraging the new media. There's still a lot of misunderstanding as to how to leverage one's work through new media, specifically online. So let's talk about it for a minute.

It's helpful to view social media sites like Facebook, Twitter, Vimeo, and YouTube not as places of *consumption as an end user* but instead as *relational distribution channels for artists creating content*. That means old forms of marketing need to be abandoned, not just retooled for a new medium, as many advertisers are still trying to do.

This is no small thing to realize. It starts by understanding that most experiences on the Internet are built *for the consumer*, not the seller. Consumers love getting access to whatever they want, whenever they want it. "If it's digital," the consumer unconsciously seems to feel, "I should have access to it when I want it." Many people go so far as to feel entitled to it. And yet they *don't* want anything shoved down their throats.

Where does that leave content producers who need to make a living?

The reason I say we ought to view social media as *relational distribution channels* is that these channels need to be used delicately. No one likes being force-sold (spam) or having their online experience hijacked by ads and involuntary detours to advertisers' sites. But most of us *do* appreciate trustworthy recommendations and honest sharing. The goal as content

producers is to create great content and then share it with *those who've told us they want to know what we think.*

This is where that feeling of entitlement can help you get the word out about what you've created. Consumers are eager to consume quality content. There is an audience, and you have the power now to reach them. But you have to invite and *be* invited, rather than bombard.

Our job, in the words of Chris Brogan, is to be "trust agents," or in the words of Seth Godin, to "earn permission to market," rather than interrupt to market. The former is what friends appreciate. The latter is what consumers resent. My job as a creative then is twofold: (1) Create great content and (2) earn trust so I can share it unencumbered through new media. It's all about invitation.

With a proper mind-set as to how to leverage online relational distribution channels, the next step is to choose the *best vehicle* to share your creations. The vehicle you choose depends on the product you're sharing, of course.

For example, an event photographer might choose to upload images to their Facebook page and invite clients to (1) become friends and (2) to "tag" tastefully branded images with participants' names in their social network. This way many new people can gain access to the images while simultaneously sharing content with those who were captured at the event.

Or think about when Vincent Laforet self-funded his now infamous "Reverie" video that was captured on Canon's 5D Mark II SLR camera. The video was seen as many as 5 million times and actually shut down Canon's website, forcing them to move the video to SmugMug, a media site better suited for video distribution.

More recently, Chase Jarvis's video and stills showing off the capabilities of Nikon's new consumer-grade cameras—which consumers viewed and downloaded strictly voluntarily—not only promoted Chase but were viewed as Nikon's most successful

campaign in its history. (See "Chase Jarvis RAW: Advanced Testing the Nikon D90" on YouTube.)

What we have to understand is that the new channels of distribution are controlled by the consumer rather than by the distributor. Content has to be a voluntary choice. And when it is, it can spread like wildfire. We've all heard stories of the Twitter account scooping the Associated Press on a big story or the big producer avoiding television and publishing straight to the Internet. The big, powerful, controlling distributor is becoming an anachronism. The new trick is to have the kind of content that everyone wants to see and to share it on *their own terms*, not yours. How you do that is a wonderful creative challenge of the new millennium.

Now It's Your Turn

Now it's time to get to work, so come up with some products to leverage your work and promote your business's vision.

#1 BRAINSTORM YOUR VEHICLE (APPROX. 45 MINUTES)

Anyone familiar with Oprah? With her core vision of "Live Your Best Life," some of the *vehicles* her team has come up with to deliver that vision include The *Oprah Winfrey Show*, *O* magazine, and Oprah's Book Club.

What are some vehicles that your images might travel on? Come up with at least twenty-five possible products that could serve as delivery vehicles for your images. Examples could include things like gallery wraps, handmade cards, custom-framed prints, and online flash galleries. But don't stop there. Depending on your genre of shooting, think big and include ideas like in-person gallery shows, billboards, infomercials, online slideshows, or fusion videos. Include animation or special effects if appropriate. The trick is to not let yourself off the hook until you are exploding

with options. Don't *judge* the options yet. For now, just get as many brainstorms as you can on paper.

#2 RANK YOUR IDEAS (5 MINUTES)

With your vision in mind and your target market front and center, take your list of twenty-five products ideas and rank them as to which would be most aligned with the promise you are making.

#3 PLAN THE PROTOTYPE (APPROX. 45 MINUTES)

Now, take your top five products and think of ways that you might build prototypes to see how they look and feel. If they seem out of budget, go to the next item on the list. The point is to test-market at least five ideas to see if you can come up with a few totally unique delivery mechanisms for your products that could turn into promotional vehicles.

#4 MAKE YOUR PRODUCTS "REMARKABLE" (APPROX. 30 MINUTES)

As Seth Godin has suggested, the job of the promoter is to take remarkable products and make it easy for people to remark about them. In this final assignment, I want you to take your five prototypes and brainstorm at least three scalable (self-replicating) systems that would make it easy for your customers to talk about the cool products you just made. Map out these three simple plans for letting your customers know how to promote your great products (and thus you as a photo business). Some simple examples would be posting a slideshow of your best images on your blog and inviting your network to view and share it, or placing an email button on your website images, allowing users to easily email them to friends.

Think about online channels. Are you on Flickr? Facebook? Vimeo? Twitter? How are you building trust and not coming off as a salesperson? What problems are you solving, and what tools are available for you to solve with? Are you being an invitation?

To what? How will you break through the noise and be seen and heard? Are you seeking out clients or waiting for them to come find you? Are there ways to move away from broadcast advertisements and closer to personal connections?

#5 TAKE THE BST!
Before we move on to the final section of book, please return to the Business Stress Test [http://ftpBST.com] and take part 3.

Let's Review

» What you do after the shoot can be more important than your photos.

» Leveraging your work takes vigilance, patience, and awareness.

» The products you deliver to your clients have the potential to become promotional vehicles, but this needs to be done with care.

» Don't ever let your marketing show.

» Photographers have a unique ability to evoke emotion and trigger memories.

» The new media are all about invitation, not force. Make it easy for people in your target market to consume your content and share it.

SECTION 4 | **START YOUR BUSINESS ENGINE**

Chapter 10
Keep It Real by Staying Connected

"Something Changed"

I was recently talking with a friend of mine who happens to be a popular yoga instructor. She began recalling, with some nostalgia, the early days when she first started practicing yoga. "In those days, yoga was my passion," she lamented. "Now, that I'm a professional, I sometimes wish I could just have a bad day once in a while without anyone having to know about it."

Hmm…I'd always assumed that when yoga instructors had bad days, they did some yoga! After I suggested that strategy to her with a grin, she laughed but then remarked, with a tinge of regret, that things had changed for her when she turned pro. "The hardest thing is to practice what I preach. What used to be a refuge has, at times, become a little like a prison."

What she fantasized about was a chance to practice her yoga without being overwhelmed by the burdens of running a business. When you think about it, the dream she was describing is precisely what I'm prescribing for you. The only difference is, your dream doesn't have to be wishful thinking. By practicing the ideas we've

been discussing, you can make the *business* part of your business less burdensome so that you can enjoy the work you love for the rest of your life! You're free to live your dream…as long as you don't lose your connection to what that dream is.

Stay Connected to Your Passion

The problem with great business tools is how intoxicating they can become. If you're not careful, you can lose track of where it all started. I'm not saying you'll get too busy, though that can happen too. I mean you'll forget your *whys*: why you chose photography, why you're driven to master it, and why you believe it's meaningful work.

In my first book, *Fast Track Photographer*, I invited you to consider the idea that you are not your photography. I made the case that as a photographer your greatest strength is the creative core inside you. In the present book, I've been arguing that the photo business you were born to lead should be a true reflection of you. With you as the CEO, it begins with your vision, which percolates through each and every business practice you champion. You've now been given some tools for building your photo business into a sales-driven machine that perpetuates itself. But before we're done, I want you to reconnect with what matters most as an artist in commerce: your humanity.

Ultimately, your business is not about the tools and the systems. The tools and the systems are what free up your time and attention so you can focus on what's really important. And what *is* really important? Well, I can't answer that question for you, but I can promise you that, at bottom, it comes down to human beings, not widgets. You got in this game to move people. A creative business is ultimately a human enterprise. It comes down discovering and declaring the kind of person you want to be and the contribution you choose to make to your particular corner of humanity. Every business choice you make,

from the macro to the micro, should be leading you in that direction.

Stay Connected to Your Evolving Self

Engineering a successful business can be deeply challenging and deeply rewarding. In fact, if you do it the Fast Track way, I'm betting it will be both for you. But I promise you'll enjoy this process most if you never forget who you were before the engineering began.

Commit to having the courage to always look humbly and honestly in the mirror. By doing this you will give yourself and your company the gift of never having to pretend you're something you're not. How freeing! It's absolutely essential to be true to yourself and let everything else flow from there.

> "The biggest mistakes I've made in bookings have taken place when I felt scared and desperate for business. While I do think it's necessary to maybe take many jobs to get your name out when you first get started, I also feel you have to check in with yourself, about your core values, and make sure you're not agreeing to projects that go against what you are comfortable with."
>
> —MICHELLE WATERS, OWNER, MICHELLE WATERS PHOTOGRAPHY

But here's the catch: Who you are will not remain static; it will evolve over time. And that's a good thing. At the end of the day, being your true and evolving self is the only fulfilling path to enjoying your life as an entrepreneur.

Unless you make "being you" a priority, you won't have the first clue as to how to launch a business that will make you happy. And unless you keep "being you" as a running priority, your own success may actually begin to hem you in. The external identity you put out there in the world will begin to take on a life of its own. Before long you may find yourself in conflict with that old image of you.

It will start to feel like a coat that no longer fits you, but one that you wear out of duty and a fear of losing old customers.

One person committed to staying true to himself is Greg Gibson, a two-time Pulitzer Prize-winning documentary photographer who, after years of shooting as a staff photographer for United Press International (UPI) and the Associated Press (AP), transitioned to teaching photography and documenting families. Here's what "keeping it real" meant for Gibson:

> "I left journalism in March of 2000 on a twenty-four-month sabbatical shortly after winning the Pulitzer Prize for coverage of the Monica Lewinsky scandal. Coverage of the scandal had a very tabloidish feel and I didn't get into journalism to become a paparazzo. I felt myself losing my passion for journalism, and even worse, for photography. You can't do anything well without passion, especially when you're doing it at a high level on a national stage. I took some time away from photography to recharge and re-energize.
>
> I decided to become a wedding and portrait photographer because it was a good fit for my skills as a journalist. It was also a type of photography with happy outcomes where people are actually glad to see you when you arrive with your camera. I can't say people were always glad to see me during my years as a news photographer!
>
> While my images may not have an impact on society at large as a great news picture might, I could still provide my clients with images that have the same tremendous impact on their individual lives. Most importantly I provide them with a lasting legacy of a small slice of their lives that will outlive their own existence and provide a documentary of the individual family histories to be passed down through the ages."

Now, from a branding perspective, it's wise to keep your marketing messages consistent to avoid creating confusion. But— and this a big but—this needs to be balanced against who you are and who you are becoming. As you evolve, so should your business. And if you wake up and discover you've grown out of the area you're

making money in, you should know that you have permission to reinvent your brand to better align with who you've become.

Of course, if you decide to change what you sell as a photographer, you'll be putting yourself back in re-start mode when it comes to clients. The foundational systems you've built can still serve you, but you'll be starting afresh when it comes to functional practices like booking work in a new area of photography. Be deliberate in the move but patient as you start building new client relationships.

Some artists fear that when they begin to lose interest in the work they were doing before, they are losing sight of who they are. But in fact they may be *gaining* sight. It is natural to evolve artistically over time and you'd be wise to honor those natural shifts.

> "Being true to yourself isn't about finding a certain note, it's about staying on key."
>
> —JESH DE ROX, OWNER, JESH DE ROX FINE ART PHOTOGRAPHY

One more story helps illustrate this point. It comes from Jeremy Cowart, self-described "photographer to the stars and the suffering." A few years back, Cowart was meeting with a major television network about a commissioned job that involved flying to Fiji to shoot a particular A-list celebrity. After he had shown his glossy Hollywood portfolio, the meeting, which seemed to have gone well enough, was coming to a close.

At the last minute, however, Cowart decided to show a book of images he had recently shot that fell well beyond the scope of the job at hand. The pictures were from a trip he took to Kenya that were ultimately published in the book, *Hope in the Dark*. They showed a fuller picture of the photographer he was evolving into.

Not only was the network ecstatic about what they saw, but they also felt they had discovered a photographer who could do more than your average "big lighting guy." Given the modest

setup he had worked with in Africa, the executives concluded that Cowart might be the kind of shooter who could capture the personal side of his subjects without forcing the network to fund the kind of large-budget "concept shoot" so many celebrity photographers demand.

Cowart had something special and now the network knew about it. In time, he became the exclusive go-to photographer for jobs that required an ability to get personal with the subject. Since that meeting, he has been hired to shoot at least ten big celebrity jobs in a little less than three years, from the Kardashians to Ryan Seacrest to the cast of *The Girls Next Door*.

Not everyone is meant to shoot one area of photography for a whole lifetime *or to shoot it in the same way*. In fact, not all photographers are made to take pictures throughout their whole lives. If you come to the conclusion that you need to make a transition, know that this is normal, put together a plan, and move forward.

> "Be sure you know the products you are trying to sell, including yourself. You are a product just as much as the photo books, prints, and signature photo finishes are."
>
> —STACY PEARSALL, COMBAT PHOTOJOURNALIST, CO-OWNER F8PJ

Stay Connected to Your Business: Make Sure Your Culture Reflects You

One way to make sure your business remains vitally connected to who you are, both today and tomorrow, is to recognize the central role you play in your business culture and to be intentional about that role every day of your business life.

We talked about culture a little bit in Chapter 5, while discussing teams. What we didn't discuss is the idea that culture can work on two levels, conscious and unconscious. Intentional and unintentional. Deliberate and incidental. Your business

culture exists, whether you claim ownership of it or not. And you are at the core of it, whether you like it or not.

Culture can be defined as the living vehicle by which your brand is communicated to everyone who connects with your business. It is the vibe you put out, both formally and informally, deliberately and unintentionally. It colors what *everyone* connected to you thinks about your company. It's your reputation, your personality, your style, your value system and your artistic DNA, all mashed together. It's the way people come to know you, touch point by touch point. And it goes beyond what you *want* to tell people about your company. It comes down to what you *do* tell people about your company. Day in and day out.

Even if you're the only employee in your company, you still connect to a lot of people. These can include business partners, investors, vendors and employees, prospective clients and leads, current customers and former customers. As these people talk about your business, you want them all to "get" you and you want them all to be saying and experiencing the same great things. More than any clever marketing tagline or ad campaign, your real, living culture is what will make that happen. This is why it's so important to remain actively intentional about the culture you're creating.

Culture flows directly from who you are. As a company of one, you get to decide everything about your business culture: what your core business values are; the way you communicate with customers; the kind of clothing you wear; the level of whimsy you encourage. But it goes beyond obvious branding choices to encompass character and ethical choices as well. Culture is the subtle air you breathe at your workplace, the way you treat others, the principles you personally uphold, and what people talk about when you're not around.

Tragically, some business owners are naïve to the existence of their company culture. But ignoring or disregarding it doesn't make it go away. Like a garden overgrown with weeds, a neglected

culture will continue to mature, killing your chances at creating a healthy, flourishing enterprise. Your culture will then become known as confused, lazy and unfocused.

Think of a company that is consistently late paying its bills or a photographer who is more concerned about the art he or she is creating than the client he or she is serving. Your culture is your business's reputation, whether you're conscious of it or not. So I recommend you *get* conscious about it sooner rather than later. And although *your* culture will be based on *your* personality and your particular set of values, I strongly recommend that it be all of the following:

A culture based on systematizing: Establish a culture in which you and everyone on your team are focused on what they're supposed to be doing and nothing more. Systematize everything except the mission-critical stuff that requires a personal or creative touch. Then address the mission-critical stuff yourself or hand it off to highly trusted team members. As you think about building this kind of culture, ask yourself:

» Do I lead by example, always systematizing the routine and repeatable tasks of business?

» Do I empower my team members to make decisions about tasks that fall within their areas of responsibility? Do I make it clear which jobs and decisions are to be mine alone?

» Do I encourage the constant refining of existing SOPs and the creating of new ones?

A culture of creativity: Establish a culture in which creativity is allowed to flourish unhampered. The reason you're systematizing all of your operations, after all, is so you and the creative members of your team can spend the bulk of your time being creative and delivering on it. Ask yourself:

» Do I actually take advantage of systematizing by spending focused time on the creative stuff? Do I point this out to my team members?

» Do I encourage creativity on the part of my team? How?

» Is innovation a high value in my day-to-day work?

A client-centric culture: Establish a culture that revolves around the client experience you are dedicated to creating, based on your vision. Make sure that culture filters down to every touch point the client contacts. Ask yourself:

» Do I constantly remind team members to think about the customer experience?

» Do I take the time to make sure every team member is 100 percent clear on the customer experience I am committed to delivering?

» Do all of the touch points of my business support the customer experience I am committed to delivering?

A culture of collaboration: Establish a culture in which ego, blame and interpersonal competitiveness have no place. Reinforce and reward a collaborative approach in everything you do. By your example, let it be known that producing great results for the client is all that matters. Make it fun and fulfilling to be part of your team. Let your culture announce, loudly and clearly: *Everyone works together; no one has to go it alone.* Even you. Especially you. Ask yourself:

» Am I known for encouraging collaborative input from team members?

» Do I solve problems openly with my team and use them as "teaching moments" rather than "blaming moments"?

» What are some ways I show my team members that pleasing the customer is more important than taking personal credit?

Gandhi famously said, "*Be* the change you want to see in the world." In a similar way, you must *live* the culture you want to create. To the extent that you do that, consciously and deliberately, you will create a business you are proud to own.

Stay Connected to Your Community

Photography, by its very nature, can be a lonely and isolating profession. That's why we need to make an extra effort to stay connected to others, and to create opportunities for others to stay connected with us. Connection matters, not just for our clients and customers, but for us, the practitioners. Connection keeps us honest, keeps us growing and keeps us compassionate.

> "Community is so important. When not overseas working on a project, I am usually downstairs in my basement studio shooting conceptual stock photos or working the computer editing. My kids used to say I was going down to my mole hole. The hours working alone in the dark basement were profitable but I found myself desiring to be around people. I needed to rub shoulders with other creatives. This need has been satisfied with virtual communities on the web and with joining professional organizations. We really can't do this photography thing in a vacuum."
>
> —GARY S. CHAPMAN, HUMANITARIAN PHOTOGRAPHER

The main reasons I first reached out to my peers in the industry were my motivation to learn and my desire to feel connected. When I started reaching out through online forums, networking events and conferences, however, I often experienced hesitancy from those "inside" the circle to let newcomers like me in.

Looking back, I can understand why. Our industry is highly competitive, with new photographers showing up every day. But one thing has become clear as a Leica lens to me after many years in the photo game: Cooperation and community are infinitely more rewarding—financially *and* emotionally—than exclusion and competitiveness.

So where does one go to find community? Where do other shooters hang out?

If I were starting out today, the online forums are where I would go first. Miki Johnson agrees. As the former senior editor at *American Photo* magazine in New York, she's seen firsthand how rough it can be for photographers to find a community. This is one of the reasons she's so effective in her current role directing social media strategy for liveBooks, a web design company for creative professionals. She understands what photographers need. "With the newsrooms and print labs largely gone, it's really tough to find a place to meet up with other photographers. But online it's a different story. There's just so much possibility there now."

Mainstream social media sites are having a huge impact on the photo community. One established pro confessed to me that he still gets a little thrill every time someone "like"-clicks his images on Facebook. Another photography instructor told me about how a South African shooter reached out via Twitter to ask a question and received an answer from an American. Months later, that 140-character connection led to the two of them meeting in person for breakfast in Atlanta.

At the same time, many more niche online photo forums, blogs and magazine-style sites are being tooled to reinforce learning and encourage more authentic relationships. "The Photography Post" (thephotographypost.com) is just such an example. Not only does this blog publish its own posts around commercial, editorial and art photography, but it also curates a collection of photo blogs from around the world, letting readers vote as to which they

appreciate most. I like this approach: Not only is there a filter to ensure that professionally edited content is showcased, but photographers are invited to weigh in on which subjects they believe are most relevant to the community.

Another example is the photography blogazine, *Too Much Chocolate* (toomuchchocolate.org), started by twenty-four-year-old commercial photographer Jake Stangel. It's a free online community but, to gain entry, your application must pass the review of its creator. His intentions may sound elitist, but actually are refreshingly supportive, especially if you're a young, emerging photographer looking for a serious but safe place to find your way. Whether you're an editorial, fine art, or commercial photographer, you need to get your portfolio up to par if you want to be included. But the investment is well worthwhile; once you're accepted you become a member of a community of others who are serious about their work.

Stangel's hope is that these virtual relationships will convert into real-world connections. And they have. Many, including Stangel himself, report to be meeting regularly with colleagues whom they didn't know previously. The popularity of this "virtual coffee house" is undeniable. Not only did it attract Kodak as a major sponsor but it received over forty thousand hits in one month, just a year after its launch.

Beyond these more progressive community-based sites, there are also tremendous resources available through professional organizations. Here are just a few that provide genre-specific information, resources and training for all their members:

» American Society of Media Photographers (ASMP)

» National Press Photographers Association (NPPA)

» Advertising Photographers of America (APA)

» Professional Photographers of America (PPA)

» Wedding and Portrait Photographers International (WPPI)

» North American Nature Photography Association (NANPA)

» And, of course, the Fast Track community
 (http://forums.fasttrackphotographer.com)

Regardless of *how* you find community, it will be invaluable to you throughout your career. Community provides the opportunity to learn, as well as the support, the encouragement and the laughs we all need to keep us motivated.

Stay Connected to Your True Purpose

One assumption I've made throughout this book is that you are one of those individuals who, when you have a camera in your hand, believe you are doing what you were put on Earth to do. You feel most humanly yourself when you're taking pictures. You are convinced this is the professional life you were made for.

Or not.

Alas, a lot of folks, after they've been at it a while, discover that they got into photography for the wrong reason. Maybe they didn't like their old job (or their old job didn't like *them*). Maybe they needed to make a buck and got sold on the idea that becoming a photographer was an easy way to do it. After trying it for a while, they realized that the work—and the *booking* of the work—is harder than it first appeared.

Let's face it, making a living through a service-based business is tough. We've talked a lot about scaling in this book, but there are certain aspects of photography that remain labor intensive by nature. *We* never get removed entirely from the picture. A creativity-based business makes unending demands on us personally. And that's not for everyone.

So, if you're getting to the end of our conversation and are feeling that all this small business/photography stuff may not be for you, cheers! The money you paid for this book was well spent. From a business perspective, there's no shame in coming to the

conclusion that this isn't the road you were made to walk. In fact, I may have saved you tens of thousands of dollars and several years of your life!

But if, after all this, you can't believe your good fortune that someone has shared some well-tested practices that will give you a better shot at getting paid for your art, the money *you* invested in the book was also well spent. My hope in writing this book is that you can keep your dream alive by making the business part of it less laborious and better suited to the times we live in.

In his book *DRiVE*, Daniel Pink makes the case that individuals are best motivated when they are (1) self-directed or autonomous, (2) can actively harness all their strengths toward the pursuit of mastery over the thing that matters to them, and (3) are living a life that's bigger than themselves. In other words, when they are living with purpose.

If you choose to lead your professional life in the direction of photography, are willing to pursue mastery, and can see the sense of purpose you'll derive from the images you create, you may just have landed the perfect opportunity. And this big break may have showed up just in the nick of time. In his book *Linchpin*, Seth Godin suggests that, for centuries, would-be creatives have bartered their artistic birthright for a sense of security, like some sort of pact with the devil. But not so with you. You're giving yourself a chance to truly become what you were made to be.

Is this book a guarantee for success as a professional photographer? Of course not. As Godin also explains, companies don't have a right to people's business; neither are artists entitled to make money with what they create. That said, I believe what we've talked about here will give you your best chance to have your cake and eat it too. Let's just bake a good one.

With that in mind, I invite you to take the final step in this book. I invite you to commit to paper the first draft of your Fast Track business plan!

Let's Review

» As you build your business, don't forget why you chose to be a photographer in the first place. Let that passion drive you.

» Be true to yourself and let your business reflect that.

» As you evolve as an artist and person, so should your business.

» Your business culture flows from who you authentically are. Be intentional about it.

» Community is vital for photographers and other isolated creatives.

» It's okay if you discover, by reading this book, that running a photo business is not your true purpose.

» If running a photo business *is* your true purpose, then welcome to one of the most thrilling careers imaginable!

Chapter 11
Connect the Dots: Craft Your Own Fast Track Photographer Business Plan

Start Your Engine

We began this adventure by firing you from your frontline photographer job and promoting you to CEO of your business. From that high elevation, I asked you to take responsibility for leading your company. You named and claimed your vision and promise to the world. You followed that up by looking at your money practices and thinking about ways to build a team and systematize your workflow. Finally, you adopted some sound functional practices to help you book and shoot jobs in way that translates into future bookings. The only question that remains is this: What are you going to do with that information now?

I told you at the beginning of the book that this was not your typical fill-in-the-blanks, wow-the-investors book. I promised we would be more focused on the stuff that goes *inside* the blanks. I hope I've fulfilled that promise. I hope I've prompted you to think about the big-picture aspects of running a thriving, fulfilling business. I also hope the BST has prompted you to take stock

of the areas of your fledgling business where you are both the strongest and the most deficient and has given you a better sense of where some of your top action priorities lie. At the same time, I don't want to leave you adrift in a sea of abstractions. And so, I *am* going to ask you write a plan and we *are* going to "fill in the blanks" a bit, but we're going to do so armed with the right kind of intelligence. I invite you now to take a final step that will set the cement we've been pouring for the last two hundred plus pages. That means getting your ideas down on paper.

Now, if you've been doing the written exercises at the ends of the chapters, you will already have made good headway. We'll refer to some of those exercises and synthesize ideas you generated there. If, however, you have been *avoiding* the written exercises, I encourage you to write your plan anyway. For some parts of the plan it will help to go back and complete an earlier exercise, but that's up to you. Just remember that the plan isn't the end game; it's the point of takeoff.

The *purpose* of writing your plan is to both review all the ground that we've covered while simultaneously giving your business strong launch (or relaunch). You're not going to write an exhaustive (and exhausting) five- or ten-year plan or try to anticipate every obstacle you might encounter. Rather, think of your business path as a chain of unexplored islands you want to navigate. I can't give you a map to the whole chain; it hasn't been charted yet. All I can do is help you get to the first island. Once you get there you'll need to look around, recalibrate, revise, and plan your route to the next island. You can and should have an overall idea of where you ultimately want to go, but how you get there will always involve some customized navigation.

With that in mind, let's get rolling. Remember, this isn't about impressing investors. This is about getting your business started. If you want advice on how to write a standard, money-raising

business plan—which you may wish to do—there are plenty of books and online resources that can help you with that, some of which are included in the appendix.

Bon voyage!

The Plan

The "plan" I'm asking you to write here is a beginning foundation on which you are going to build. If you do it conscientiously it will force you to think about, and commit to, a wide range of specific choices in areas such as vision, products, money, SOPs, marketing materials, and much more. Its purpose is to help you get as clear and committed as possible on the main foundational and functional aspects of running a thriving photography business.

It is designed to do a number of things: reinforce the ideas we've been discussing throughout the book; invite you to commit to some specifics that you may still be feeling nebulous about; answer some new questions not posed in the body of the book; and continue the work you started in some of the end-of-chapter assignments.

But—just so you're clear—this plan is *not* going to tell you what to do when you get up next Monday morning. It is not going to provide you with a tight schedule of the day-to-day activities you need to do to run your business. I don't know enough about you or your business to give you that level of hands-on guidance. Only you do.

What I'm saying is this: This plan is not going to run your business for you. It's up to you to do that in the best way you know how. No one but you can tell you what needs to be done today, tomorrow, or the next day to move your business forward.

You are now seizing the reins as CEO of your company. Part of that job is to start prioritizing actions and building a day-to-day approach that works for you and serves your business vision.

Armed with the results of the BST, you should have a better sense of where you're going to need to focus the bulk of your energy and attention. This plan will be your foundational and functional starting place.

With that understanding in mind, let's get started.

Transfer the statements in **bold** to paper or enter them into your computer, one by one, and write responses according to the suggestions.

Step 1: Define Your Vision

For this first group of statements, refer to the Vision exercises you did at the end of Chapter 2.

1. Consider the following questions: "Why am I starting a business as opposed to pursuing a hobby?" "What goals, beyond making money, do I intend to accomplish?" "How do I intend to make my signature contribution?" Now create a one-sentence vision statement. **The purpose for which my business exists is:**

2. Considering your personality, your values, your artistic identity, and your leadership qualities, write a list of three to seven personal qualities that will define your leadership style. **I intend to lead my business toward my vision by embodying the following qualities:** .

3. Write a short list of commitments you are willing to make to yourself and your business in order to bring your vision to life. These are general commitments, such as: seek to systematize my routine work, explore outsourced solutions, treat the customer like royalty, etc. **I intend to lead my business toward my vision by consistently doing the following:**

4. Write a one-paragraph description of the company culture you intend to create to support your vision. Include details such as the atmosphere of your workplace, the behavior and dress of your team members, the values your company will embody, the look of your marketing materials and the style of your work. **My company culture will embody the following qualities:**

5. Make a list of responses you hope customers will express after working with you. Be specific, avoiding terms like good and satisfied. **Words and phrases my customers/ clients will use to describe their experience of my company will include:**

Step 2: Define Your Products and Services

Refer to the assignments you did at the end of Chapters 3, 4, and 9 as a starting point.

1. Focus on your one to three main products/services and describe them in specific, concrete terms. For most of you, these will involve images and/or photography services, but they may entail ancillary products as well. **The main product(s) and/or service(s) I intend to sell at the launch of my business is/are:**

2. Describe a market need that is not being filled adequately and to which your products will provide a better/alternative solution. **The solution my product or service will offer to my chosen market is:**

3. Describe the "hook" that will make your product stand out. **The main feature or quality that makes my product/service unique in the market is:**

4. Describe at least three ways in which your product/service embodies and advances your vision. **My product/service promotes my vision and brand in the following ways:**

Step 3: Take Stock of Money Matters

Refer to Chapter 4 and its assignments for more information.

1. Factor in all start-up expenses and calculate your start-up costs. Please circle whether each cost will be immediate (you intend to incur this cost now), deferred (you will incur the cost but plan to defer it temporarily), or not applicable (you don't need or plan to spend in this area in the foreseeable future).

Deposits to utility companies _____ (I / D / N.A.)

Internet and phone equipment and set-up costs _____ (I / D / N.A.)

Licenses and permits (city, state) _____ (I / D / N.A.)

Development of basic marketing materials (see sample list below) _____ (I / D / N.A.)

Website development _____ (I / D / N.A.)

Insurance premiums (liability, equipment, etc.) _____ (I / D / N.A.)

Photo equipment, including redundancies _____ (I / D / N.A.)

Office and computer equipment _____ (I / D / N.A.)

Photography, productivity, and office software (Photoshop, MS Office, Quickbooks, etc.) _____ (I / D / N.A.)

Furniture, fixtures, and office décor _____ (I / D / N.A.)

Starting supplies/inventory _____ (I / D / N.A.)

Professional/consulting fees _____ (I / D / N.A.)

Vehicle expenses _____ (I / D / N.A.)

Rent or purchase of physical space (if you plan to have one) for meeting clients _____ (I / D / N.A.)

Renovation costs for above _____ (I / D / N.A.)

Rent or purchase of office space _____ (I / D / N.A.)

Renovation costs for above _____ (I / D / N.A.)

Professional attire _____ (I / D / N.A.)

Signage _____ (I / D / N.A.)

Advertising and promotion costs for launch _____ (I / D / N.A.)

Operating cash _____ (I / D / N.A.)

Miscellaneous/other _____(I / D / N.A.)

 TOTAL (immediate):

 TOTAL (deferred):

I will need $_____ (total immediate, above) to launch my business.

I currently have $_____. Therefore, I need $_____.

List additional sources of revenue. **I will get the remaining start-up funds from:**

I will defer a total of $_____ (total deferred, above).

2. For any deferred cost, please list the item, the cost, and the date by which you plan to make the expenditure:

Item	Cost	Planned spending Date (approximate):

3. Estimate your total monthly overhead costs.

Utility costs (heat, water, electricity) _____

Internet and phone costs _____

Marketing and promotion costs _____

Professional services (legal, accounting, etc.) _____

Licenses and permits _____

Professional memberships _____

Travel and transportation costs _____

Trade show fees _____

Insurance premiums _____

Trade publications _____

Photo equipment and supplies _____

Office and computer equipment _____

Software, including upgrades and renewals _____

Website hosting and other web expenses _____

Office expenses (postage, printing, paper, etc.) _____

Furniture, fixtures, and office décor _____

Rent or mortgage (even if only for part of your house) _____

Maintenance of equipment and physical space _____

Professional attire _____

Your salary (if you are paying yourself a salary) _____

Office help (if you hire a part-time assistant, etc.) _____

Other _____

My overhead expenses per month for the first year will be approximately $_____

4. Using the assignment at the end of Chapter 4 as a starting place, list your proposed fees for all of your products and/or services. (These may be increased/

adjusted later.) Remember to build in costs associated with outsourcing; these are part of your routine product expenses. **My fee schedule for each of my products/ services, at launch, will be $ _____**

5. If you offer a single product or service, calculate how many "units" you will need to sell per month to reach your goal. If you offer multiple products/services, list a few sample combinations that will add up to your goal. **To meet my financial goals, I need to sell _____ units of my main product/service per month, or a combination of sales, such as:**

6. List other sources of income you have, such as a full- or part-time job, savings, inheritance, etc. **I will continue to use funding from _____ until sales from my photo business have permitted me to pay myself a salary of $ _____ for _____ consecutive months.**

7. Set short-and long-term goals. **My short-term goal is for my business to be earning $_____ per month by _____ (date).** *Note: Remember to account for deferred start-up costs when determining your goals.*

My mid-term (1–2 year) goal is for my business to be earning $_____ per month by _____ (date). *Note: Remember to account for deferred start-up costs when determining your goals.*

My longer-term goal (3–5 years) is for my business to be earning $_____ per month by _____ (date). *Note: Remember to account for deferred start-up costs when determining your goals.*

Step 4: Define Your Target Market

Refer to the assignments you did at the end of Chapters 3 and 4.

1. Consider the ideal client/customer you would like to serve. Will you target the general public or industry buyers? Is it a niche product? If so, what is the niche? A target market can be described in terms like, "Actors looking for affordable head shots with a sense of whimsy," or "Fashion editors looking for an inventive techno style." Think about how attracting the wrong clientele can be as damaging as attracting no clientele. **My target market is:**

2. Consider the "problem" you intend to solve with your products/services. What kind of reaction do you hope for in your market? Write down at least three imaginary quotes that you would like to read in reviews about your business.

Three imaginary quotes from reviews of my business and products that I would like to read are:

3. Factoring in the strengths and weaknesses of the "competition," make a short list of opportunities that exist in the current market. **Opportunities that exist in the current market are:**

4. Take a realistic inventory of your main strengths and weaknesses as a company. **Three main strengths and three main weaknesses of my business are:**

Considering the opportunities that exist in the market, three ways I intend to leverage my strengths and minimize my weaknesses are:

Step 5: Reach Your Target Market

Refer to the exercises at the end of Chapter 7 as a starting point.

1. Think of at least ten "touch points," such as business cards or websites, that you intend to turn into "invitations." For more examples of touch points, go back to the assignments at the end of Chapter 7. List the touch point and then the way you intend to transform it into a branded invitation, and then the date by which you intend to do this. Remember, every touch point should reflect your vision and culture. **The first group of touch points intend to turn into "invitations" are (list):**

Touch point	How will I make it inviting	Date I will do it by
1.		
2.		
3.		
4.		
5.		
6.		
7.		

Touch point	How will I make it inviting	Date I will do it by
8.		
9.		
10.		

2. Make a plan for getting your basic marketing materials made. You may not use all of the items listed below, at least at first, and you may plan to use others that are not listed (see further explanations of items below.) List the date and the outside resource (e.g., print company, consultant), if any, you will use to get the item completed. **I will have my basic marketing materials created by the following dates:**

Item	Resource	Date
Business name		
Logo		
Color scheme		
Business cards		
Elevator pitch		
Website		
Listings		
Marketing materials		
Stationery		
Other (list)		

Business name: Choose a punchy name that reflects your vision, style, and culture but also says something about the actual business you're in. Take the time to choose the perfect name; don't settle for the easy and obvious.

Logo: Have a simple and attractive logo designed. There are online services that do this fairly inexpensively. Later you may wish to pay a premium designer, but don't let perfectionism hold you back for now.

Branded color scheme and font: Your logo should use two or three colors that work in combination with one another and function as your branded colors. These same colors should be used in all of your printed and online materials—stationery, web page borders, etc. You should also choose one to three main fonts that you will always use in your marketing materials. Don't use "font salad"; pick your branded fonts and use them across your marketing efforts. The font should reflect your style and vision.

Business cards: Consider creating something unusual that uniquely captures the flavor of your brand values. If "elegant" is a value, a sleek black matte card might work. If "eco-conscious" is a value, coarse recycled stock might be best, etc. Experiment with shape, too.

"Elevator pitch": Prepare a twenty- or thirty-second statement that encapsulates the essence of your business, its products, its strengths and benefits, and why customers will want to work with you. You never know when an opportunity to pitch your business will arise. Unless you have an elevator pitch prepared, you'll be stammering when the time comes.

Website: A website is now required in business. The more thoughtful and style conscious it can be, the better. Also, the more free value it can give to the end-user, the better. Offer something for free that will keep your target market coming back. Consider including a blog. Work with a copywriter if writing isn't one of your talents.

Marketing materials: Make sure all of your printed materials, such as brochures and flyers, highlight the solution you offer to the market. Again, use of a good writer may be a valuable investment.

Listings: Make a list of all the places you want your business and services to be listed—industry and freelance job sites, professional organizations, etc.—and get it done.

Stationery, etc.: Create branded letterhead and envelopes with your company logo and address. Also, remember thank-you cards, buck slips, etc.

3. Consider ways you can market yourself by providing free content. Such activities might include speaking at a professional event; distributing free photos via a social network (Facebook, LinkedIn, etc.); writing a blog, article or advice column; adding a content-intensive post to a forum (not necessarily a photo forum—try, for example, a parenting forum if you photograph babies); posting a YouTube video; creating a

podcast or vodcast; giving a workshop at a venue where your target market gathers; etc. Focus on activities that provide direct contact with your audience. **I commit to doing at least five "free content" marketing activities per month (aimed at my target market) for the next three months. These will be:**

Month 1:

Month 2:

Month 3:

Step 6: Define Your Processes for Product Delivery and Customer Service

Refer to the content of Chapters 7 and 9.

1. If you do scheduled shoots, describe the booking process (SOPs) you intend to use, from initial client contact through the shoot. Remember that these SOPs should not only be efficient and effective, but should reinforce your business's vision and culture. **The step-by-step process by which I will book jobs/orders is:**

2. Think of three ways that you will bring added value—little "extras"—to the booking process. For example, offer a complimentary gift (such as a gourmet chocolate or a coupon from a strategic partner); follow up with a thank-you note or a note explaining your promise to the customer, etc. Make these "extras" consistent with your vision and note how and where they will be inserted into the process you've just described above. **Three ways I will add unexpected value to the booking process are:**

3. Describe the SOPs for your product delivery process, as you did for your booking process. **The step-by-step process by which I will deliver my main product/ service to the customer is:**

4. As above, think of three ways that you will bring added value to the delivery process. **Three ways I will add unexpected value to the delivery and proofing process are:**

Step 7: Check Your SOPs

Refer to content of Chapter 6 and exercises at the end of that chapter.

1. I commit to doing a thorough systems review of ALL SOPs used in all operations of my business by _____ (date).

2. As part of my systems review, for each major business operation, I will ask and answer the following questions:

 1. What are the minor operations that make up this system? List them.

 2. Can the major operation or any of its minor operations be:

 » Automated? If so, how? With what tools/software? Can I implement it now? If not now, by what date?

 » Outsourced? Can an outside resource do this job in a way that I can comfortably build into my pricing structure? If so, who? By what date can this start?

 » Delegated? Can someone in-house* (besides me; family members, fellow professionals with whom you are bartering for services, etc.) do the job?

 » Better systematized by SOPs? If so, by what date will I have SOPs written/rewritten for this microsystem?

Note: You'll need to review your processes for such systems as:

» Shooting

» Postproduction

» Product delivery

» Handling mail

» Customer communications (phone, email, etc.)

» Taking orders for products/services

» Processing payments

» Billing/accounts receivable

» Bookkeeping

» Paying taxes

» Equipment maintenance

As you're designing new SOPs, follow the eight steps shown on page 136–137 in Chapter 6.

*In-house staff can include family members volunteering their time, fellow professionals with whom you are bartering for services, etc.

Step 8: Make an Outsourcing Plan

Using as reference materials the examples of outsourced tasks suggested on page 117 of Chapter 5, and the task lists you generated in the assignments at the end of Chapter 5, write a list of all operations, both job-specific and general, that you will consider outsourcing within Year One. List the task, the date by which you will explore at least three outsourcing options and the date by which you will implement outsourcing (if in fact you decide this task can be outsourced).

Task/Operation	Date by which I will explore outsourcing	Date by which I will implement (if applicable))

Step 9: Plan Your Launch

1. **I plan to launch (or relaunch) my company on** _____ **(date)**

2. Think about the way you want to launch your company. Do you see a "grand opening" of some kind? Or will it be more of a "stealth launch," slowly building up customers until you can afford to quit your day job? Describe in detail the way you envision it. **The way I plan to launch my company is:**

3. If you're doing an official "launch date," think of at least five ways you will publicly announce it and build up excitement and momentum. **Steps I will take to announce the launch of my business are:**

Note: Make sure that the way you choose to launch your business is completely consistent with your vision and culture.

One Last Thing: Be a Work in Progress

I'm delighted that you've decided to make it real by getting to work on an actual plan. Take your time with this; you don't need to rush. As you write your Fast Track business plan, though, there's one last thing I'd like you to keep in mind: You're not going to get it right.

You're not going to cover everything. You're not going to anticipate all the obstacles. You're not going to make all the right decisions.

And that's wonderful.

You've heard the old business saw, "Those who fail to plan, plan to fail." Usually it's meant to *warn us off* from failing. But I say, failure is where all the fun is. When I use the term, "work in progress," I mean I'm wholeheartedly anticipating failure along the way. You see, I view failure as the quickest road map to success. I'm with Thomas Edison, who, when asked about his countless unsuccessful attempts to find the right filament for the light bulb, famously said, "I haven't failed. I've found ten thousand ways that don't work."

Here in the United States, we take a dim view of failure. We treat it as a shameful outcome to be avoided at all costs. And so we create a lot of fear and resistance around it. We hedge our bets. We play it safe. We insulate ourselves in layers of blaming and buck-passing so that if we *do* fail, it can be someone else's fault.

I, on the other hand, sing failure's praises from the rooftop. I am a great advocate of failing one's way to success. Stumbles, after all, are what teach us how to stand and walk. Sour notes are what teach us how to play sweet ones. Slices and hooks are what teach us how to hit a ball straight. Take the shame away from failure and you have nature's most elegant teaching system.

Because we're so afraid of the *shame* of failing, however, most of us don't even try. We stick with the familiar, even when we loathe and resent it. But I have great respect for those among us who fail and fail boldly. Failure is a declaration that you refuse to let fear be your master. Failure means you're willing to step up to the plate and swing the bat, even though you know the odds of getting a hit are against you.

And *repeated* failure? Oh…that means you're *truly* committed to success.

So be bold, my friend, and fail like crazy. Of course, do your best to not repeat failures. You're more creative than that anyway. Just don't get bogged down in the fear of making the wrong

decisions about your business. You *will* make wrong decisions. Don't worry about it. Reality will correct you soon enough, and you will have acquired a wealth of information about making a better choice next time around.

The shame is not in failing, the shame is in being so afraid of failure that you refuse to act. If I had to sum up the *real* fast track to business success, I would do it in these three words: *Get back up.* Make that your habit as a leader, and your professional creative business will be on a sure trajectory to thrive.

Recommended Resources

The following is a brief resource list to get you started.

ASSESSMENT TESTS

» Online assessment to measure your strengths as a photographer: http://ftpBST.com

» Online assessment to measure the strength of your business: http://mypDNA.com

TUTORIALS

» Fast Track workshops: http://store.fasttrackphotographer.com

» Off Camera Flash: http://strobist.blogspot.com

» Light workshop: http://www.onelightworkshop.com

» Adobe: http://adobe.tv

» Digital photography, design and development, and motion: http://lynda.com

BUSINESS BUILDING LOGISTICS

» Comprehensive resources for starting a business: http://startupnation.com

» Employer ID number acquisition: http://j.mp/empid

OUTSOURCING PARTNERS

» Postproduction photo editing: http://shootdotedit.com

» Online image proofing and sharing: http://pickpic.com, http://smugmug.com, http://pictage.com, http://flickr.com, http://photobucket.com

» Layout proofing: http://albumexposure.com

» Payment processing: http://authorize.net

» Printing and product fulfillment: http://whcc.com

BOOKS

Photography/business:

» *Fast Track Photographer: Leverage Your Unique Strengths for a More Successful Photography Business*, by Dane Sanders

» *Visionmongers: Making a Life and a Living in Photography,* by David duChemin

» *Best Business Practices for Photographers*, by John Harrington

» *The Photographer's Survival Guide*, by Suzanne Sease and Amanda Sosa Stone

» *No Plastic Sleeves: The Complete Portfolio Guide for Photographers and Designers*, by Danielle Currier

Photography/technique:

» *Understanding Exposure: How to Shoot Great Photographs with a Film or Digital Camera,* by Bryan Peterson

» *Digital Photography Bootcamp,* by Kevin Kubota

» *A World in HDR,* by Trey Ratcliff

» *Photojojo! Insanely Great Photo Projects and DIY Ideas,* by Amit Gupta with Kelly Jensen

» *The Creative Photographer: A Complete Guide to Photography,* by John Ingledew

Business and productivity:

» *Getting Things Done: The Art of Stress-Free Productivity,* by David Allen

» *Zen to Done: The Ultimate Simple Productivity System,* by Leo Babauta

» *The Art of the Start: The Time-Tested, Battle-Hardened Guide for Anyone Starting Anything,* by Guy Kawasaki

» *The Plan-As-You-Go Business Plan,* by Tim Berry

BLOGS AND WEBSITES
Photography:

» My blog: http://blog.danesanders.com

» Fast Track Photographer blog: http://blog.fasttrackphotographer.com

» Chase Jarvis blog: http://chasejarvis.com/blog

» Nick Onken blog: http://nickonken.com/blog

» Zack Arias blog: http://zarias.com

» Joe McNally blog: http://www.joemcnally.com/blog

» Scott Bourne blog: http://photofocus.com

» DP Review: http://dpreview.com

Business:

» Seth Godin blog: http://sethgodin.typepad.com

» Chris Brogan blog: http://www.chrisbrogan.com

» 37Signals blog: http://37signals.com/svn

Portfolio building:

» Portfolio website building software: http://getshowit.com/dane

» Portfolio website templates: http://livebooks.com

» Websites and tools for photographers: http://photoshelter.com

BLOG SOFTWARE

» Open-source blog software: http://wordpress.org

» Pay-for blog software: http://typepad.com

BRANDING

» One-stop branding solution: http://yourelevation.com

VIDEOS

» Weekly video conversation with me and special guests: http://AskDane.com

» Online and in-person conference for creatives:
 http://EscalateLIVE.com

» Online and in-person photo learning:
 http://CreativeLIVE.com

OTHER

» Regularly updated list of recommended products:
 http://j.mp/killerapps

Acknowledgments

When I had the privilege of writing my first book, I thanked some fine people for supporting me in that labor of love. This book however, was different. Candidly, it was harder to write. Whereas *Fast Track Photographer* kind of flowed out of me, this one required the discovery and exercise of some muscles I didn't know I had (or wanted to have). Thus, a lot was demanded by the people mentioned here. I'm happy to report, they came through in ways and at times that made me overflowing with gratitude (tears included). These are good people.

So, it is with great thanks that I acknowledge the following folks:

First, to Danielle Svetcov and Jim Levine at Levine Greenberg, your pragmatic and especially kind approach with this late-blooming author made me a believer in you (and even in me). I literally can't imagine this project without you both by my side. You talked me off the ledge more than once and although you'll discount that as "that's just what we do," I know different.

To Julie Mazur, Kimberly Small, Autumn Kindelspire, and all the fine folks at Random House/Amphoto Your belief in me is one of the highest accolades of my professional life.

To Joshua Seale, your positive attitude and kindness in the midst of my own case of the grumpies made it possible to hit

deadlines I was convinced could not be. To Lindye Galloway for holding down the photo fort while I ran around the planet. To Jennifer Yee for our sprint of an adventure, wishing your Google wisdom my way. To Sarah Raimone for your editing help out of the gate. To Andy Wolfendon for your stealth edits and sheer strength to drag me across the finish line.

To Michele Mollkoy for walking yet another crazy idea all the way out with me. To Rachel LaCour Niesen and Andrew Niesen, your encouragement in the storms of life and wisdom to overcome were pure gifts. To Julieanne Kost, Skip Cohen, Scott Bourne, Vickie and Jed Taufer, Mike Hanline, Tamara Lackey, Julia and Jeff Woods, Jesh de Rox, Jerry Ghionis, Melissa Tirado, Jules Bianchi, Joy Bianchi Brown, Chris Becker, Jeff Jochum, Steve Bender, Jeff and Allison Rodgers, Gary Sikes, Kirk Kirlin, Stacy Scott, Todd Proctor, Dan Tocchini, David duChemin, Laura Novak, Miki Johnson, Vincent Laforet, Zack Arias, Jeremy Cowart, and all the incredibly kind photographers and professional creatives who answered surveys, took interviews, scolded me, sent me care packages, prayed, and loved this thing into being.

To those of you on Facebook and Twitter who encouraged me to fight on when I wanted to quit. To the hundreds of Fast Track FEO Roadshow graduates who showed up as real friends and humans to me in a time our industry needs real friends and humans.

To the Fast Track Founders who invested in this idea turned movement long before it was ever written down.

To Judy Sanders-Morse, Tom Morse, Derek Sanders, David Sanders, David and Beth DeMello, Jason and Wendi Kliewer, Troy and Jessica Campbell as well as Doug and Sharon Campbell: You guys are about as constant as gravity and I am thankful.

Finally, to Tami, Drew, Abigale, Analise, Alaree (and even Zoe)…you taught me once again that at the end of the day, creativity and business are just creativity and business. But, family is where I want to spend my life. You love me more than I deserve. Thank you for sacrificing your husband and dad for a bit to get this thing done. I love you.

Dedication

I dedicate this book to the photographer sitting in a room, right now, by themselves, reading this book, wondering if choosing to risk it all on who they believe they were meant to be is worth it. Although no one can make that choice but you, know that you are a hero to me for even considering the gamble. My money's on you. It's also who this book is dedicated to. All in.

Index

marrying vision with
problem-solving, 63–64,
70–72
meaning clients associate
with, 197–198
model for success, 70–72
new development
steps/rules, 72–75
providing solutions, 63–64,
70–72, 193–196
that promote, 196–198
Venn diagram to assess,
64–66
Professional organizations,
222–223
Professional Photographer's
of America (PPA) Benchmark
Survey, 103
Profit centers, outsourcing,
115
Profit, planning into pricing,
93–94, 96
Promises to world
breaking, 52
defining yours, 51, 52–53
examples of, 51–52
making good on, 51–54
Purpose, connecting with,
223–224. *See also*
Connectedness

Resources, 243–247
Rodgers, Allison, 168

Salary, 95
Salary-equivalent pricing, 88
Sales psyche, 195–196
SAS (Subject/Attention/
Simplify) procedure,
181–182
Scaling business, 113–114
Selling your services. *See*
Booking jobs; Invitations
(to clients); Leveraging jobs;
Products (or services)
Setting, challenging situations,
176
Shooting challenges, preparing
for, 173–182
assignments, 186–188
clients and subjects,
176–177
competition, 177–178
creating your own SOP
acronyms, 187

elements (weather, etc.),
175–176
equipment issues, 174–175
image loss and/or
corruption, 178–179
physical setting, 176
SOPs alleviating, 180–182
time constraints, 173–174
trial run, 187–188
your own anxiety and fears,
179
Shooting jobs, 171–189
being prepared for anything.
See Shooting challenges,
preparing for
CERFS procedure, 180–181
clearing way for creativity,
172–173
client experience and,
183–186
core focus of, 183–186
EDFAT procedure, 182
efficiency in, 186
firing yourself as
photographer and, 23,
171
keeping business
perspective, 171–172
LUDA procedure, 182
as one of three main
functions, 151–152
professional photographer
comments on, 175, 178,
184–185
repeat business and, 183
SAS procedure, 181–182
Signature Brand
Photographers, 27, 28, 53,
89, 103, 186
Social media, 203–205
Solutions, providing, 63–64,
70–72, 193–196
Standard operating procedures
(SOPs)
assignments, 146–148
checking, for business plan,
237–238
clearing way for creativity,
172–173
creating, steps for, 136–137
creating your own, 148
creating your own
acronyms, 187
examples of, 133–136,
139–140

KISS approach to, 180
mail example, 133–136
for major and minor
operations, 138–140
manual (wiki) for, 140–141,
146–148
relative importance of
operations and, 138–140
running client meeting
example, 139–140
shooting examples,
180–182
for shoots, 180–182
for small tasks, 131–132
value of, 128, 129, 131–133
Stangel, Jake, 222
Starbucks, 52, 123
Start-up expenses, 96–98,
230–231
Strategic partners. *See*
Outsourcing; Team
development
Strengths and weaknesses
defining, 55
importance of knowing, 38
Subject/Attention/Simplify
(SAS) procedure, 181–182
Systematizing, 128–148
assignments for, 146–148
automating processes,
141–143
backing up operations and
data, 145–146
batch processing and,
143–145
building a machine instead
of sculpture, 129–131
clearing way for creativity,
172–173
culture based on, 218
defining processes, for
business plan, 237
meaning of, 128
Melissa Oholendt on,
133, 145
reasons for, 128–129,
211–212
repeated tasks. *See* Standard
operating procedures
(SOPs)
"rule" for, 129

Target market
evaluating experiences of, 53
identifying, 53, 233–234